Hollywood
Rides a Bike

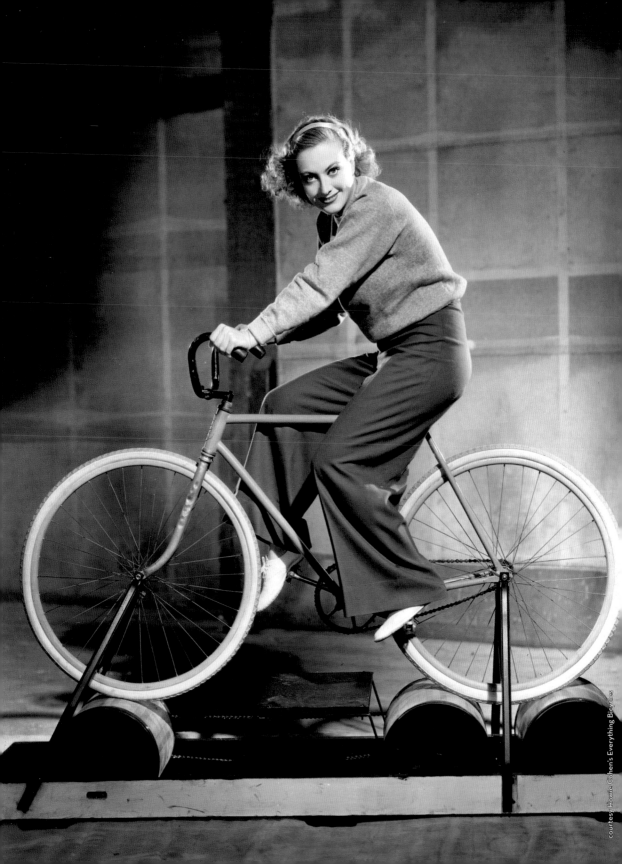

Hollywood
Rides a Bike
Cycling with the Stars

Steven Rea

ANGEL CITY PRESS

FRONTISPIECE:

Joan Crawford rides a bike. It's a good thing this bike is on rollers (wooden ones!)—That's not a silvery fleur-de-lis design on the left fork, it's some seriously mangled metal. Heedless, Ms. Crawford pedals merrily along. This publicity still was taken when the actress was doing *Dancing Lady* (1933) for MGM. She stars as a dancer reduced to burlesque halls, arrested for indecent exposure, and bailed out by Franchot Tone. But her real love is Clark Gable. David O. Selznick produced.

[VERSO:] Joan Crawford maintains a strenuous exercise program for her role in "Dancing Lady" for MGM; here she is on a stationary bicycle.

*"Are you going bicycling?
It's a lovely day."*

—Peter Fonda, *Lilith*

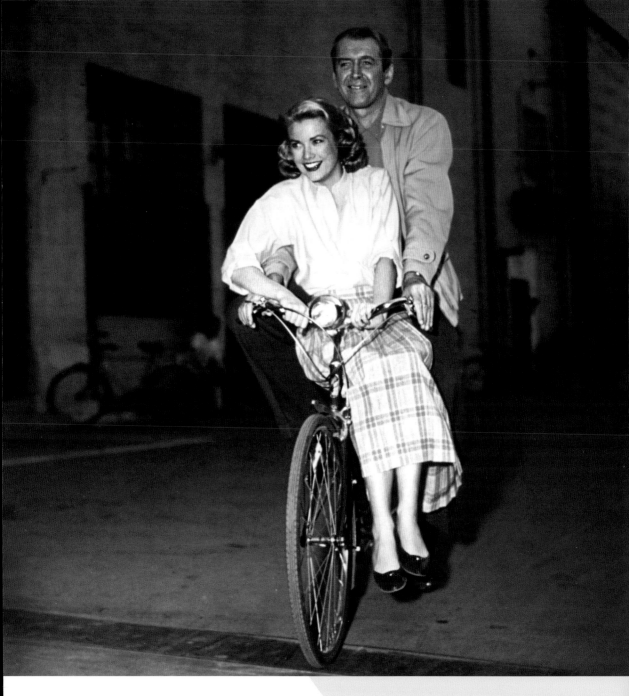

James Stewart and Grace Kelly ride a bike. So, the wheelchair was a ruse? *Rear Window*'s (1954) winning twosome take a nocturnal cruise around the Paramount lot during a break in shooting Alfred Hitchcock's voyeuristic mystery classic. Stewart, of course, is apartment-bound with a broken leg when he witnesses what he believes to be a murder across the courtyard. Kelly is his girlfriend. The bike, a red Phillips, definitely does not figure in the plot.

introduction

Way back in the last millennium, in my capacity as movie critic for the *Philadelphia Inquirer*, I went up to New York to do an interview with Meryl Streep, who was promoting *Dancing at Lughnasa*, the screen adaptation of Brian Friel's Ireland-in-the-1930s family drama. I had a half-hour allocated to chat with the Oscar winner about her new film and her career, but after a few words regarding the genius of Friel's writing and the talents of Michael Gambon and her fellow cast mates, we spent most of the time talking about the pleasures she experienced during the shoot, riding a vintage Raleigh rod-brake bike—with a Brooks leather saddle—down narrow country roads in County Wicklow. She loved it. Alas, thirty minutes expired, there wasn't much of a substantive, career-surveying Q&A there to offer my readers, but I felt that *La Streep* and I had bonded.

That's not the only time I've gone off-point with the movie stars that I've had the chance to talk to over the years (Zach Galifianakis, an avid cyclist, told me about pedaling his bike through Malibu, sweat pouring off of him, to meet his *Due Date* co-star, Robert Downey, Jr., for the first time), but for the most part (*Inquirer* editors take note) I've been diligent about my work. I've been lucky to write about film for a living. It's something I love.

But the bicycle is something I love, too. I live in a city that's easy to get around on two wheels and that has become increasingly accommodating to those of us who do so. It's not Amsterdam, but here in Philadelphia there are times when you find yourself falling in with a makeshift peloton of commuters and students and families, and it feels very civilized.

Which is how William Holden must have felt, tieless, his shirtsleeves rolled up, cruising past the Paramount arch, or Olivia de Havilland, in slacks and spectator shoes, riding through the fake city streets on the Warner Bros. backlot, towing her *Capt. Blood* trailer loaded with script and makeup (and perhaps, as one wise-guy friend noted, with Errol Flynn's empties, too). In the 1930s, '40s, and '50s, the studios stocked fleets of Schwinns, Shelbys, Raleighs and Rollfasts so its actors, writers and crew could get from one giant soundstage to another, zip back and forth from dressing room to commissary, or just to take a break between scenes. It was Hollywood's idea of a bike-share program, long before Paris implemented Vélib'. Look at the shot of Jimmy Stewart with his *Rear Window* co-star, Grace Kelly, dangling her legs from the top tube—the guy spent hour after hour trapped in a wheelchair, a phony cast on his leg, doing Hitchcock's bidding. Just think how liberating it must have felt to flee the scene and take his British-built three-speed for a spin . . . with one of the most beautiful women on Earth along for the ride.

So, movies. So, bikes. So, why not both? I had a few photographs that I'd collected over the years: Bogart on a bike, Bacall on a bike, and one particular image that had been in my mother's family photo album for decades. It turns out that her great uncle, my great-great uncle, an English oil prospector by the name of William Robertson, had caught Shirley Temple out for a ride. It was 1936, the child star was seven or eight, staying at the Desert Inn in Palm Springs. He took her photograph, her trademark tresses in curlers—a Hollywood star

with her two-wheeled vehicle.

I launched *Rides A Bike* on Tumblr —the platform with its kabillion bloggers— on a whim on Thanksgiving of 2010. I had my handful of photos and thought, what the hey, this'll be fun. I could share my twin passions—cinema and cycling—with a few like-minded folk.

Whoa, Nelly.

Before the weekend was out, it was clear, from the number of Tumblr followers and Facebook "likes," that I had bumped into quite a crowd: biking enthusiasts, artisan frame builders, and bike-tour companies, fashionistas, old movie buffs, style junkies, photography collectors, sustainability zealots (yes, biking—the ultimate in energy efficient transport!), Bogie fans and Hepburn fans (Audrey and Kate—both of them keen cyclists), and people with a taste for the classic and the cool. I was getting messages from France, Brazil, Sweden, Australia, and there were even people asking if they could send photos, gratis, to add to the *Rides A Bike* collection. (Yes, please!)

As a rule, the photographs in the following pages fall under four distinct categories: the candid backlot shots, taken by publicity lensers who happened across stars as they wheeled around the Burbank, Culver City, Universal City, and Hollywood lots; the production stills from movies where the actor, in character, rides a bike (Jane Fonda made her screen debut crashing a Rollfast into two of her co-stars; Julie Andrews and her towheaded charges were singing "Do-Re-Mi" as they took to the alpine blacktop); the staged studio portraits—a lot of cheesecake (Deborah Kerr and Veronica Lake and Rita Hayworth, oh my!) and beefcake; and then just real-life photos of the likes of Kim Novak, Cicely Tyson, and Julie Christie riding along on palisades paths, Central Park byways, and English country lanes. (Long before anyone had heard of *US Weekly*'s "Stars—They're Just Like Us!")

Many of the photographs I've been collecting—from movie memorabilia shops, from eBay vendors, a few from friends and *Rides A Bike* fans—have terrific typewritten captions, or snipes, pasted or printed to the back of them. Short commentaries on so-and-so's penchant for cycling, and a plug for the studio and the picture. I have this image in my head of a crusty Hollywood flack, just back from a two-cocktail lunch, handing a napkin with a caption scrawled on it to his secretary for her to run through the Remington. (Some of the sentences, grammatically speaking, certainly read like they were the result of a two- or three-drink cogitation.) Many of the pithier and more entertaining of these "verso" snipes are reprinted, unedited, along with the photographs.

As for the bikes themselves, retro fiends will note the streamlined angles, artful detail, and old-school craftsmanship on the cruisers and roadsters, folders and tandems, English lightweights and the occasional trike, triple- and high-wheeler pictured herein. In the same way that the typewriter has made a comeback, finding new generations of collectors and connoisseurs, and analog recordings and good ol' vinyl have their ardent, MP3-shunning adherents, these 1920s, '30s, '40s, '50s, '60s and even '70s bicycles are objects to admire. They mark a time and place when things were built to last, when design and function dovetailed neatly—well, perfectly, in fact.

And for the cineastes out there, the cycling icons captured on these pages represent decades of A-list artistry and B-movie stick-to-it-iveness. To look at Humphrey Bogart casually coasting through the backlot is to see Sam Spade and Rick Blaine and Philip Marlowe riding a bike. Sophia Loren on a 1940s Italian step-through—*Desire Under the Elms* (1958), *Heller In Pink Tights* (1960), *Two Women* (1960), *El Cid* (1961)—there she goes, and there go some of the star's unforgettable screen moments, too. Purveyors of pin-ups never had it so good: put a bike alongside a halter-topped starlet or high-heeled chorine and all of a sudden there's a legitimate prop to show off a lot of leg and limb, torso and more so.

So, *Hollywood Rides a Bike*. It's become an obsession—for all the aforementioned reasons, and others, too. It's heartening to see people riding bikes who haven't squeezed themselves into logo-emblazoned Lycra and Tour-de-France gear. In fact, in more than a few instances here, the cyclist in question is sporting some pretty high-class couture. And whatever your position on the helmet debate, clearly people have gotten by without them for decades. Not to mention the havoc helmets would have wrought on Elvis' pompadour, or Marlene Dietrich's beehive.

Arthur Conan Doyle, creator of Sherlock Holmes (yes, I'm still on the prowl for a Basil Rathbone-on-a-bike shot, if anyone out there has one), once wrote this about bicycle riding: "When the spirits are low, when the day appears dark, when work becomes monotonous, when hope hardly seems worth having, just mount a bicycle and go out for a spin down the road, without thought on anything but the ride you are taking."

And to that I would add: without thought on anything but the ride you are taking—except, perhaps, the Hollywood stars you're taking it with.

Steven Rea
Philadelphia

Esther Williams gets ready to ride a bike. The competitive swimmer and leading lady of a series of MGM's "aqua-musicals" also knew her way around the bike pool. Here she is, fashionably attired for a ride, and ready for her screen debut opposite Mickey Rooney in *Andy Hardy's Double Life* (1942)—which was called *Andy Hardy Steps Out* when it was in production. Note the cycle chic-ish photo caption, replete with fashion details.

[VERSO:] READY FORE A RIDE . . . Esther Williams, who makes her screen debut in Metro-Goldwyn-Mayer's "Andy Hardy Steps Out" enjoys an early morning ride on her bicycle. Perfect for this is the smart lipstick-red jersey blouse, enhanced by its antique silver buttons, and the hunter green jersey culottes worn by the young starlet. To complete this charming playsuit, Esther has chosen a soft hunter-green cap with a matching red wool cord tied in front. The culottes, blouse, and cap are by Lanz of California.

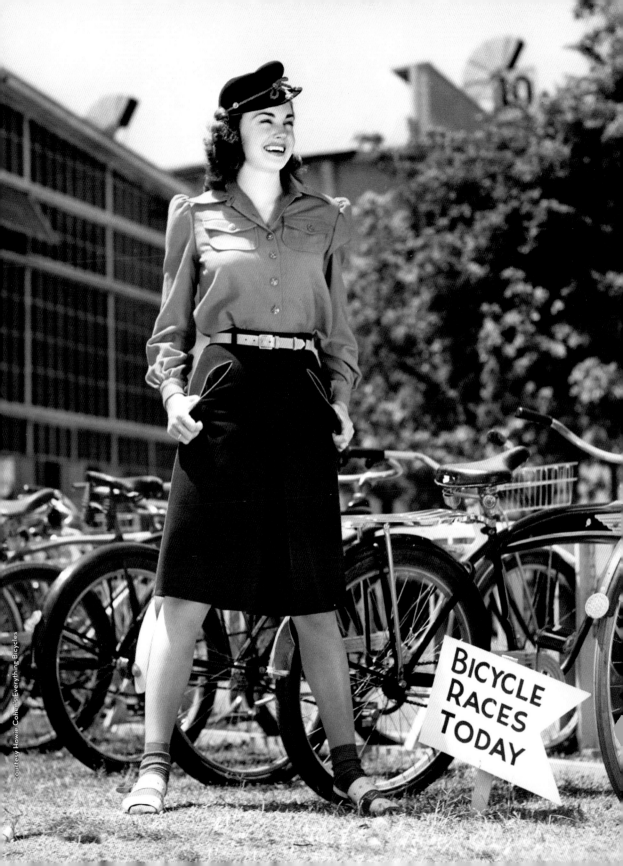

BICYCLE
RACES
TODAY

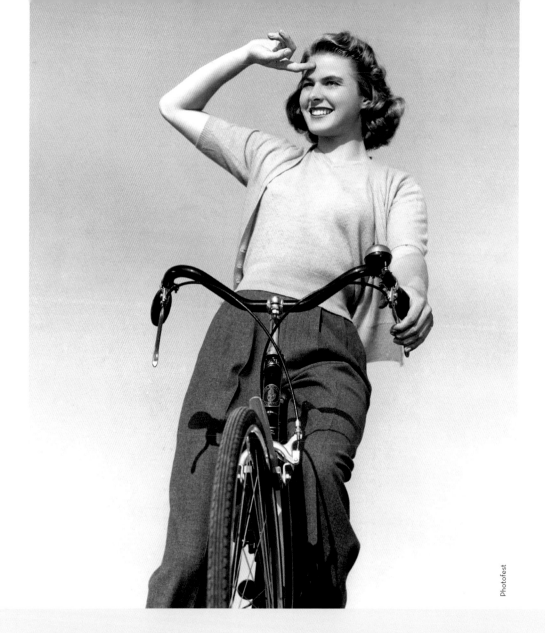

Photofest

Ingrid Bergman rides a bike. A Swedish cyclist heads in the right direction, even if her iPhone doesn't have a Map My Ride app . . . Ingrid Bergman, who made her American screen debut in *Intermezzo: A Love Story* (1939), reprising her role from the Swedish original, went on to do a few obscure little pics, like *Casablanca* (1942), *For Whom the Bell Tolls* (1943), *Gaslight* (1944), *Notorious* (1946), and *Joan of Arc* (1948). Here she proudly rides a ladies' Rudge Whitworth, the classic British bicycle from Coventry. Bergman continued to make movies into the early 1980s (her last: a biopic of Israeli prime minister Golda Meir). She also continued to ride bikes.

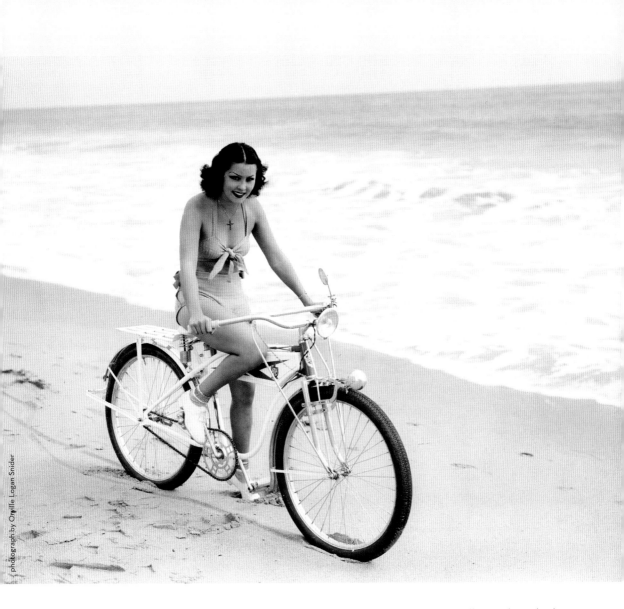

Raquel Torres rides a bike. Mexican-German Raquel Torres grew up in Hollywood, worked in late-1920s silents, the early talkies, and perhaps most significantly, as Vera Marcal, the sultry Sylvanian spy in the Marx Brothers' mayhem-mad masterpiece, *Duck Soup* (1933). Cruising along the Pacific surf, Torres is on an elaborately kitted-out Rollfast. Note the chain bell, the extended stays on the rear rack, and the headlamp wired to a D-cell in the horn tank. Those "H"s on the chainring are for D.P. Harris, the prolific bike manufacturer whose brands, in addition to Rollfast, included Harvard, Hawthorne, Roamer, and many others.

[Verso:] Raquel Torres' front lawn is made of sand. Shown here in front of her beach cottage at Malibu.

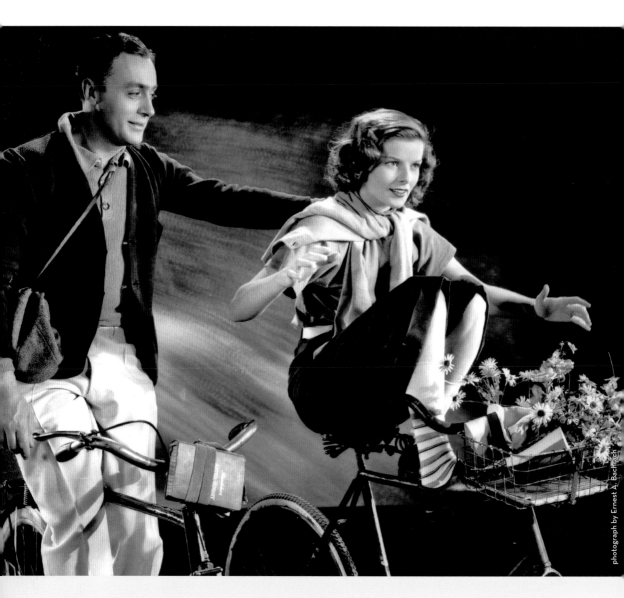

Katharine Hepburn and Charles Boyer ride bikes. Look Charles, no hands!—and no feet!
. . . Katharine Hepburn displays her bike-balancing chops—and a cute pair of striped socks—
as Charles Boyer looks on in this publicity still from RKO's romantic melodrama *Break of
Hearts* (1935). He's a famous orchestra conductor, she's a talented young composer, and the
two go off for a European honeymoon (hence the Baedecker's *Austria-Hungary* guidebook
strapped to Boyer's handlebars). Things go south when the couple returns to New York and
Boyer's womanizing past catches up with him. Hepburn's sprung saddle absorbs some of the
shock. An Ernest Bachrach studio portrait.

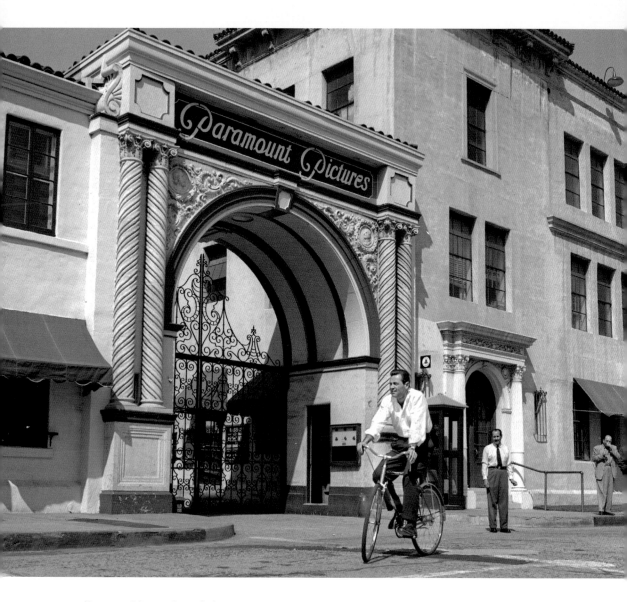

William Holden rides a bike. The star of Billy Wilder's brilliant Hollywood noir, *Sunset Boulevard* (1950), takes a relaxing ramble around the Paramount lot on a Schwinn New World with a large-flange rear hub. Standing in front of the Pacific Telephone phone booth, a studio co-worker steals an admiring glance at the cycling thespian. Holden's shirt sleeves are rolled up, ready for a ride in the blazing So-Cal sun.

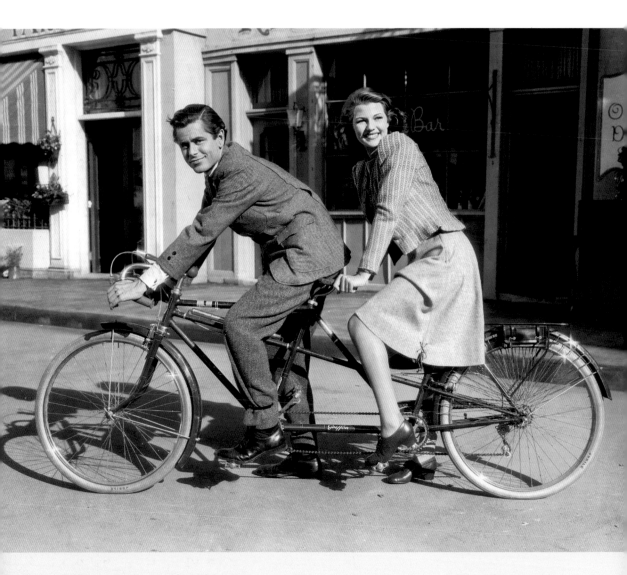

Glenn Ford and Rita Hayworth ride a bike. Tweed ride, anyone? . . . The dapper couple, starring together for the first time in the romantic drama *The Lady In Question* (1940) mount a gorgeous Griffon tandem. The French marque, also known for its motorcycles and "tricars" (a precursor of the pedicab, with the passenger in the front and the cyclist in the rear), commissioned a series of drop-dead gorgeous Art Nouveau posters during its time. Ford and Hayworth are pretty drop-dead gorgeous here. He's the son of a Parisian bike shop owner, who was a juror at the trial of Hayworth's Natalie Rougin, accused of murder and then acquitted. She moves in with Ford and his *père* (Brian Aherne) and the wooing begins. Ford and Hayworth went on to do four more films together, including the noir classic, *Gilda* (1946). For *Lady In Question,* Columbia's prop master also imported some other classic French bikes, including a ladies' Automoto.

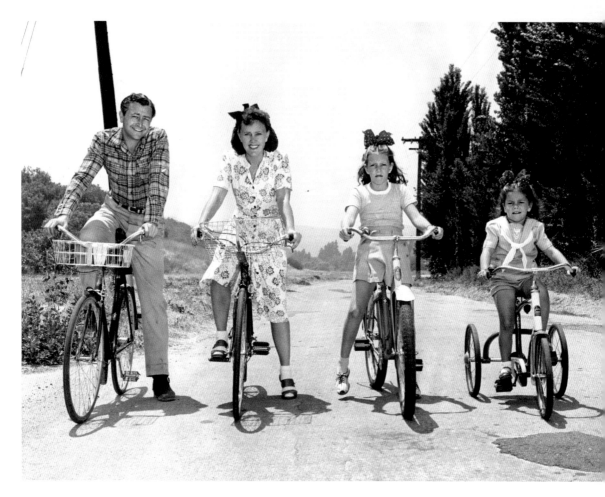

Robert Young, Betty Young, Carol Anne Young, and Barbara Queen Young ride bikes.
Family bike ride time! Robert Young, the 1940s and '50s film star perhaps best remembered
for his TV turns as Jim Anderson, the understanding paterfamilias in *Father Knows Best*, and
as Marcus Welby, the compassionate doctor in the hit series of the same name, spends time
with the wife and kids in this December 1942, press photo. The girls are riding a Colson tri-
cycle and a Schwinn-built Ace; Robert and Betty are on British Hercules with distinctive HC
(Hercules Cycle) headbadges.

[VERSO:] HOLLYWOOD ROLE: FAMILY MAN—Screen actor Robert Young is the sort of guy who goes home
from work every night and plays with his own kids. He's modest, so modest in fact that when MGM's
Louis B. Mayer asked to see him, Bob thought he was going to get a cut in his salary. He almost
passed out when Mayer gave him a new contract, doubled his salary and gave him star billing—
for the first time in Bob's twelve years in Hollywood—in MGM's new picture, "Nothing Ventured,"
which he is now making with Lana Turner. Bob, the quiet, unassuming family man, is pictured
here with Mrs. Young (formerly Betty Henderson) and their two children, Carol Anne, 8, and Bar-
bara Queen, 4, enjoying a bicycle ride in the country near their Tarzana, Calif., ranch home.

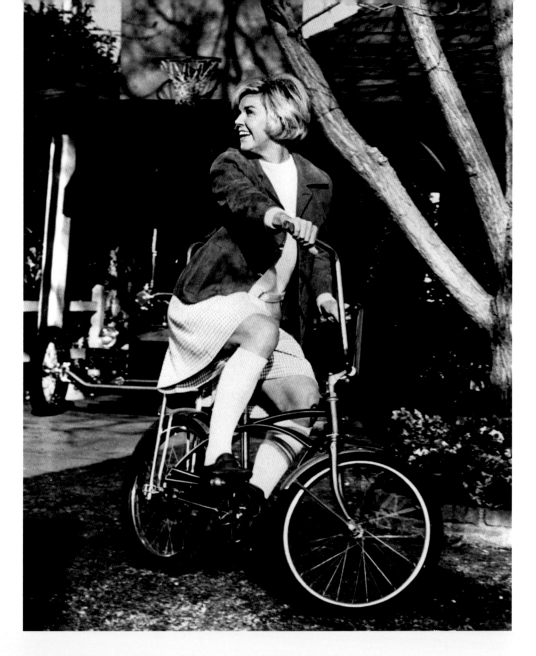

Doris Day rides a bike. It was the rare day that Doris Day, star of more than 40 films in the 1950s and '60s, including several huge hits with Rock Hudson, didn't take a spin around Beverly Hills on her bike. The actress and singer was such an avid cyclist she even did a series of print ads for Schwinn. Here she is on a classic Schwinn Stingray, in a still from *With Six You Get Eggroll* (1968), in which Doris plays a widow with three sons who meets a widower (Brian Keith) with a teenage daughter (Barbara Hershey). It was her last feature film. From 1968 to 1973 she starred in *The Doris Day Show* on CBS.

Louise Allbritton falls off a bike. Does the "B" in B-movie actress stand for bicycle? Here's Allbritton, the tall and charismatic Universal contract player who had the female leads in *Son of Dracula* (1943), Abbott and Costello's *Who Done It?* (1942), and the classic from which this still is taken, *San Diego I Love You* (1944). The farce—in which she plays the lone sister in a family whose father (Edward Everett Horton) is an eccentric inventor—is of especial note to Buster Keaton fans: he plays a sourpuss San Diego bus driver who picks up Allbritton and Jon Hall for an unforgettable ride. The bicycle belongs to one of Allbritton's character's four brothers. Has Cindy Sherman seen this photo?

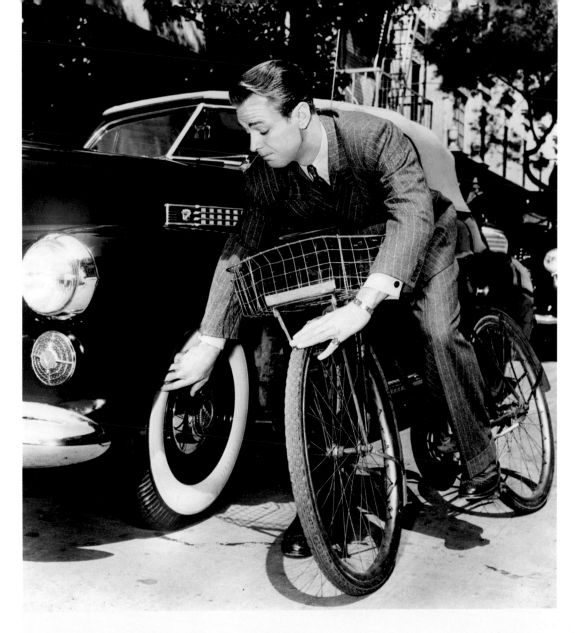

Alan Ladd rides a bike. The Hollywood leading man, playing tough-but-composed heroes in gangster pics, westerns and noirs, shows his ability to work under pressure—tire pressure, that is. Ladd, in pinstripe suit and Oxford brogues, is on the Paramount lot heading to work with the glamorous Veronica Lake in *The Glass Key* (1942), director Stuart Heisler's adaptation of the Dashiell Hammett caper. Check out that pinky ring.

[VERSO:] FOR COMPARISON'S SAKE—Alan Ladd, sensational new Paramount star, cycling between dressing room and the set of his current starring film, "The Glass Key," pauses to compare his tires with those of another star's limousine, and to himself ventures a prediction that his will outlast the car's.

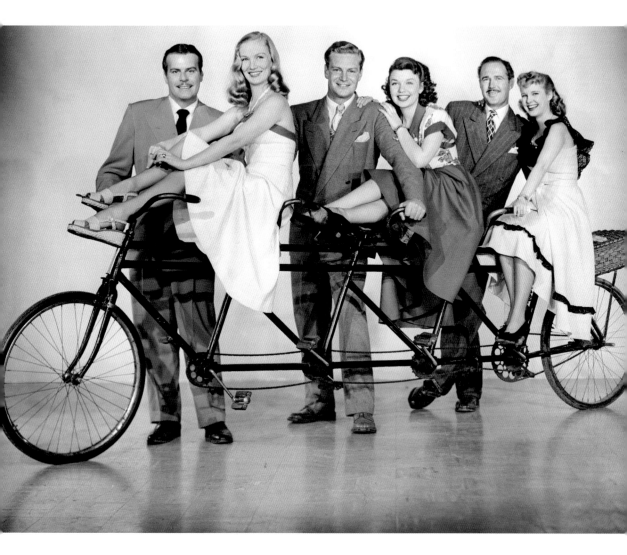

Veronica Lake, Mona Freeman, and Mary Hatcher ride a bike. Billy De Wolfe, Richard Webb, and Patrick Knowles stand by. Suited up in contemporary dress rather than the Reconstruction-era costumes required of the cast when the cameras rolled for Paramount's musical *Isn't It Romantic?* (1948), Veronica Lake, Mona Freeman, and Mary Hatcher perch atop a "quadruple" with a Philco front brake, while the male leads smile heartily for the camera and wonder why the photographer insisted on a bicycle-built-for-four as a prop.

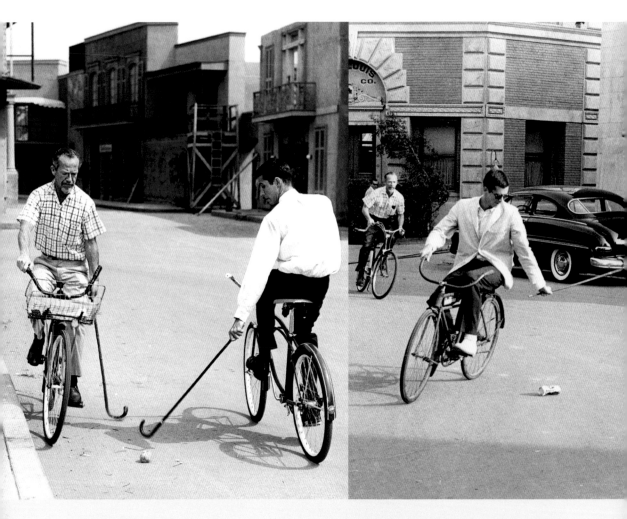

Ray Walston and Anthony Perkins ride bikes. And play polo. On the Warner Bros. back-lot between takes on *Tall Story* (1960), the college-campus rom-com in which Jane Fonda makes her screen debut (see her on page 48), Ray Walston and Anthony Perkins bat around a ball and a tin can in a makeshift, bike polo match. Walston, who plays a college prof, was a busy character actor who later paired with Bill Bixby for the hugely popular 1960s sitcom, *My Favorite Martian* (the *Alf* and *Mork and Mindy* of its day). Perkins, playing a varsity basket-ball star who Fonda plots to meet and marry, is forever remembered as Norman Bates, the mother-loving motel proprietor of Alfred Hitchcock's *Psycho* (1960).

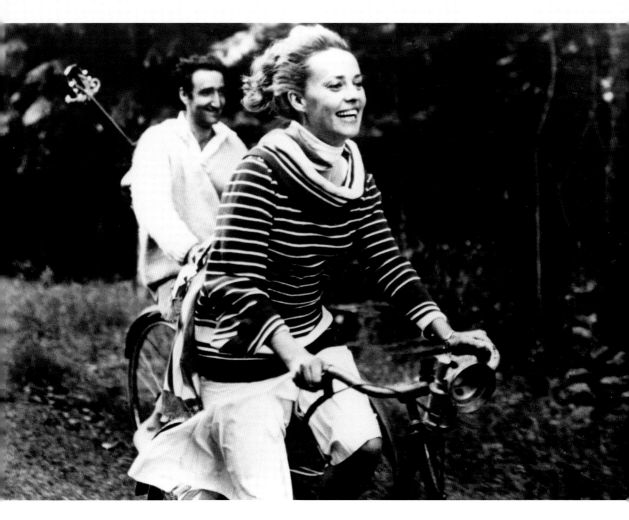

Jeanne Moreau and Henri Serre ride bikes. *Heureusement.* Hair blowing in the wind— and her scarf and her skirt, too—Jeanne Moreau coasts blissfully down a country road in the company of Henri Serre in this still from Francois Truffaut's French New Wave classic, *Jules and Jim* (1962). It's the tale of two men (Oscar Werner is Jules) and the woman they love, and this scene, set to Georges Delerue's spirited score, captures the freedom and happiness of the moment. (A very short-lived moment, as Jim, who wants Moreau's Catherine for himself, veers off to ride solo.) Truffaut and his cinematographer, Raoul Coutard, shot some of the black-and-white classic using lightweight cameras mounted on, yes, *les velos*. Woody Allen, in *Vicky Cristina Barcelona* (2008), is one of many directors who tipped their hats to this iconic sequence when his *ménage à trois*—Penélope Cruz, Scarlett Johansson, and Javier Bardem— bicycled down a rustic road.

Grace Bradley rides a bike. Gracefully balanced, Grace Bradley sits atop an 1890s Gormully & Jeffrey high-wheel (note the racing-style handlebars) in this cheesecakey, 1933 stunt photo. A Broadway star, she headed to Hollywood and signed with Paramount, where she appeared in *Too Much Harmony* (1933), *Anything Goes* (1936), *Wake Up and Live* (1937), and *The Big Broadcast of 1938* (1938). In 1937, she married *Hopalong Cassidy*-star William Boyd, who was better known for riding horses than bikes.

[VERSO:] On A Bicycle Built For-An Acrobat. Grace Bradley, Paramount Screen Actress, is a brave girl to climb all the way up this forerunner of the present popular bicycle. The old-time wheel is owned by J. Walker Lyon, collector of Pasadena. It was once ridden by Anna Held when she visited Fresno with her famous Floradora Girls.

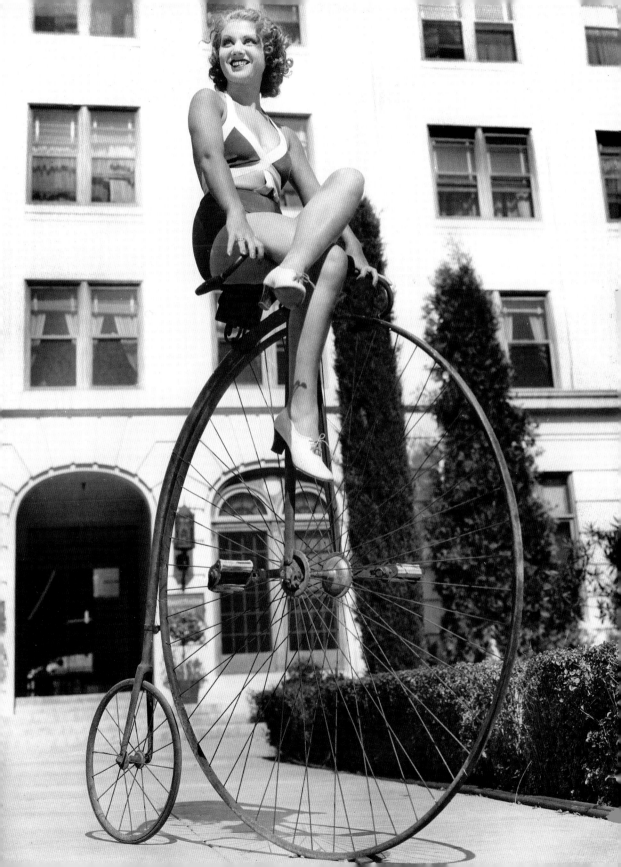

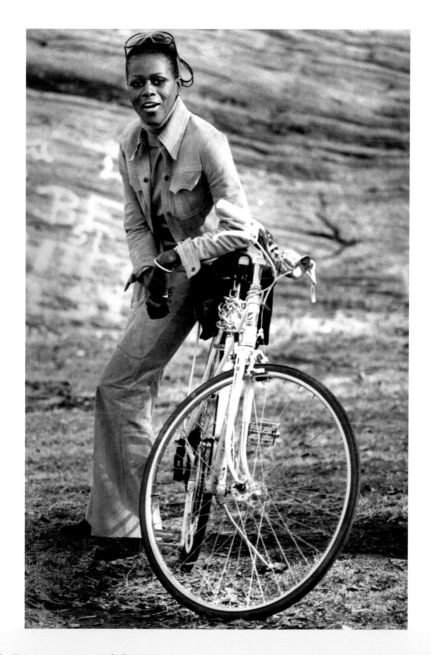

Cicely Tyson rests on a bike. Nominated for the best actress Oscar for her work in the Depression-era sharecropper family drama *Sounder* (1972), the New York-based actress took a few spins around Central Park before she headed out to Los Angeles for the Academy Awards ceremony. Here she is with her Peugeot mixte roadster (note the heavy chain wrapped around the seat post). According to the snipe on the back of the publicity photo, Tyson, like most Manhattanites, didn't own a car.

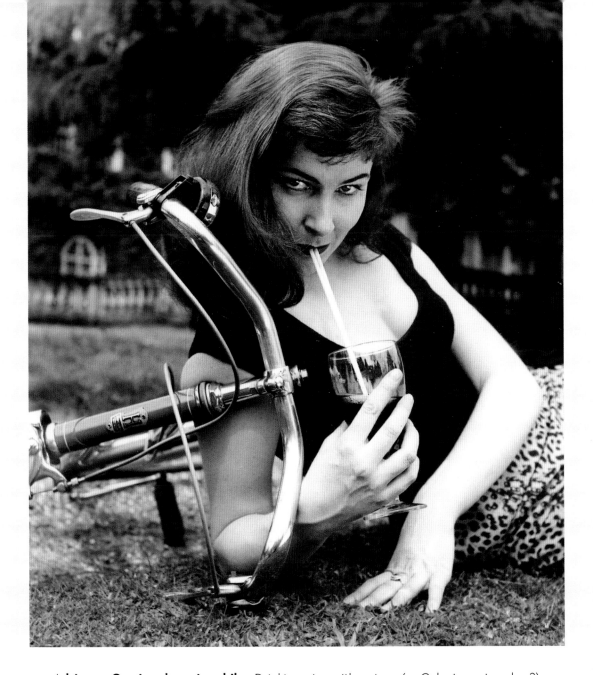

Adrienne Corri curls up to a bike. Drinking wine with a straw (or Coke in a wine glass?), the Scottish redhead gets intimate with her beloved Hercules single speed, equipped with Lucas bell. It's 1954, when leopard-skin pedal pushers were all the rage, and Corri—to be remembered several decades hence as the droogs' rape victim, Mrs. Alexander, in *A Clockwork Orange* (1971)—relaxes during the production of the British release, *The Little Kidnappers* (1953), a boys-and-their-dog heart tugger. Hercules, the popular British bike, was taken over by Nottingham's Raleigh Industries in 1960, but Corri's is a genuine Birmingham-made model.

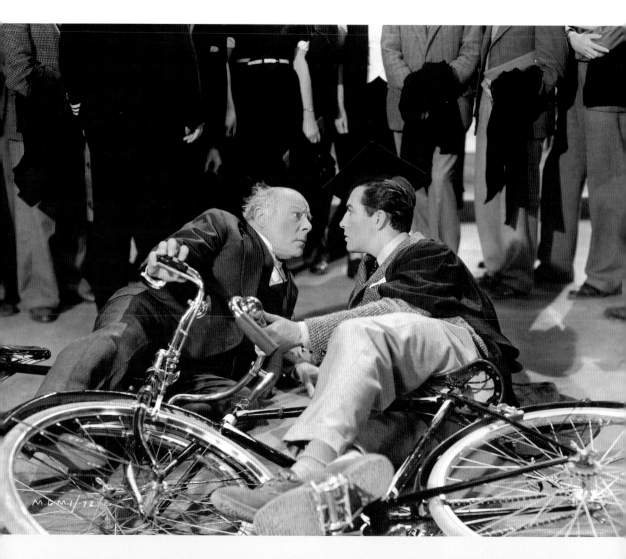

Robert Taylor and Edmund Gwenn crash bikes. As a "two-fisted American college student" who heads across the Pond in *A Yank at Oxford* (1938) to study at the venerable British university, Taylor collides with the Dean of Cardinal College, played by Gwenn. Taylor—whose character also runs and crews—is riding a handsome, high-end 1930s British lightweight with a flip-flop rear hub and drop bars. Gwenn's on a traditional rod-brake roadster. The MGM comedy was remade nearly a half-century later as *Oxford Blues* (1984), with another Rob—Rob Lowe—in the Taylor role.

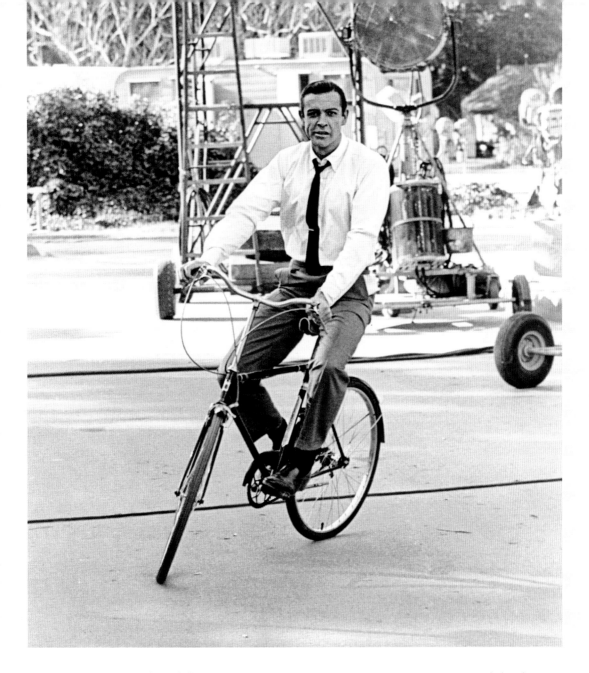

Sean Connery rides a bike. After *From Russia With Love* (1963), Agent 007 moonlighted as Mark Rutland, owner of a Philadelphia insurance company, who hires and then seduces Tippi Hedren, a compulsive thief and liar, traumatized by loud noises and the color red. Alfred Hitchcock called his psychodrama, *Marnie* (1964), a "sex mystery." Looking puzzled, Connery circles the Universal set on a Schwinn with an unusually high stem.

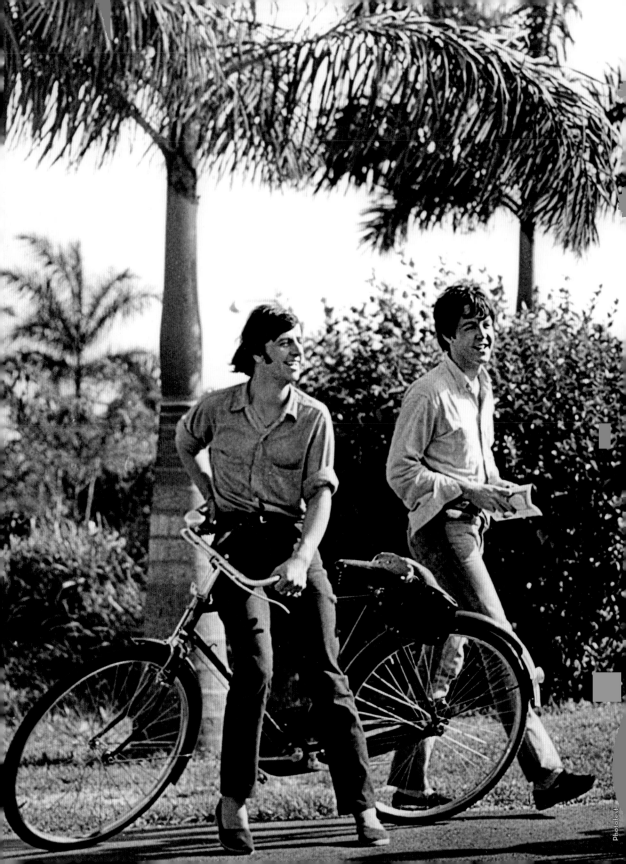

The Beatles ride bikes. Richard Lester directs traffic. Ticket to ride . . . Ringo Starr, John Lennon, and George Harrison park their BSA rod-brake roadsters while Paul McCartney thinks he's spotted some loose change on the Bahama blacktop. It's *Help!* (1965), Richard Lester's sun-splashed follow-up to the groundbreaking Fab Four frolic, *A Hard Day's Night* (1964). The matching BSAs (the initials stand for Birmingham Small Arms, and the headbadge image is of three intertwined rifles) come from the same company famous for their now-coveted vintage motorcycles.

Alan Bates rides a trike. A wayward British soldier in World War I France, Bates has the title role in Philippe de Brocca's beloved arthouse hit, *King of Hearts* (1966). As Private Charles Plumpick, the British actor heads for the rustic village of Marville, where the only folks left are inmates from the local asylum. They crown him king, and he goes along for the ride. Here he is on a beautiful 1880s, French, adult tricycle with plunger brake, solid tires and coasting peg on the fork.

Barbra Streisand rides a trike. Ryan O'Neal gives a push. Borrowing a red Worksman front-load delivery trike (from Franklin Bros. Groceries), Streisand and O'Neal go off on a screwball tour of San Francisco in Peter Bogdanovich's madcap farce, *What's Up, Doc?* (1972). In the comedy, which involves a mix-up of identical plaid suitcases, top-secret documents, and lots of hugger-mugger, Streisand is an itinerant college student (on her fifth or sixth university) and O'Neal, a bespectacled, bow-tied prof. Their ride up and down the hills of San Francisco takes them smack into the middle of a Chinatown festival procession. Streisand, on the back of the trike, says "Where are we? I can't see." "Well, there's not that much to see, actually," O'Neal responds breathlessly. "We're inside a Chinese dragon."

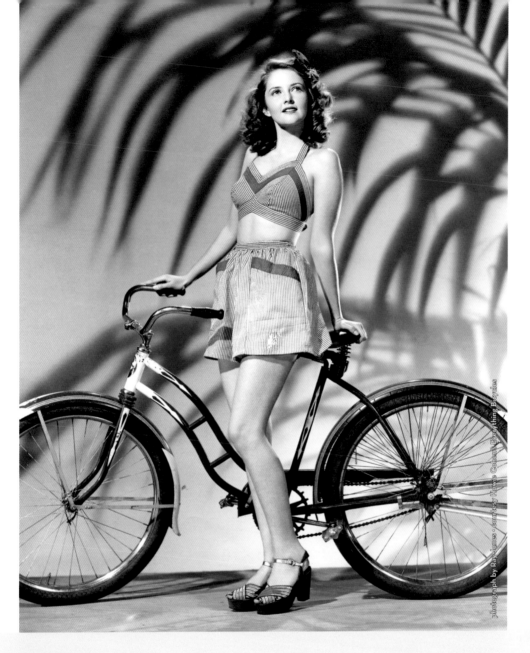

photograph by Ray Jones • courtesy Howie Cohen's Everything Bicycles

Martha Vickers stands by a bike. With a dreamy look in her eye, Vickers—born Martha MacVicar in 1926—poses in a little seersucker outfit alongside a 1945 Rollfast in this gorgeous glamour shot by Hollywood photographer Ray Jones. Vickers started out in bit parts at RKO and Universal, and then made her provocative splash into the big time as Lauren Bacall's seriously messed-up, thumb-sucking younger sister, Carmen, coming on to Humphrey Bogart in *The Big Sleep* (1946). From 1949 to 1951, Vickers was married to Mickey Rooney.

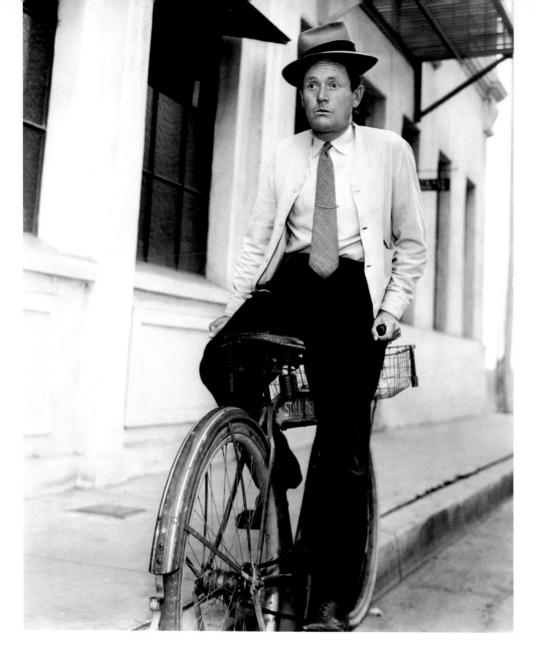

Roscoe Karns rides a bike. Backwards. Borrowing a delivery bike from Paramount's still department, the busy character actor pedals nowhere fast. Karns was sort of the Zelig of his day—he shows up in some of the key motion pictures of the 1920s, '30s and '40s, hobnobbing with the likes of Gable and Lombard, Cooper and Crawford, and lending his rubbery mug and rat-tat-tat delivery to such classics as *The Jazz Singer* (1927), *His Girl Friday* (1940), and *They Drive By Night* (1940). Note the plaid trousers, tie chain, and fedora askew. The backlot photo was taken when Karns was at work on, among other titles, Bob Hope's *Thanks for the Memory* (1938).

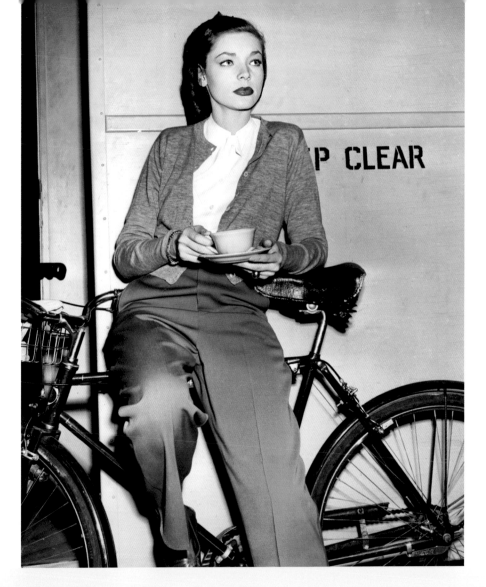

Lauren Bacall leans on a bike. Just twenty, the former Betty Joan Perske of New York rests against a studio bike with her cup of joe, contemplating her next move. Bacall smoldered in her 1944 debut *To Have and Have Not* with future spouse Humphrey Bogart ("You know how to whistle, don't you, Steve? You just put your lips together and blow.") The bike is outfitted with front basket and a New Departure two-speed hub. Bacall is outfitted in white blouse, cashmere cardigan, gabardine trousers, penny loafers—and an aerodynamic snood.

[VERSO:] Dynamic Lauren: Lauren Bacall made film history with Humphrey Bogart when she stepped into the lead opposite him in "To Have and Have Not," and made a one-girl sensation out of her first screen role. She's dynamic, is easily the most photogenic subject who has come to films in many a day. Lauren prefers slacks, sweaters and bicycles to dresses, silk stockings and open cars. She likes to be free and unencumbered, she says. Here's Lauren in a new and informal pose in a Hollywood studio." 1/11/45. Wide World Photo

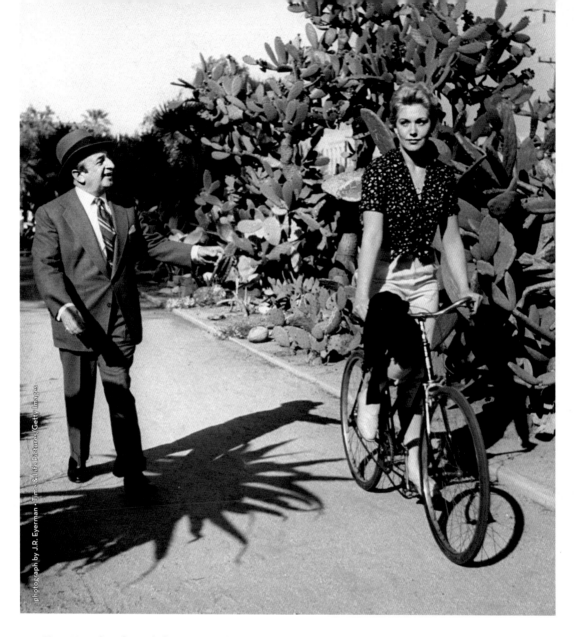

Kim Novak rides a bike. Louis Shurr points at a star. No sign of vertigo here. A stand of cacti to her left, Novak pedals coolly past Louis Shurr, the agent who discovered her, in this reenactment of how the duo met, taken by J.R. Eyerman for *Life* magazine in 1954. The cool yet sultry star, whose doppelgänger role as a mystery woman in Hitchcock's masterwork, *Vertigo* (1958), is the stuff of cinema history, made more than thirty films. Most of them hailed from the 1950s and '60s, including *Picnic* (1965) (opposite William Holden) and *The Man With the Golden Arm* (1955) (with Frank Sinatra). Novak went on to raise and ride horses, but she's a fan of cycling, too, appearing on the cover of the July 1957 issue of the entertainment weekly *Picturegoer* atop a Schwinn.

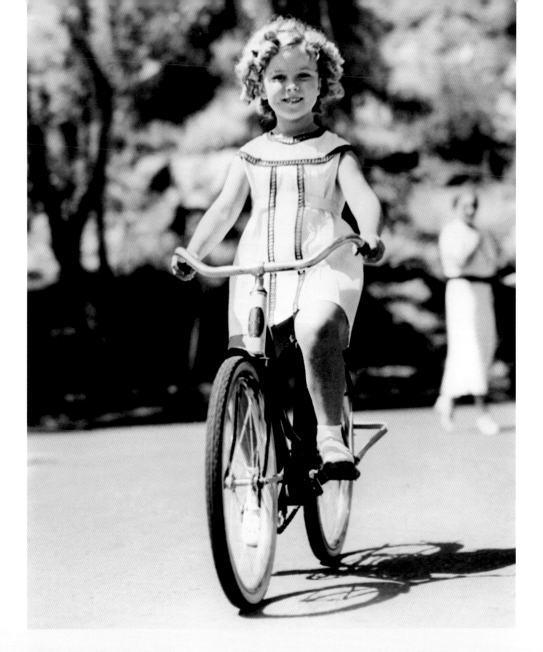

Shirley Temple rides a bike. Temple of the two wheels. The hugely popular 1930s child star is photographed in Palm Springs, April, 1936, beaming with confidence—and without training wheels—just a few days before her eighth birthday. That same year, four of the curly-coiffed kid's vehicles rolled into rialtos nationwide: *Captain January*, *Poor Little Rich Girl*, *Dimples*, and *Stowaway*.

[Verso:] A Veteran Novice: Shirley Temple won't ride her velocipede any more since she's learned to handle a bicycle. Here she is seen shortly after her first lesson, riding down a street of Palm Springs, California, 4/18/36.

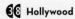

Jean-Claude Brialy rides a bike. Around Anna Karina's apartment. Jean-Luc Godard once famously opined, "All you need to make a movie is a girl and a gun." And a bike? In the French New Waver's anarchic anti-musical, *A Woman is a Woman* (1961), Karina stars as a stripper who can't decide between her two admirers: Brialy and Jean-Paul Belmondo. Here Brialy borrows Karina's French road bike (with the cool wing nuts and Simplex shifter) and rides around her apartment. In the scene just before, he oils the chain with a little oil can— *pourquoi pas?* Karina, the French New Wave icon, was Godard's muse, and the first of his three wives (all named Anne or Anna).

Carole Lombard and Fritz ride a bike. The highest paid star of the 1930s, Lombard received a best actress Oscar nod for her sublime screwball turn in *My Man Godfrey* (1936), opposite ex-husband William Powell. Later she tied the knot with Clark Gable. The couple settled into an Encino ranch, sold to them by director Raoul Walsh, who raised horses there. Gable and Lombard didn't have ponies, but they ran a veritable animal shelter. Among their many pets over the years: Edmund, a rooster; Eli and Jessie, a couple of chickens; Josephine, a cat; Pushface, a Pekingese; Queenie, one of two dachshunds; Smoky and Dudey, cocker spaniels; and a sheepdog named Beau. Here she is with her other dachshund, Fritz. Lombard died in a plane crash, returning from a war-bond rally in 1942. She was thirty-three.

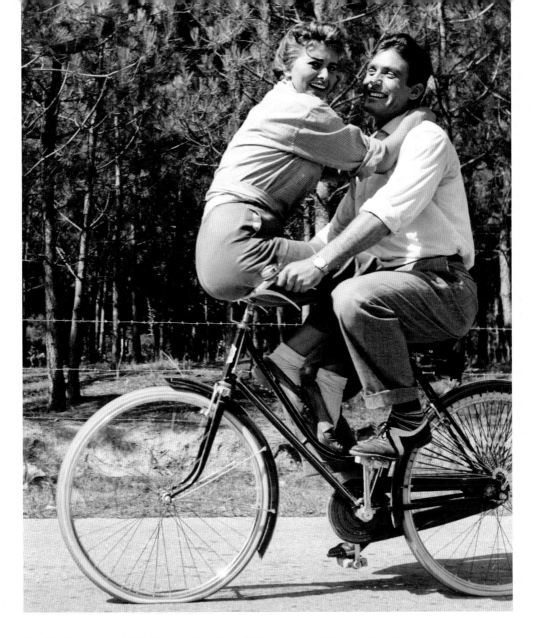

Sophia Loren and Rik Bataglia ride a bike. In one of her earliest lead roles, in 1954's *La donna del fiume* (released stateside as *Woman of the River*), Sophia Loren is a peasant girl and Rik Battaglia the fisherman and smuggler she longs for. Here they are clowning down a country lane on an Italian (of course) step-through rod-brake bicycle. There are bikes all through *La donna del fiume*—and an entertainingly phony rear-projection motorcycle ride, too. Bataglia, who went on to work in a bunch of spaghetti westerns (including Sergio Leone's *Duck, You Sucker* [1971]) needs to raise his seat a little. Loren has her own ideas about positioning oneself comfortably for the ride.

Jean Hersholt rides a bike. Against himself. Long before the Jean Hersholt Humanitarian Award was handed out at the Oscars, its namesake was a serious cyclist. Here the actor, on a double-top-tubed bike with Fauber cranks and chain ring, races against a projected image of his younger self, in a nifty 1930s MGM publicity still. Hersholt, born in Copenhagen in 1886, spent his Silent Era years mostly playing villains, but then transitioned to kindhearted gents, like Shirley Temple's grandfather in *Heidi* (1937) and the title role in *The Country Doctor* (1936) and its sequels. In all, he made more than 140 films. In 1939, Hersholt was key in the establishment of the Motion Picture Relief Fund. He also served as president of the Academy of Motion Picture Arts and Sciences.

[VERSO:] Jean Hersholt appears in this photographic composition as a twenty-year-old cycling champion . . . and as he would later be seen in an MGM movie.

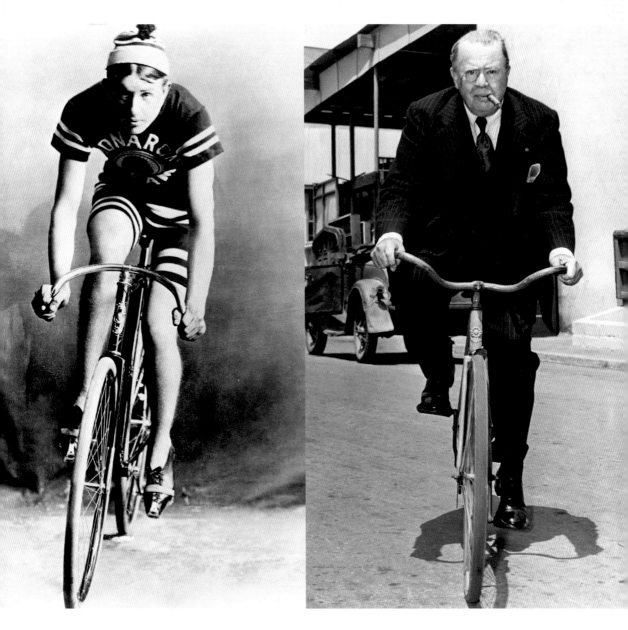

Charles Coburn rides two bikes. The courtly character actor—he of the monocle and the memorable roles in a host of 1940s and '50s screwballers—rode for the Monarch Team back at the turn of the century. Some forty years later—1945 to be exact—he's patrolling Universal's backlot on a Rollfast, suited up, with a stogie in his mouth during a break from making *Shady Lady* (1945). In the comedy, Coburn plays a cardsharp and "Colonel," not unlike the cardsharp and "Colonel" he played in Preston Sturges' *The Lady Eve* (1941). Speaking of Monarch, coincidentally, Coburn appeared in print ads for the completely different Monark Bicycles ("Insist on a Monark . . . the sensation of 1947!") too.

Kevin Bacon rides a bike. The hair, the Giorgio Moroder synthesizer, the Raleigh Competition . . . Welcome to the 1980s! As a New York options trader who loses everything—including his parents' life savings—Bacon's Jack Casey slings on a messenger bag and takes to the streets, joining Kurtzweill's Quicksilver Express. Laurence Fishburne is one of his cycling confreres; Jami Gertz is the girl he picks up (when she's hit by a truck while riding a bicycle); and there are even a couple of "bike dance" numbers. *Quicksilver* (1986), Bacon's follow-up to the hit *Footloose* (1984), bombed with critics and at the box office, but over the ensuing years has taken on an aura of nostalgic kitsch.

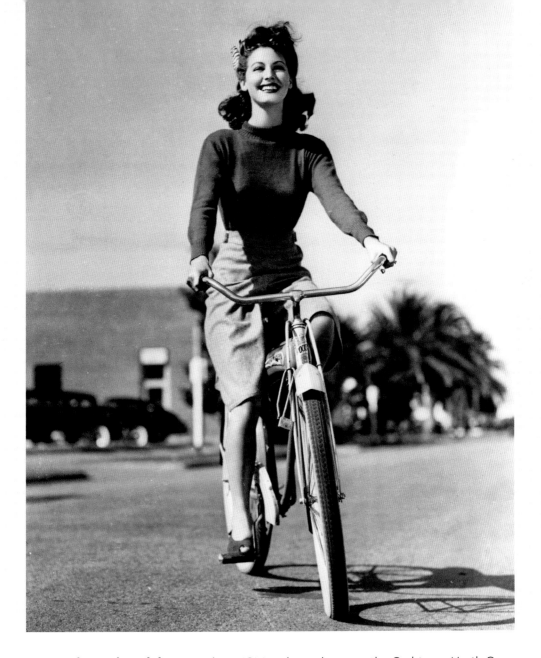

Ava Gardner rides a bike. Signed to MGM in the early 1940s, the Grabtown, North Carolina, native—and avid cyclist—went on to play Kitty Collins, the lethal chanteuse in the film noir gem, *The Killers* (1946). Married serially to Mickey Rooney, Artie Shaw, and finally Frank Sinatra, Gardner received a best actress nomination for her work in *Mogambo* (1953). Here she is, riding a spiffy 1941 Monark Rocket around town. Note the padlock dangling from the bars—bike theft in 1940s L.A.? Say it ain't so.

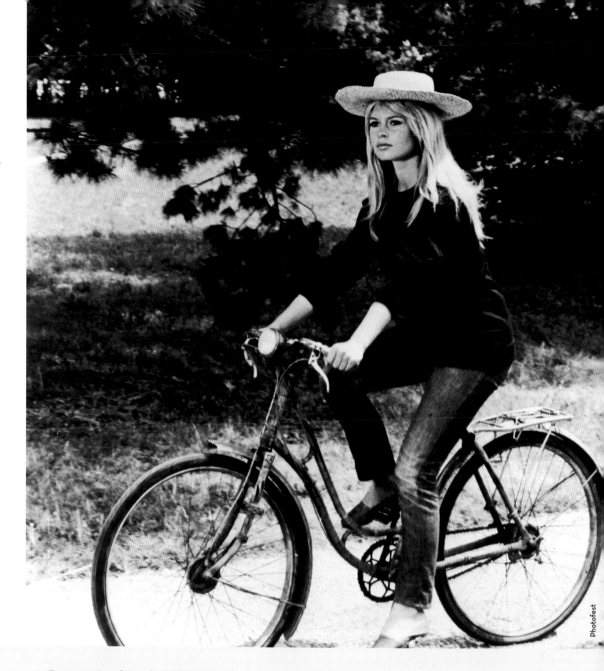

Brigitte Bardot rides a bike. You're an international goddess of a model-turned-actress, the paparazzi and the press follow you everywhere you go, and so do hordes of fans and creeps. What's a poor French sex symbol to do? Get on her bike and go for a ride in the countryside, of course. In the Louis Malle-directed *A Very Private Affair* (1962), France's famous BB plays a loose variation of her real self, one plagued by fame and a life in the spotlight. Things end badly for Bardot's Jill, but she certainly seems happy enough in this pastoral moment, idly spinning through *la campagne*.

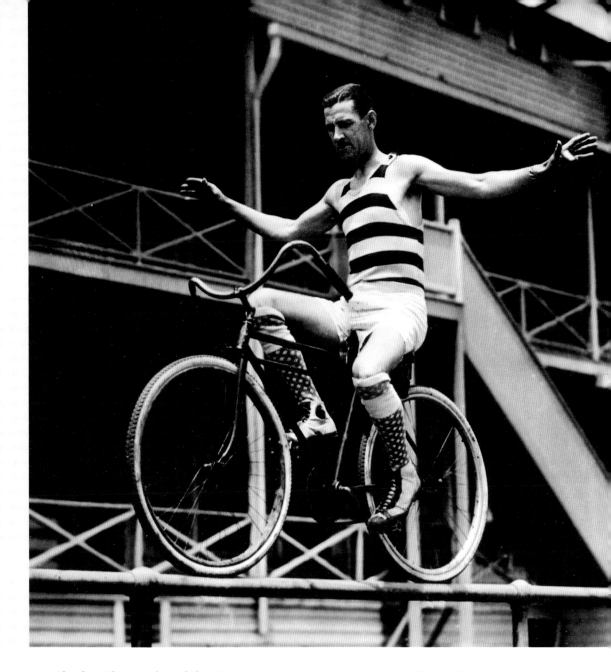

Charley Chase rides a bike. The silent screen comedy star—born Charles Parrot—makes a daring fashion statement (stripes! polka dots! knee socks!) as he makes his daring way across a balance beam on his double-top-tubed safety bike. This June 1929 photo was taken when Chase was signed to the Hal Roach Studio, producing dozens and dozens of two-reelers. Some years later, Chase directed the Three Stooges classic short *Violent Is the Word for Curly* (1938).

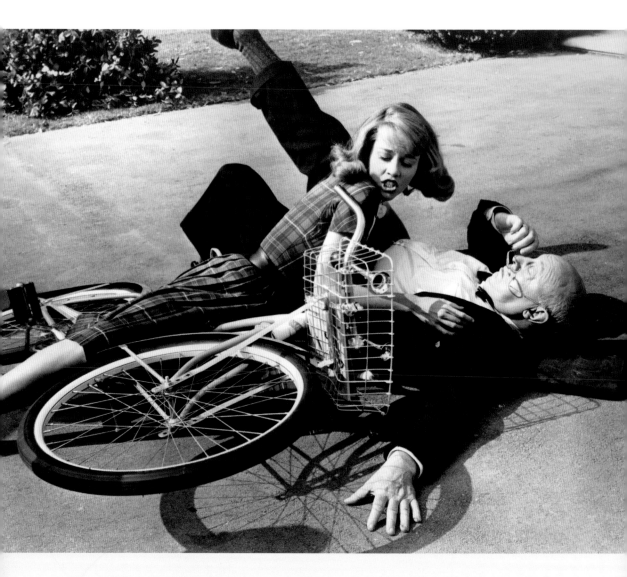

Jane Fonda rides a bike. Into Marc Connelly. Actress crashes into the movies . . . and into character actor Marc Connelly in her screen debut in *Tall Story* (1960), a screwball romance in which Fonda is the aptly-named June Ryder, a coed intent on marrying Custer College's basketball star (Anthony Perkins). The scene in which Miss Ryder (not Ms. Ryder—this is definitely pre-feminist Fonda!) pedals her Rollfast across campus, tooting the horn and toppling her professor, was shot at Occidental College. The Joshua Logan-directed Warner Bros. release also marked the first movie job for another cinema icon-to-be, Robert Redford (he's one of Perkins' teammates). On page 22, see Anthony Perkins and Ray Walston, bike-poloing between scenes of, yes, *Tall Story*.

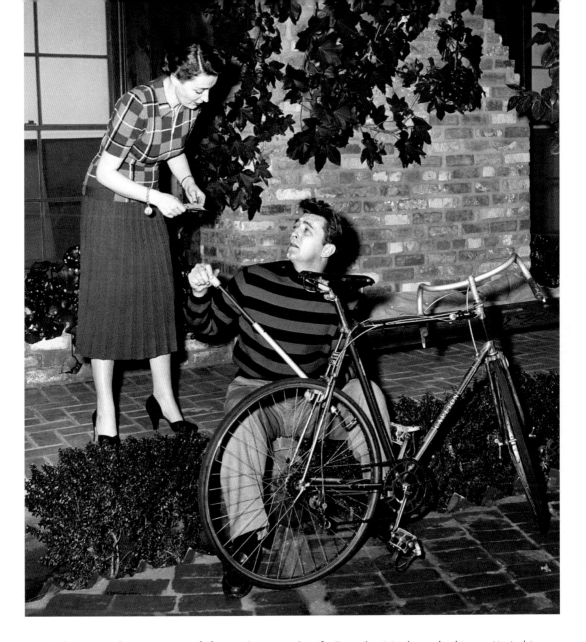

Robert Mitchum pumps a bike. At home with wife Dorothy, Mitchum—looking natty in his penny loafers and striped sweater (all the peloton-ers are wearing 'em!)—puts air into the rear tire of a beautiful late-1940s Carlton club bike. Note the chrome lugs, Brooks saddle, Cyclo derailleur, Chater Lea chainwheel, GB wingnuts, and top-tube-mounted shifter. (And the gracefully arcing cable work.) Mitchum, of course, was one of the coolest of Hollywood's cool, an iconic figure in the essential noir *Out of the Past* (1947), a veteran of mysteries, westerns, war movies, and more. The fact that he owned a Carlton, one of the elite British lightweights, just confirms his total coolness.

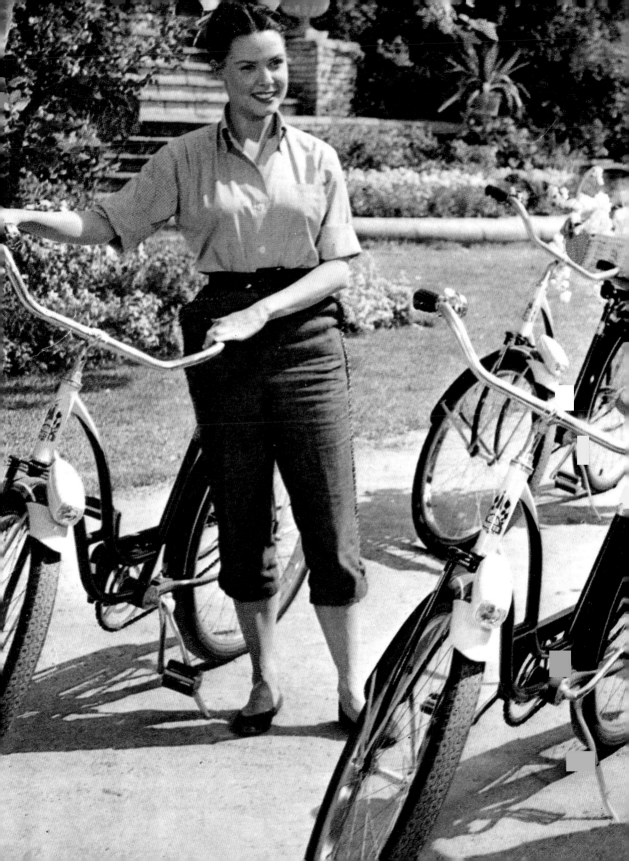

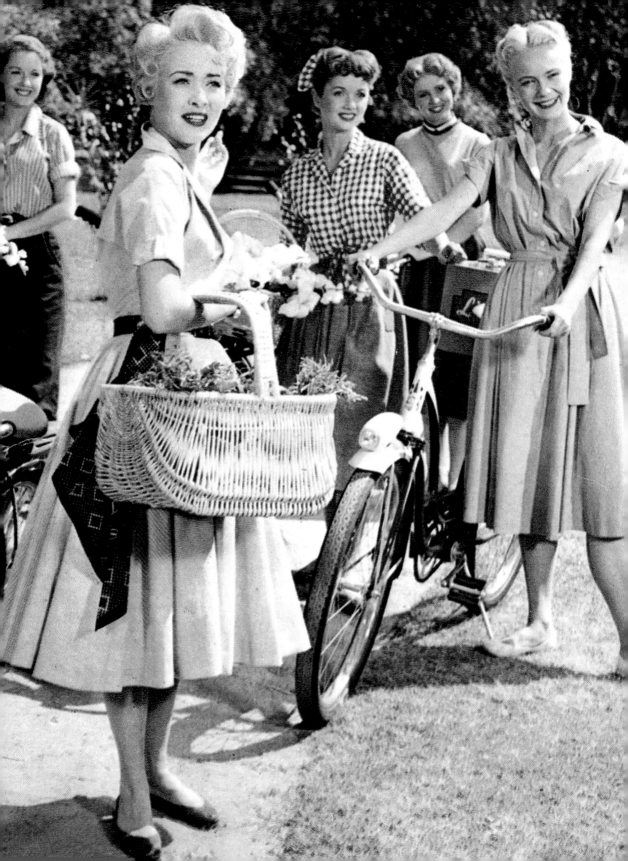

OVERLEAF:

Jane Fischer, Virginia Gibson, Jane Powell, Debbie Reynolds, Cecile Rogers, and Nancy Kilgas stand by their bikes. *Stepford Wives*, the prequel? No, it's *Athena* (1954), an MGM musical about seven sisters in a family of health and fitness nuts—hence the fleet of Roadmasters—and their various love lives and fashion crises. Per the original trailer, the unofficial *Seven Brides for Seven Brothers* (1954) spinoff (Jane Powell is in both), also boasts "the marvelous musclemen of the Mr. Universe contest." Note Powell's basket of fresh produce—straight from the neighborhood farmers market.

OPPOSITE:

Rita Hayworth rides a bike. And contemplates a swim. Circa 1940, poolside at the Beverly Hills Hotel, Rita Hayworth straddles her Rollfast cruiser. Note the distinctive ball-bearings headbadge, sprung saddle, and rocket-shaped fender-mounted headlamp. Note Hayworth's and Rollfast's reflection in the water, too.

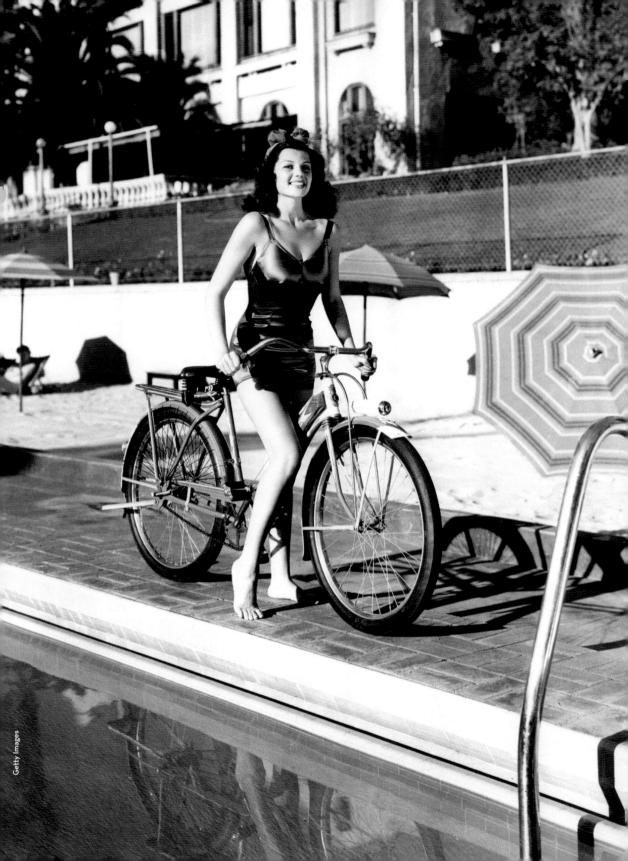

Jean Chatburn and Eleanor Stewart ride Ingos. MGM starlets Chatburn, left, and Stewart explore the fronds on their 1934 Ingo-Bikes—a flexible scooter-like two-wheeler on which the rider, standing on the oak platform, bounces rhythmically, setting the rear hub in motion. The Ingos were made in Chicago, from 1934 to 1937 (and were featured in a Three Stooges episode, too). Chatburn, who started her career as a double for Barbara Stanwyck, made only a dozen movies before she retired—but they include *The Great Ziegfeld* (1936) and the all-star *Dramatic School* (1938) with Luise Rainer, Paulette Goddard, and Lana Turner. Stewart worked well into the 1940s, mostly in westerns (hence the jaunty neckerchief?), including three with William "Hopalong Cassidy" Boyd.

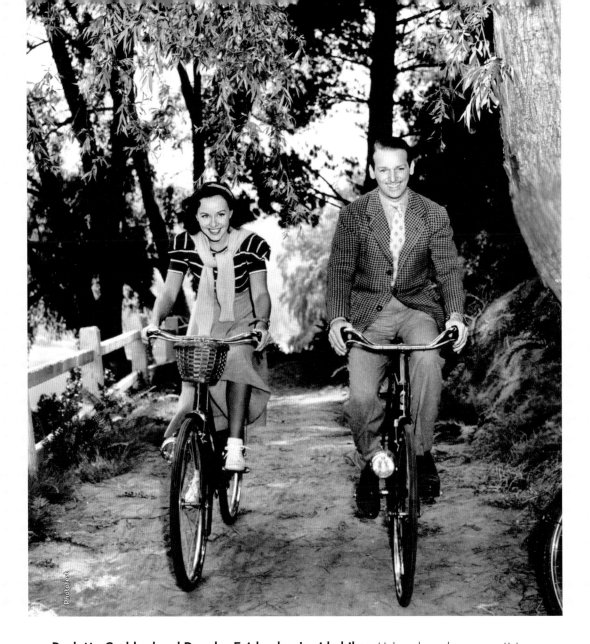

Photofest

Paulette Goddard and Douglas Fairbanks, Jr. ride bikes. He's a shameless con artist an-
gling to inherit large sums from a lonely millionairess; she's an enterprising, no-nonsense em-
ployee of a British-American engineering association. Before long, they're off riding on their
matching Sunbeam rod-brake roadsters (with fork-mounted headlamps), out and about in
the country near London. Goddard and Fairbanks shoot sparks in *The Young in Heart* (1938),
a screwball comedy from David Selznick. Fairbanks' and Goddard's ride ends somewhat ca-
lamitously when a Flying Wombat—a futuristic sports coupe being driven by Roland Young
(as Fairbanks' con-artist father)—sends them flying off the road and into the dirt. The opening
credit sequence features the silhouette of a high-wheel bike.

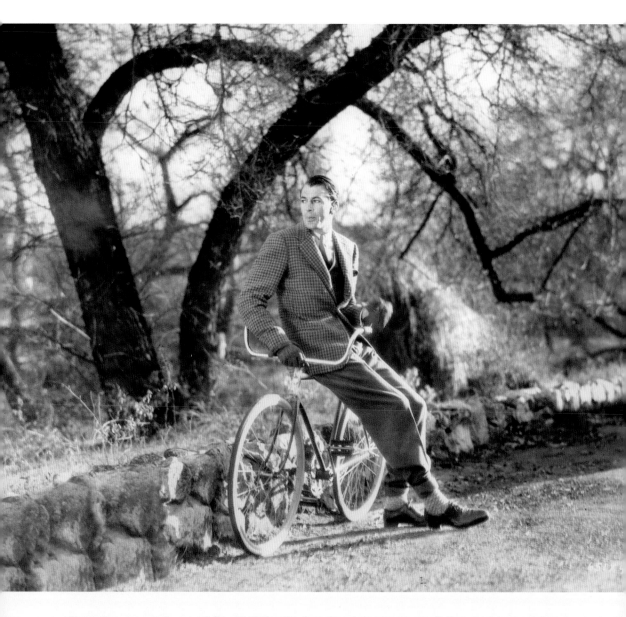

Gary Cooper rests on a bike. Nattily. Outfitted in the requisite garb for a country gentle-man—houndstooth jacket, vest and tie, wool pants (with all-essential trouser clips), checkered socks, brogues, leather gloves—the Coop takes a break by a stone wall. It's supposed to be England, circa 1916 (but the bike is a mish-mash American affair). The tall and handsome star plays Richard Bogard, a wealthy Yank moved to an estate in Kent—where he falls for its oc-cupant, played by Joan Crawford. On a ride together he tells her he loves her, but so does a lieutenant played by Robert Young. Then Bogard enlists in the RAF, and the MGM romance, *Today We Live* (1933) directed by Howard Hawks, leaves the bicycles behind for the biplanes of the Great War.

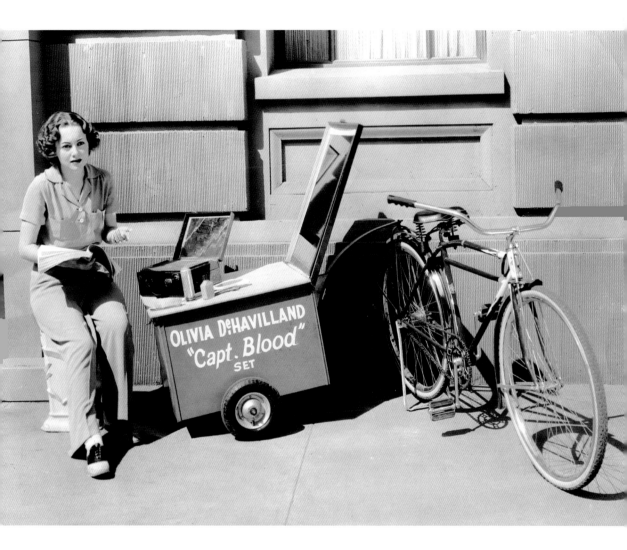

Olivia de Havilland parks a bike. Taking a break to check her makeup and her lines, de Havilland rests her Hawthorne and its personalized "Capt. Blood" trailer on the Warner Bros. backlot. (Note the mirror on the open lid.) Michael Curtiz directed *Captain Blood* (1935), a high-seas swashbuckler in which de Havilland plays Arabella Bishop, daughter of Jamaica's governor, opposite Errol Flynn's jaunty pirate, Dr. Peter Blood. Curtiz paired the stars several times again, most memorably in *The Adventures of Robin Hood* (1939).

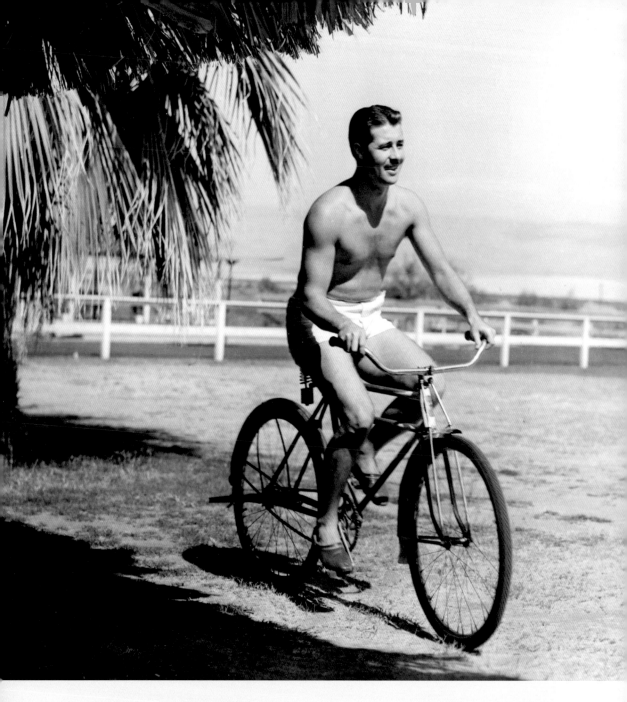

Don Ameche rides a bike. Naked bike ride, anyone? . . . Photographed around the time he was starring as an intrepid foreign correspondent in Twentieth Century Fox's World War II air-raid shelter romance, *Confirm or Deny* (1941), this photo shows Ameche—leading man in *The Story of Alexander Graham Bell* (1939) and later septuagenarian star of *Cocoon* (1985)— taking a relaxed tour in just his shorts and slip-on shoes.

Brenda Joyce rides a bike. It's all uphill from here . . . Joyce, who played Jane opposite Johnny Weissmuller's Tarzan in four of the 1940s vine-swingers, stands on the pedals of her ladies' Schwinn lightweight with coaster brakes. Joyce, in a breezy sundress, is out for a ride around the time she was making *Marry the Boss's Daughter* (1941) for Twentieth Century Fox.

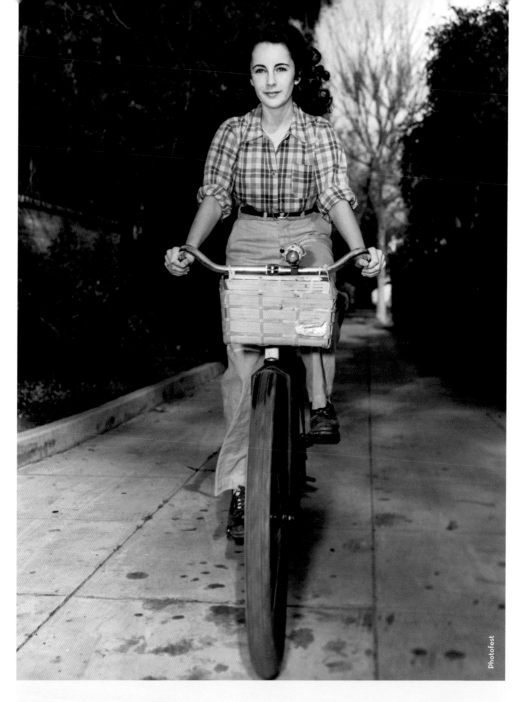

Elizabeth Taylor rides a bike. A teenage Liz cycles along the sidewalk—her whole extraordinary career and all those marriages and tabloid headlines ahead of her. Photographed about the same year *Life with Father* (1947) (the hit comedy with William Powell) was released and a few years after her girl-and-her-horse and girl-and-her-dog double whammy, *National Velvet* (1944) and *Courage of Lassie* (1946), tugged hearts and jerked tears everywhere.

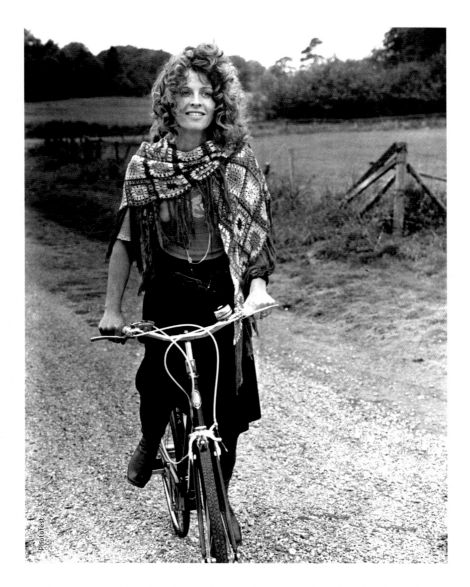

Photofest

Julie Christie rides a bike. The beautiful British darling of *Darling* (1965)—and *Dr. Zhivago* (1965), *Far from the Madding Crowd* (1967), *McCabe & Mrs. Miller* (1971), and *Shampoo* (1975)—made *The Go-Between* (1970), directed by Joseph Losey from a Harold Pinter adaptation of the L.P. Hartley novel. Set at the very start of the 1900s, it's about the upper crust-y Lady Marian Trimingham, who toys with the affection of an impossibly smitten thirteen-year-old (Dominic Guard), getting him to run missives between her and the brooding farmhand (Alan Bates) with whom she's having an affair. Here's Christie on a break between scenes, out of costume, hair blowing in the Norfolk winds, astride a small-wheel BSA "Twenty" folding bike with Sturmey-Archer three-speed. Manufactured by Raleigh Industries, the "Twenty"—a reference to the diameter of the wheels—was sold under Raleigh, BSA, Triumph, and Hercules marques.

Robert and Vivian Cummings ride a bike. Easygoing Cummings, famous for his 1950s play-boy photographer TV series, *Love That Bob*, starred in heftier fare in the 1940s, including, *King's Row* (1942), *The Lost Moment* (1947), and Hitchcock's *Saboteur* (1942). *Love and Kisses, Caroline*, the Universal romantic scramble alluded to by studio publicist Lou Smith in the photo caption below, had its name changed to *Between Us Girls* (1942). Vivian, the second of his five wives, was formerly a Ziegfeld Girl.

[VERSO:] Robert Cummings, co-starring with Diana Barrymore in Universal's "Love and Kisses, Caroline," and his attractive wife, Vivian, inspect their five-acre San Fernando Valley estate from the vantage point of a cycle built for one. Cummings raises oranges, lemons, walnuts and vegetables on the property.

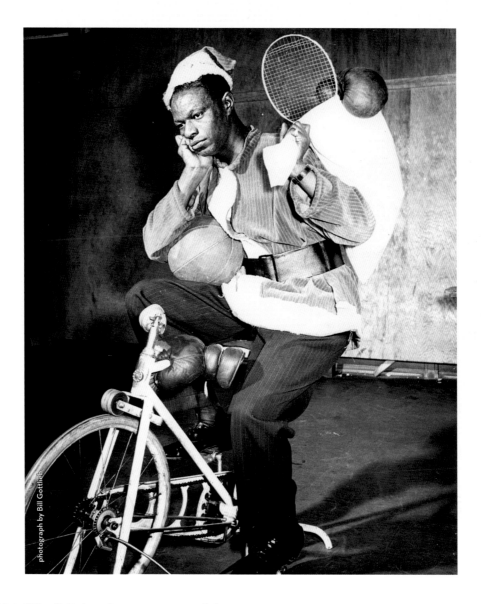

photograph by Bill Gottlieb

Nat "King" Cole rides a stationary bike. Although he recorded the ditty "On a Bicycle Built for Two," here the barrier-breaking pianist and singer sits on a cycle barely built for one—a Rollfast stationary bike. A playfully bizarre Yuletide portrait taken in the New York studio of William "Bill" Gottlieb—the writer and jazz aficionado known for his extraordinary photographs of 1930s and '40s music giants—this goofy shot finds Cole astride an exercycle, in a Santa belt and hat, and sporting sports-themed Christmas gifts. He's sporting a pretty glum expression, too. Cole appeared in twenty-two features over the course of his career, beginning with, an uncredited appearance in Orson Welles' *Citizen Kane* (1941) and ending as one of two banjo-pickin' "shouters" in the Lee Marvin Oscar winner, *Cat Ballou* (1965). He died at age forty-five, in 1965.

W.C. Fields and Baby LeRoy ride a bike. According to legend, the sour-faced comedy star William Claude Dukenfield once spiked his toddler sidekick LeRoy's milk with a healthy helping of gin. Production was halted for the day while the smiling tot tried to sober up. Here Fields is on a vintage safety bike, and LeRoy—neé Ronald Le Roy Overacker—is perched on the handlebars. The soused screen star and his pipsqueak foil's most memorable matchups were *Tillie and Gus* (1933) and *It's a Gift* (1934).

W.C. Fields rides a bike. On the sand. With sails. And clubs. This photo is from a series of beach bike poses, another of which finds the cantankerous comedian waving adieu to a bevy of bathing beauties as he "rides" off into the waves. Baby LeRoy must have been eaten by sharks.

Billy Barty rides a bike. Baby LeRoy rides a trike. The diminutive duo smile it up in an early 1930s photo. Barty, the little person who began his seven-decade career opposite Mickey Rooney in a series of Mickey Maguire shorts, later appeared in *The Day of the Locust* (1975), *Legend* (1985), *Willow* (1988), and lots of episodic TV. LeRoy, of course, is remembered as W.C. Fields' pip-squeak comic nemesis (see preceding page). In *Alice in Wonderland* (1933), LeRoy is the Joker; Barty, uncredited, can be seen in the twin roles of a White Pawn and the Baby; Fields plays Humpty Dumpty; and a couple of mugs by the names of Cary Grant (as the Mock Turtle) and Gary Cooper (the White Knight) also appear.

Warren Beatty and Jean Seberg take bikes. Beatty and Seberg pull a couple of New Jersey-made Kent three-speeds out of the bike rack (also stocked with Dunelts, the second-tier British brand) as they get ready for a ride in *Lilith* (1964), Robert Rossen's drama about an inexperienced (and disturbed) orderly at a fancy sanitorium, who falls in love with one of the patients: Seberg's dreamy-eyed title character. Beatty had already made *Splendor in the Grass* (1961), Seberg had starred in *Breathless* (1960), and Rossen had helmed *The Hustler* (1961). Peter Fonda, who plays one of Seberg's fellow patients, had made *Tammy and the Doctor* (1963) with Sandra Dee. Beatty and Seberg's ride ends with a breakdown—and we're not talking about the bikes.

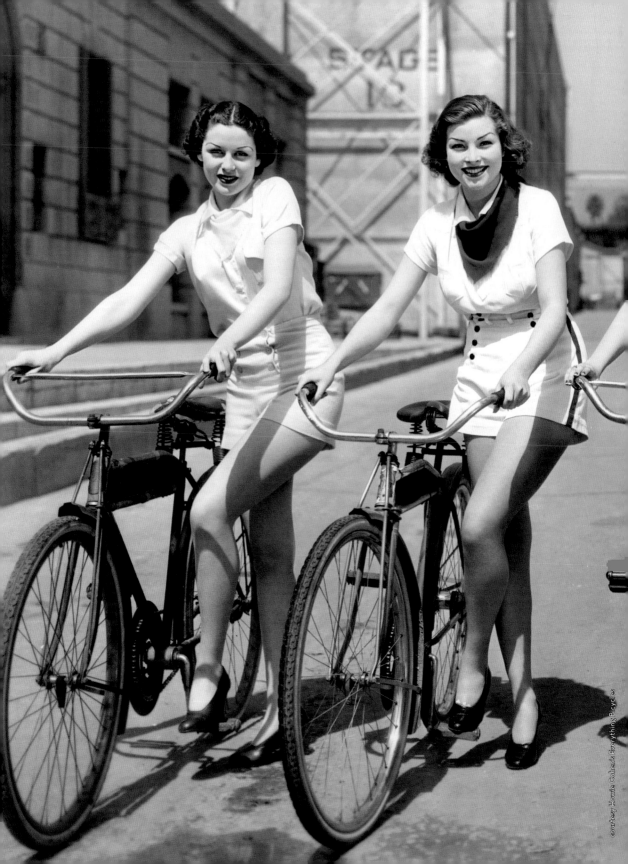

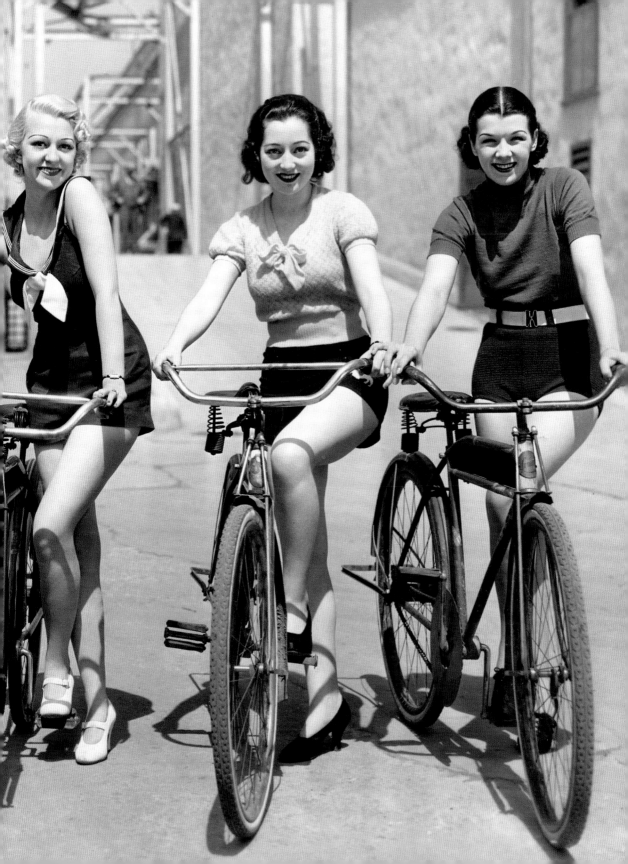

OVERLEAF:

Dene Myles, Dorothy Thompson, Bonita Barker, Esther Pressman, and Kay Gordon get ready to ride bikes. Chorines in Paramount musicals such as *Anything Goes* (1936), *It's Great to Be Alive* (1933), and *Murder at the Vanities* (1934) boasted the "Most Beautiful Girls in the World!" This quintet of studio hoofers sport the thinnest of eyebrows and fattest of balloon tires. Most of this fleet are Roamers, one of the many brands created by D.P. Harris of Rollfast fame. All the way to the right, Ms. Gordon is in possession of a now-rare Keystone.

[VERSO:] WHERE BICYCLES REIGN–Bicycles are still one of the most important means of transportation on the Paramount lot, serving each of the many departments. But sometimes they are appropriated by the players, as shown in this photo, for exercise to keep that trim figure, so essential on the screen.

OPPOSITE:

Clark Gable rides a bike. *If only I had a pump . . .* An exceptionally dapper Gable poses on an exceptionally deluxe 1930s vintage Shelby Flyer, equipped with fork-mounted siren, handlebar-mounted horn light, down-tube D-cell battery housing, saddlebag, and rear rack. But even though the rear tire is flat, frankly, Gable doesn't give a damn.

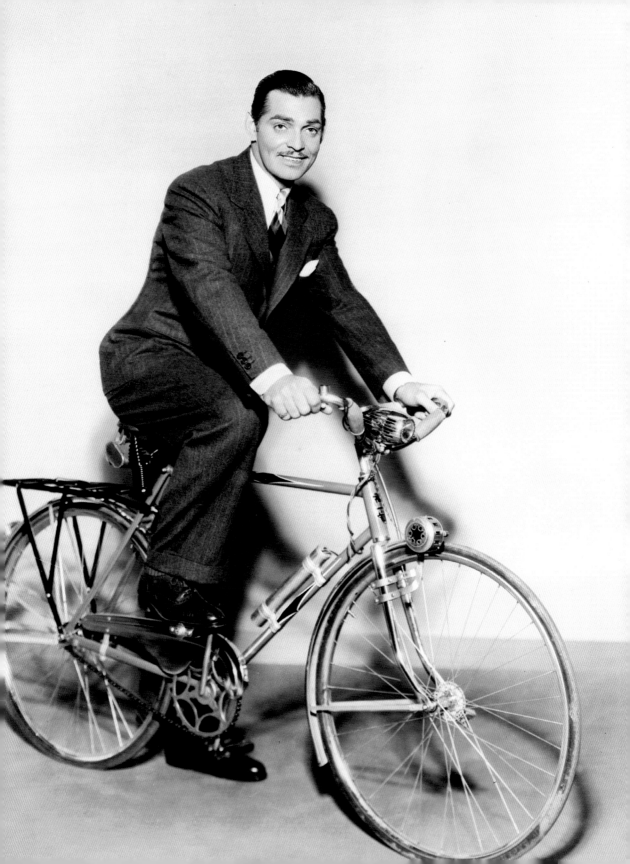

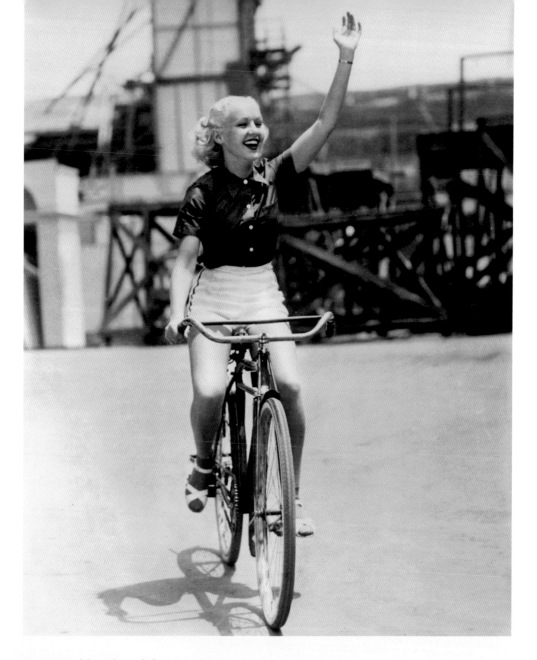

Betty Grable rides a bike. An original "Goldwyn Girl" who went on to be one of the pin-up icons of the 1940s, Grable was a peppy chorine with few pretensions. She was once quoted as saying, "There are two reasons why I am successful in show business, and I am standing on both of them." Or, in this case, pedaling with both of them. The bike is a 1930s cruiser, with 28-inch wheels and handlebar crossbar.

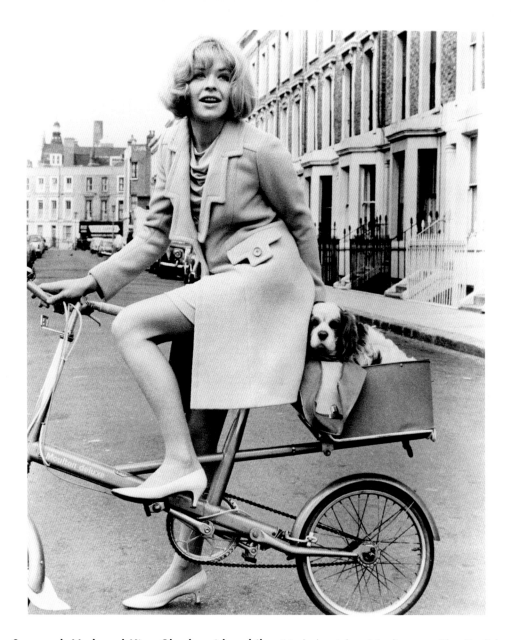

Susannah York and King Charles ride a bike. Mad about her Moulton . . . The English star stops in a London street to show off her heels, her King Charles, and more important-ly, her Moulton Deluxe small-wheel machine. The movie is *Kaleidoscope* (1966), a Warner Bros. swinging-London lark about a playboy cardsharp (Warren Beatty) and the Scotland Yard inspector's daughter who takes a liking to him. British engineer Alex Moulton's unique machine boasts front and back suspension (he also developed the suspension system for the original Mini Coopers) and a unique F-frame design. Early Moultons like York's are much sought after by collectors. Despite the small-wheel design, Moultons are not folding bikes.

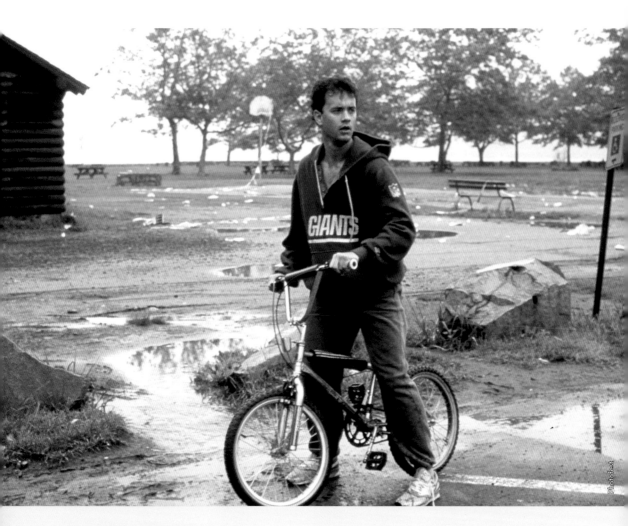

Photofest

Tom Hanks rides a bike. "I turned into a grownup, Mom! I made this wish on a machine and it turned me into a grownup!" And the morning after little Josh Baskin wakes up in the body of Tom Hanks, he jumps on his silver BMX and returns to the amusement park where the mysterious Zoltar had granted him his wish. The box office smash *Big* (1988) earned Hanks a best actor Oscar nomination—due, no doubt, to the actor's ability to cut a tight circle and speed down a winding road on his 1980s Mongoose Californian Cru Jones. Penny Marshall directed the Twentieth Century Fox release. And Hanks' kid-in-a-man's body isn't the only thing that's big in *Big*—check out Elizabeth Perkins' hair!

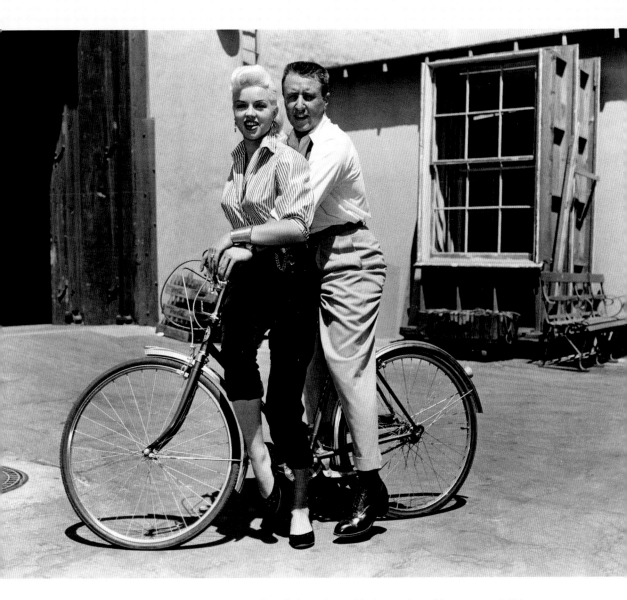

George Gobel and Diana Dors ride a bike. The unlikely combo of buzz-cutted TV comic Gobel and platinum-blonde British sex bomb Dors takes a break to tool around—and fool around—on the RKO backlot. In *I Married a Woman* (1958), he's a New York advertising guy, she's the wife who all the guys are ogling, and their future happiness hinges on a new campaign for Luxenberg Beer. Have the *Mad Men* writers seen this?

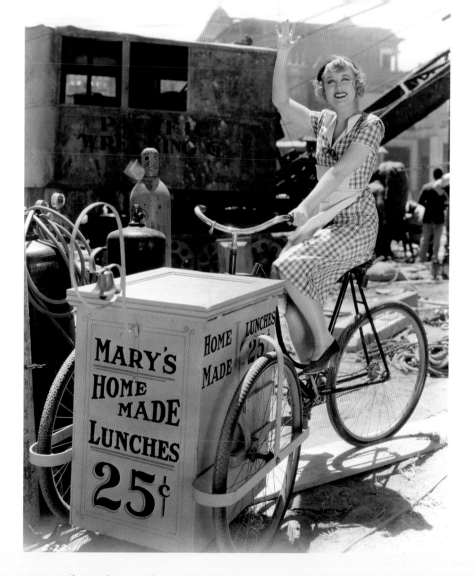

Genevieve Tobin rides a trike. No such thing as a free lunch . . . New Yorker Tobin de-camped to Hollywood in the 1930s—probably not on this gorgeous cargo trike—playing perky and flirtatious women in romances and melodramas opposite Laurence Olivier, Cary Grant, and Edward G. Robinson. In *The Wrecker* (1933), she's Mary Wilson, an industrious gal who sells homemade lunches on a construction site—and who marries the construction boss played by Jack Holt. But there's trouble ahead with a rival beau played by Sidney Blackmer. From the original poster: "If your wife had been unfaithful to you—divorced you—married her lover—stolen your child and wrecked your career—then she and her lover were faced with certain death unless you saved them—WHAT WOULD YOU DO?" Hmmm, take that delivery cycle and paint somebody else's name on it?

[VERSO:] Genevieve Tobin has one of the most colorful roles of her career in "The Wrecker," a Co-lumbia production, starring Jack Holt, in which she plays a girl who earns her living selling box lunches to workmen. But she ends up in wealthy surroundings. Albert Rogell is directing.

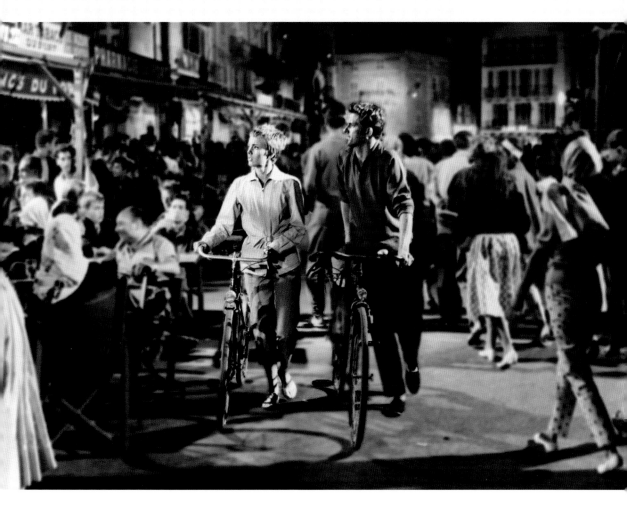

Jean Seberg and Geoffrey Horne walk bikes. Cecile, the selfish, spoiled daughter of a wealthy French playboy (played by the dashing Brit, David Niven), meets a law student who (literally) washes up on the beach of her Riviera villa. She's played by the remarkable Seberg—the Iowa girl discovered by director Otto Preminger when she was all of seventeen. He then cast her in his *Saint Joan* (1957). *Bonjour Tristesse* was Preminger's second collaboration with Seberg. It flopped, expensively, when it was released in 1958. Look at it now, though, and this sun-splashed tale of obsessive love (a daughter's for her father), of jealousy, tragedy, and the idle rich, looks fairly brilliant. Seberg, of course, went on to star in *Breathless* (1960) for Godard, and then in *Lilith* (1964) (see page 67). The law student, Phillipe, is played by Geoffrey Horne. Here they are, pushing their velos through the crowded café streets.

Bette Davis walks a bike. As Miss L.C. Moffat, an English schoolteacher in late-nineteenth-century Wales, Davis gets around on a grand old rod-brake safety bicycle in *The Corn Is Green* (1945). (Note the oil lamp mounted on the bars.) The independent-minded forty-year-old establishes a school for the kids of the coal miners, and also encourages one of the young miners—John Dall in his screen debut—to apply to Oxford. Melodrama and maternity (not Davis', but Joan Lorring's) ensue. A highly misleading Warner Bros. trailer for the 1945 adaptation of Emlyn Williams' play screamed: "The screen's finest actress brings you the most revealing story ever written about a woman and a man!"

John Kerr and Steven Terrell ride bikes. "I found this Modern Library edition to be quite satisfying . . ." In Vincente Minnelli's sexual identity melodrama *Tea and Sympathy* (1956), Kerr plays Tom, a prep school senior who'd rather sew and read than wrestle and scrum. Branded a "sister boy" by his fellow students, Kerr tries to prove his manliness by visiting a prostitute. Meanwhile, the headmaster's wife, Deborah Kerr (no relation), looks on aghast—and looks on rather lovingly, too, which doesn't sit well with her husband. Adapted from the Robert Anderson play, which ran for more than two years on Broadway, *Tea and Sympathy* is cloaked in Hays Code double-meaning. Is Tom gay? Confused? Or just a guy who likes books and bikes? Here he is on his single-speed Schwinn World, discussing literature with red-headed classmate Steven Terrell, who's on a Schwinn New World three-speed.

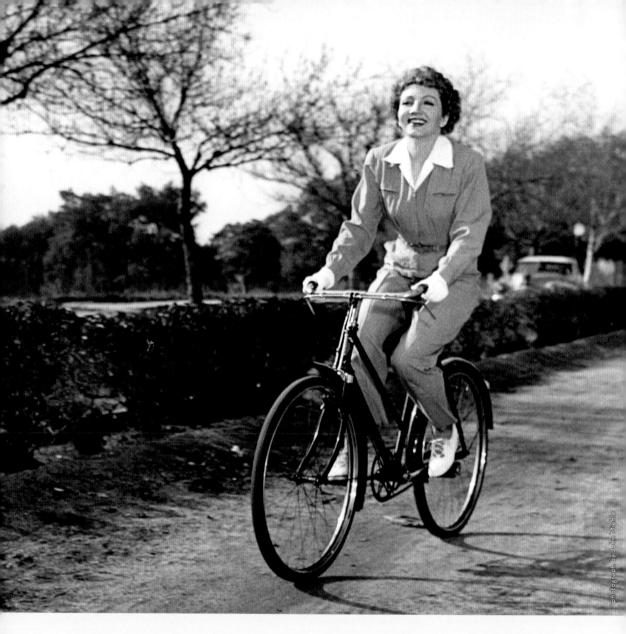

photography by John Mehle

Claudette Colbert rides a bike. Ducking out from the screwball travails of *Without Reservations* (1946)—the RKO rom-com in which she plays a novelist and John Wayne plays a Marine pilot—Colbert dons her cycling gloves (white, of course, to match her collar and shoes) and goes for a between-takes tour. Directed by Mervyn LeRoy, *Without Reservations* tries to channel the road-trip zaniness of Colbert and Gable's *It Happened One Night* (1934). And the Duke isn't bad as the guy Kit Madden thinks might make a good leading man for the Hollywood adaptation of her book, *Here Is Tomorrow*, after Cary Grant says he can't do it. (Yes, Grant is name-dropped!) Colbert, on a ladies' British rod-brake with Westrick rims, seems pleased with how things are rolling along.

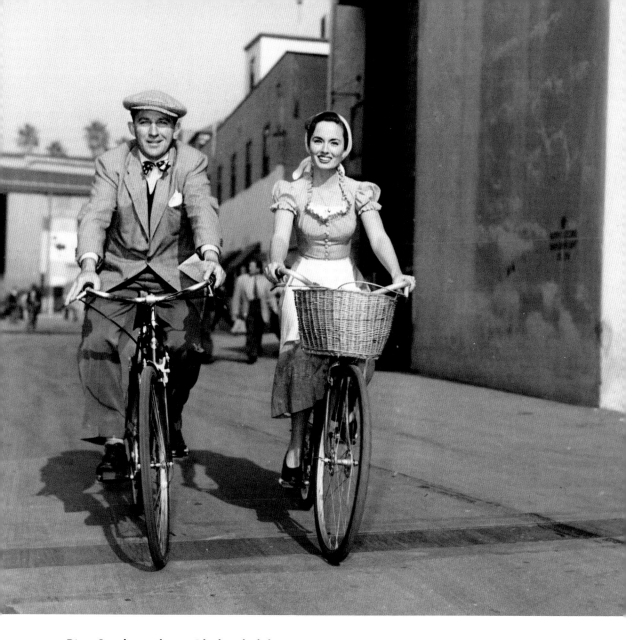

Bing Crosby and Ann Blyth ride bikes. " 'Tis sweet to think that wher'er we roam we're sure to find something blissful and dear . . ." Der Bingle and Blyth take a break on his-and-her Schwinn New Worlds during a break from their musical romance, *Top o' the Morning* (1949). He's an insurance agent investigating the disappearance of the Blarney Stone; she's the daughter of an Irish constable. For their hearthside duet of "Oh, 'Tis Sweet to Think," the singing and acting movie star has a kitchen apron tied, high-waisted over his suit. He must have left it on the set when he took off for this ride.

Marisa Merlini and Vittorio De Sica ride a bike. *Intensamente.* The Italian neorealist auteur had a thing about *le biciclette*—most famously in *Bicycle Thieves* (1948) (see page 118). Here, in *Bread, Love and Dreams (Pane, amore e fantasia)* (1954), he puts himself in front of the camera, and on the seat of a handsome Italian rod-brake number that actually had a motor attached to it, trying to woo the village beauty—Merlini. But she's more interested in one of the marshall's young *carabiniere*—and anyway, that mustache tickles. Gina Lollobrigida also appears.

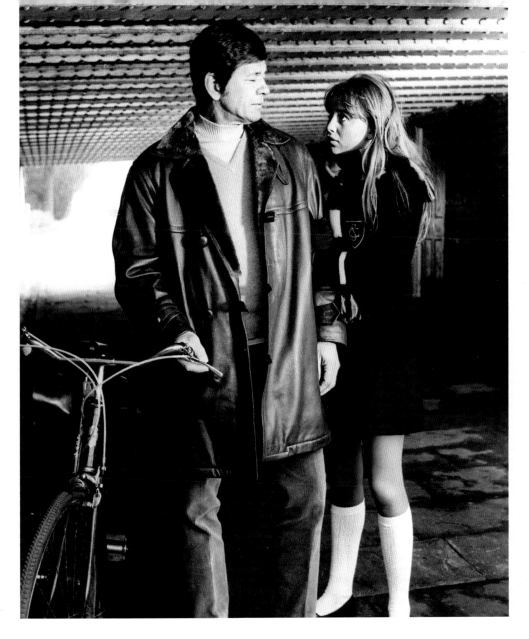

Charles Bronson walks Susan George's bike. Pedalphilia anyone? The lyrics to Jim Dale's theme song for 1969's *Twinky* go: "There's a young girl with a two-wheel bike, all grown up and it just don't seem right . . ." And it's not. Bronson plays a middle-aged writer who falls for the sixteen-year-old English schoolgirl. She rolls her early-1960s new Londoner ladies' three-speed into his apartment, climbs atop him in bed, and cooks bangers and mash, too. *Twinky*, also released (by American International) as *Lola* (1970), was director Richard (*Lethal Weapon* [1987], *Superman* [1978]) Donner's second film. Although this photo has the gritty noirish vibe of Bronson's *Death Wish* pics (1974-1994), there's nothing gritty and noirish about *Twinky*. Icky and salacious, perhaps.

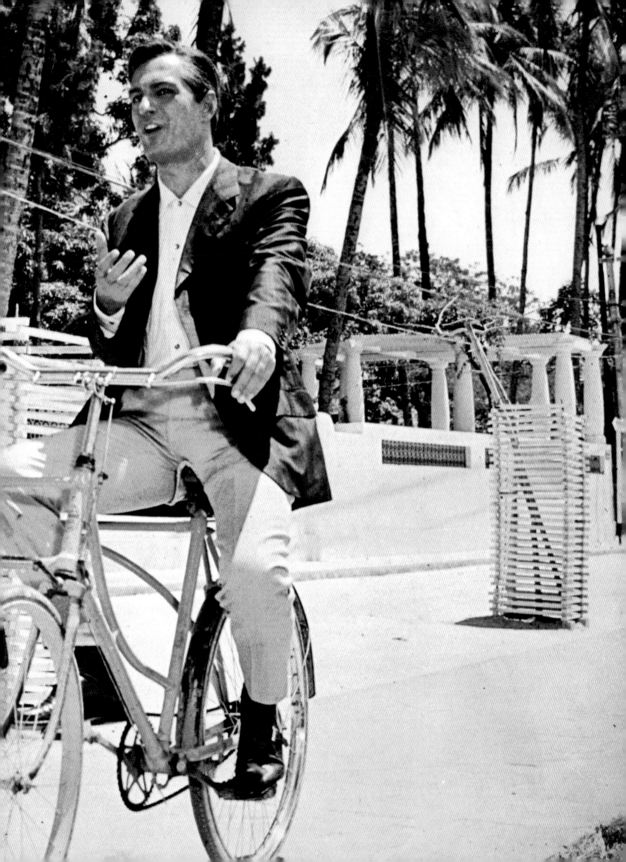

OVERLEAF:
Claudia Cardinale and Nino Manfredi ride a bike. Italian sex bomb Claudia Cardinale (Fellini's *8½* [1963], Leone's *Once Upon a Time in the West* [1968]) goes for a ride on a "sociable"—side-by-side welded bikes—with Nino Manfredi. He explains why Franco Rossi's *Una rosa per tutti*, a.k.a., *A Rose for Everyone*, or (per this German publicity still) *Eine Rose für alle*, was released stateside in 1967 as *Every Man's Woman*. Cardinale plays Rosa, a free and fiery spirit in Rio de Janeiro.

OPPOSITE:
Jean Parker hides behind a high-wheel. Signed to MGM in the 1930s, Parker made *The Ghost Goes West* (1935) with Robert Donat, *Little Women* (1933) with Joan Bennett and Katharine Hepburn, *The Flying Deuces* (1939) with Laurel and Hardy, and some seventy other titles over the course of a four-decade career. Here she poses (wearing a pom-pom-topped beret) with an 1879 Singer high-wheel—or maybe she's really testing the integrity of one of the front wheel's fifty-eight spokes? George Singer & Co., of Coventry, England, started making bikes in 1874, and some thirty years later turned to cars and motorcycles.

Photofest

Dennis Christopher rides a bike. *Veloce!* Stopping on an Indiana road on his Masi (and in his old-school leather helmet), Christopher is a restless nineteen-year-old obsessed with Italian cycling and in no hurry to get a job or go to college. Peter Yates' *Breaking Away* (1979), a coming-of-age classic, also stars Dennis Quaid and Daniel Stern—and Robyn Douglass as the Vespa-riding *signorina* Christopher chases down on his bike when she drops her notebook outside of class. The Philadelphia-born actor still works steadily in TV and film. Not sure if he got to keep the beautiful burnt sienna road bike.

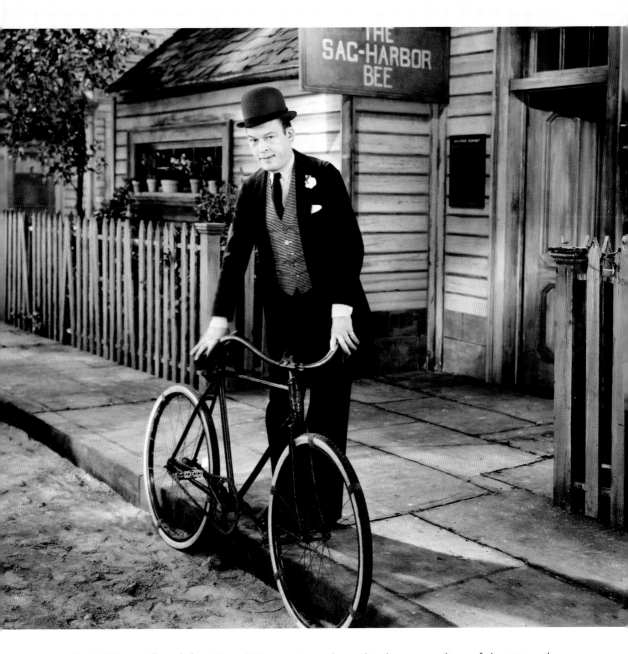

Fred Allen walks a bike. One of the most popular radio show comedians of the 1930s, the dry and witty Allen made his first on-screen appearance in *The Installment Collector* (1929), a one-shot Paramount short in which he plays the editor of the *Sag Harbor Bee*. The newspaper business isn't doing so well, and neither is Allen, who gets hounded by a repo man who comes for the comedian's watch, and then returns for his suit and pants. The single-speed safety bike, however, is safely left parked on the curb.

SPECIAL EFFECTS

SPECIAL EFFECTS

photograph by Don Brinn • AP/Wide World Photos

Paul Newman and Joanne Woodward ride bikes. A sex farce with *Mad Men*-esque ideas about women, men, and marriage, *A New Kind of Love* (1963) isn't exactly the Newmans at their thespian best. She plays a New York department store fashion buyer and "semi-virgin" who meets the playboy newspaper columnist on a flight to Paris. After a makeover in the City of Light, Woodward runs into Newman again—and he's led to believe she's a high-priced hooker. In the bike race sequence, she's fabricating an elaborate tale about a liaison with a wealthy Greek, hence Newman's "RICH GREEK" wool jersey. The bikes are 1960s French road models, and Newman's wearing Mercier Hutchinson bike shorts.

OPPOSITE:

Buster Keaton rides a bike. The sad-eyed silent screen comedy star rode on into the era of talkies and television. Here he is on a coaster-brake bike winding his way down a street on the backlot, where John Ford's thriller, *The Fugitive* (1947), with Henry Fonda and Dolores Del Rio, is "playing." Keaton wears his trademark boater, his trademark look of woe, and a tweedy suit with plus fours—his getup for the 1949 MGM Judy Garland/Van Johnson musical, *In the Good Old Summertime*.

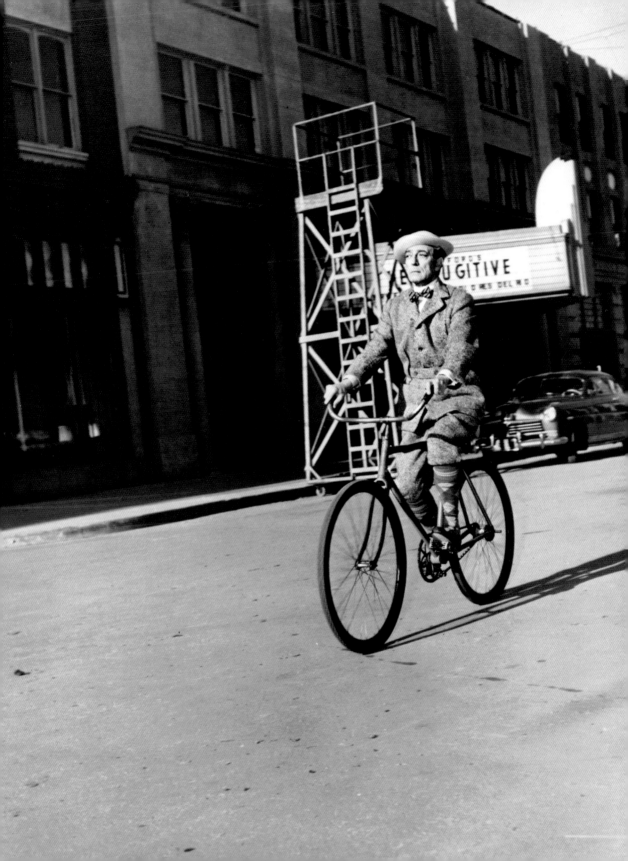

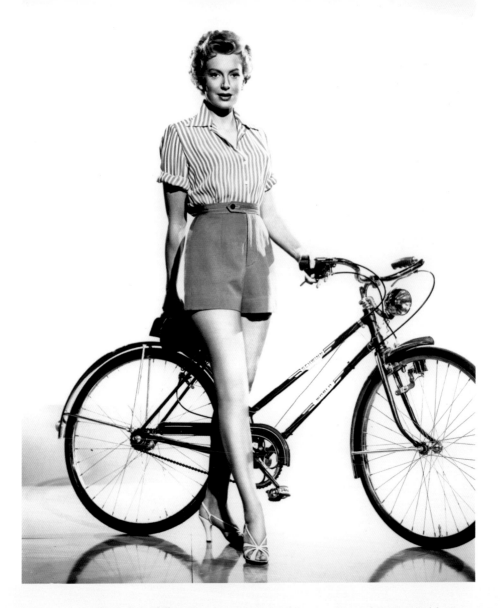

Deborah Kerr stands by a bike. From here to eternity . . . on a Schwinn World. Kerr was Oscar-nominated for her portrayal of an Army captain's wife who tumbles into a torrid affair with a brooding non-com played by Burt Lancaster in Fred Zinneman's classic. She poses in the same striped blouse and shorts she wears when a rain-soaked Lancaster first comes over to her house. The ladies' Schwinn with three-speed internal hub, generator, and headlamp must have been left on the cutting room floor—and no, those high heels are not "clipless." *From Here to Eternity* (1953), adapted from James Jones' bestseller, is set in Hawaii before the attack on Pearl Harbor. Kerr and Lancaster's Halona Cove clinch—embracing in the lapping Pacific surf—is one of the most famous love scenes in cinema history.

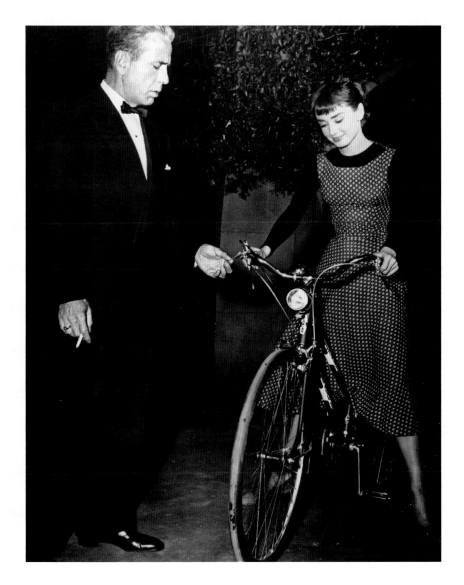

Audrey Hepburn rides a bike. Humphrey Bogart fiddles with her shifter. Maybe he's moonlighting as a mechanic at Black Tie Bike Repairs . . . Here Bogie is having a smoke and playing nervously with his leading lady's three-speed shifter. From the Paramount shoot of *Sabrina* (1954), the Billy Wilder triangular romance stars Hepburn as the chauffeur's daughter in love with her father's boss, the wealthy gadabout David Larrabee (William Holden). Bogart is Linus, the older, workaholic Larrabee brother, who likewise falls for the girl who grew up over the garage on the family's estate. Hepburn was nominated for a best actress Oscar, Edith Head won the costume Academy Award (even though Hepburn's most famous outfits were in fact the work of Hubert de Givenchy). The bike is a Schwinn World, a lightweight, 26-inch wheel ladies' model. Hepburn's vehicle of choice throughout her life was the bicycle, and she was photographed time and again touring on two wheels.

Elliott Gould and James Caan ride a bike. As vaudevillians turned bumbling villains in the 1890s, bowler-hatted Gould and Caan wheel themselves through *Harry and Walter Go to New York* (1976), a *Sting*-like lark that also boasted Michael Caine (an ace safecracker) and Diane Keaton (a newspaperwoman and suffragette). Here, Gould steers a handsomely restored 1890s safety bike through the streets of backlot New York, with Caan standing on the rear. Mark Rydell (*Cinderella Liberty* [1973], *On Golden Pond* [1981]) directed.

Laraine Day rides a bike. From a Mormon family in Utah, Day—born La Raine Johnson, and billed, early in her career, as Laraine Hays or Laraine Johnson—was a teenager doing theater with the Long Beach Players when she landed a small role in *Stella Dallas* (1937). By 1941, when this jaunty shot of Day on her Rudge Whitworth was taken, she was an MGM star, playing nurse and fiancée Mary Lamont in the *Dr. Kildare* screen series. The studio loaned her out, too, most notably to Alfred Hitchcock for *Foreign Correspondent* (1940)—she's Carol Fisher, the peace activist's daughter, playing opposite Joel McCrea's dashing New York newsman at the stormy dawn of World War II. Lots of bicycles in *Foreign Correspondent*'s Amsterdam scenes, too.

[VERSO:] October 1941 "LARAINE DAY-CYCLIST ... And when the Metro-Goldwyn-Mayer actress finished her role in "The People vs. Dr. Kildare," with Lew Ayres and Lionel Barrymore, she resumed her early-morning bicycle tours in the country. Often Laraine makes these little excursions by herself, but on occasion she will gather a group of friends and ride out into the country and enjoy a picnic lunch."

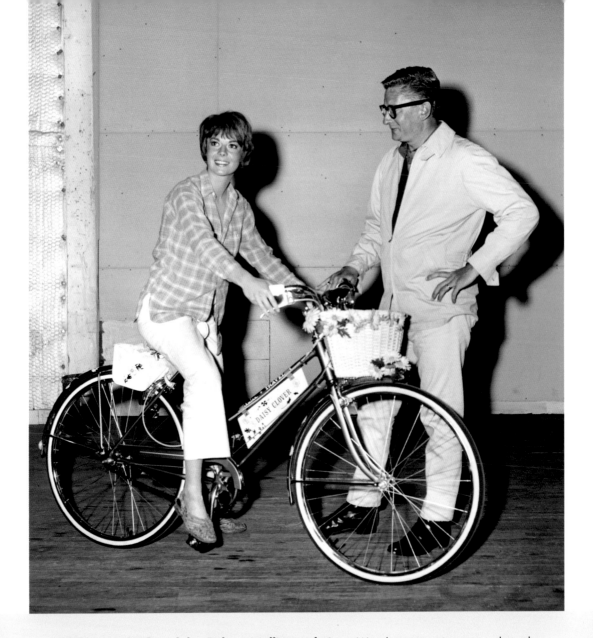

Natalie Wood rides a bike. Robert Mulligan admires. Wood was twenty-seven when she took the title role in *Inside Daisy Clover* (1965), over-emoting as a teenage wannabe star who vows "to make a noise in the world." The Warner Bros. release directed by Mulligan, also stars Robert Redford, Christopher Plummer, and Ruth Gordon as Daisy's mom—sharing a shack with her daughter on Venice beach. Here she is on the Warner Bros. backlot astride her personalized "Daisy Clover" ladies' Schwinn Traveler. Note the basket, saddlebag, and fender festooned with daisies.

[VERSO:] The bicycle is a gift to Natalie from Robert Mulligan and producer Alan Pakula which she has named "Get me to the set on time."

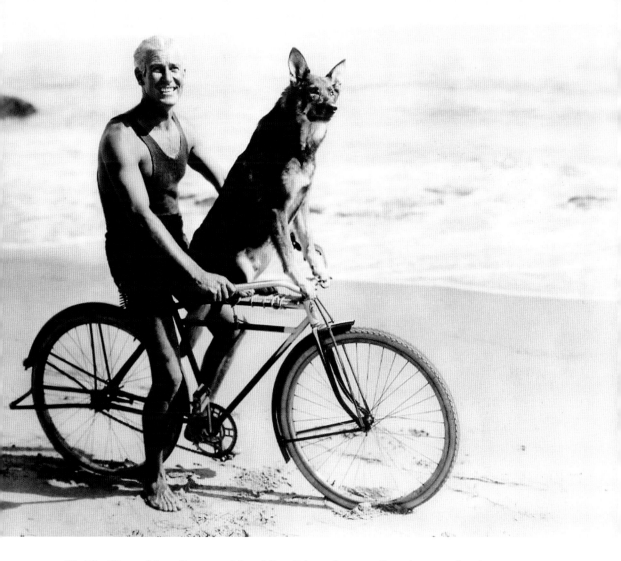

Rin Tin Tin and Lee Duncan ride a bike. Taking the term "beach cruiser" to heart, canine trainer Lee Duncan cycles the Malibu sands with "Rinty," a German shepherd he found in France during his service in the first World War and brought back to Hollywood. The dog, a box office hit in a series of adventure films, rescued Warner Bros. from financial ruin. Beginning with *Where the North Begins* (1923), Rinty made twenty-five titles for Jack Warner and company. This photo dates from 1922, when Rin Tin Tin was four. The German shepherd, gazing wistfully, his front paws firm on the handlebars, sits on a board Duncan fashioned to the D.P. Harris-built bike's top tube. Rinty and Duncan's Beverly Hills neighbor was another Hollywood star and cyclist—Jean Harlow.

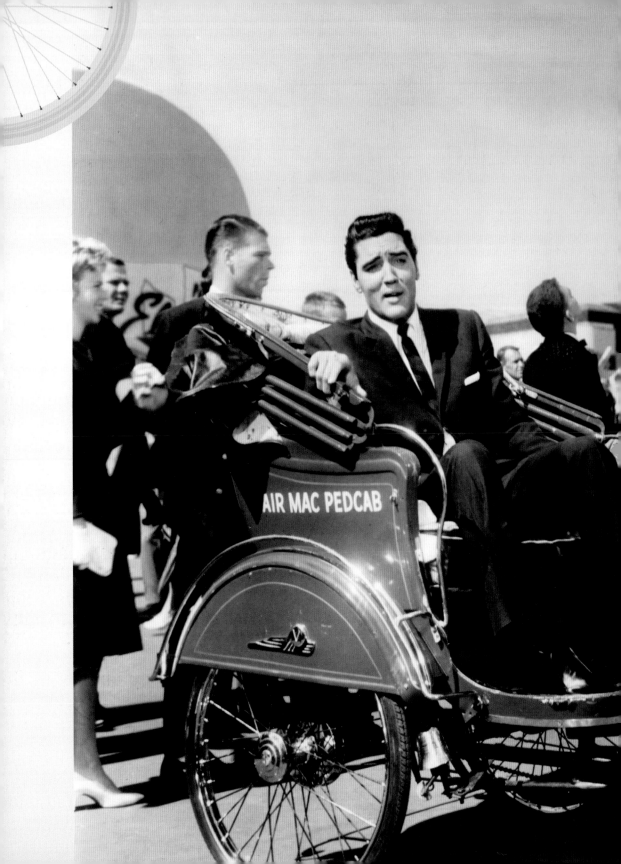

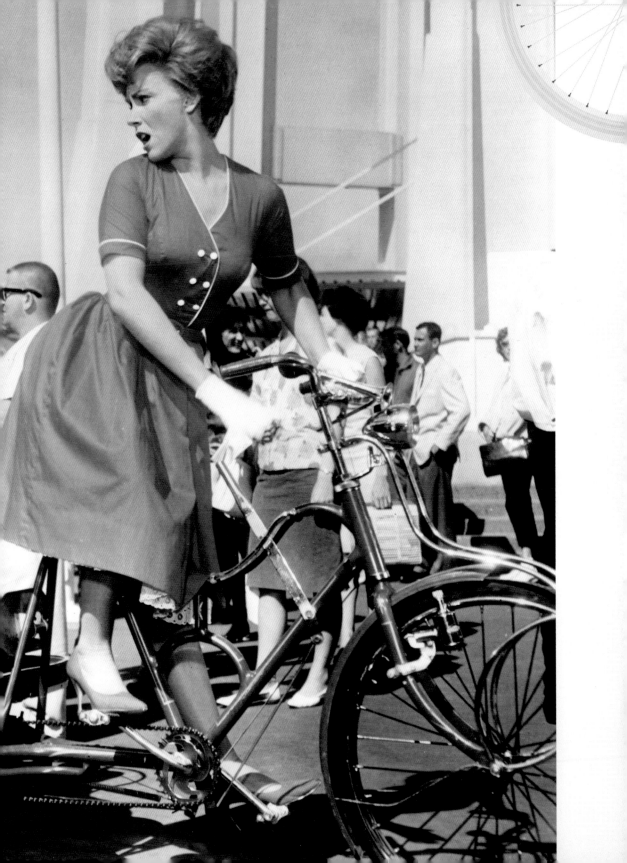

Overleaf:
Joan O'Brien rides a pedi-cab. Elvis winces. Presley is a down-on-his-luck crop duster pilot who heads for the Seattle World's Fair. He goes after the fair's nurse, Joan O'Brien, after getting a kid to kick him in the shins so she'll attend to his abrasions. Here, she's riding a red Asian-style pedicab from the dispensary to the fair's front gates. Elvis talks her into dining in the Space Needle restaurant, where he woos her with an intimate croon of "I'm Falling In Love Tonight." O'Brien had played a nurse before, opposite Cary Grant, in *Operation Petticoat* (1959), but without the pedicab she rides on *It Happened at the World's Fair* (1963).

Opposite:
Jean Harlow walks a bike. The platinum blond bombshell (two of her thirty-four films: *Platinum Blonde* [1931] and *Bombshell* [1933]) signed to MGM in 1932. Here, the cinema sex siren stands with a brand new ladies' Schwinn—note the distinctive chain case (also seen on the Hawthorne Flyer) and skirt guard. Harlow's career was tragically short-lived. The actress, paired frequently with Clark Gable, William Powell, and Spencer Tracy, died at twenty-six from renal failure.

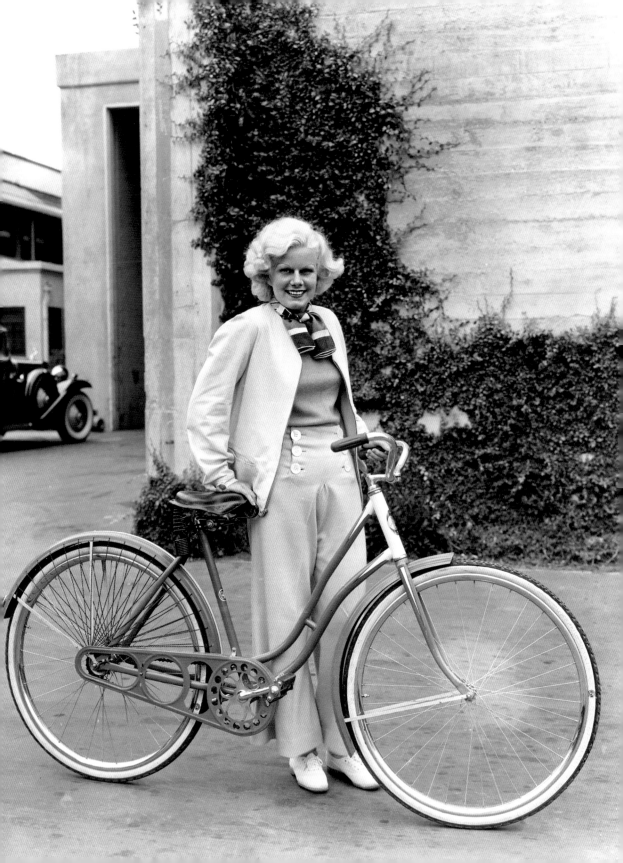

photograph by Ernest A. Bachrach

Harold Peary rides a bike. Sadly. A huge radio star thanks to his giddy intonations as Throckmorton P. Gildersleeve, next-door neighbor of Fibber McGee and Molly, Peary went on to portray the jokester and occasional crooner in four *Gildersleeve* films for RKO. This shot—by renowned Hollywood photog Ernest Bachrach, who headed RKO's photo department—is dated 1942, so the film in question was either *Seven Days' Leave* (with Victor Mature and Lucille Ball) or *The Great Gildersleeve*. Peary's bike, with its majorly sprung saddle, was borrowed from an RKO shop.

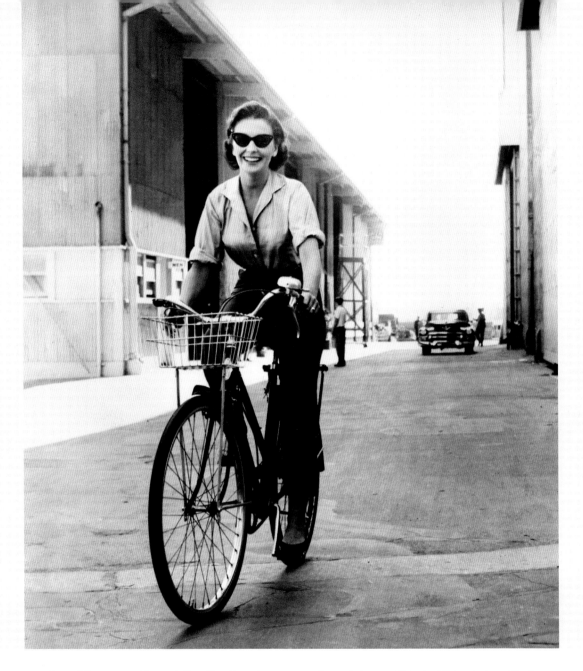

Jean Simmons rides a bike. The British actress rides a Schwinn, fitted with basket and bell, around the MGM lot on a break from shooting *Until They Sail* (1957), a melodrama about four sisters in New Zealand and their respective romances with U.S. Marines during World War II. ("They discover love's terror as well as love's beauty!" the trailer shouts.) Paul Newman gets involved with Simmons, while Joan Fontaine, Piper Laurie, and a teenage Sandra Dee (riding a nice British bike in some of her scenes) are the other sibs. No one dares attempt a Kiwi accent.

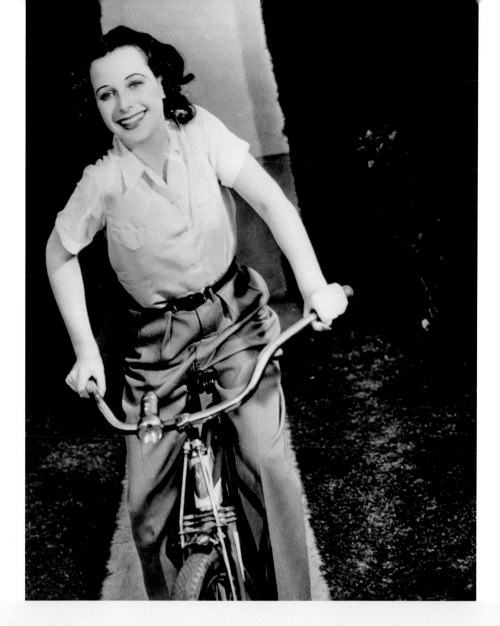

Hedy Lamarr rides a bike. Beaming brighter than her handlebar-mounted headlamp, Lamarr poses for an MGM photographer. Signed to the studio in the first half of the 1940s, the Austrian actress—who scandalized the cinema world by posing nude and doing a sex scene in the Czech feature, *Extase* (1933)—was busy making *Comrade X* (1940) (with Clark Gable) and *Tortilla Flat* (1942) (with Spencer Tracy) for Louis B. Mayer. Between MGM projects, she teamed up with avant-garde composer George Antheil to develop and then patent a frequency-hopping secret communication system. Essentially, the actress and Antheil came up with the basis for spread-spectrum communication technology, used today in Wi-Fi and mobile phones. Really.

Dominique Sanda walks a bike, Lino Capolicchio stops to consider. If it weren't for the rising wave of anti-Semitism and the hate-mongering pronouncements of Il Duce, life in Vittorio De Sica's *The Garden of the Finzi-Continis* (1970) might seem pretty idyllic. The film begins with a group of college friends in their tennis whites, in pre-World War II Italy, cycling to a match in the exclusive gated grounds of the Finzi-Contini family. And the cycling—on upright Taurus and Bianchi city bikes to work, to picnics, to amorous trysts—doesn't stop until the fascists roll in, driving their ominous automobiles. Winner of the foreign language Oscar in 1971, *Finzi-Continis* stars Sanda as Micol, the beautiful daughter of a wealthy Jewish family, and Capolicchio as Giorgio, in love with Micol since they were children. Here they stop to discuss various genera of trees, fleetingly hold hands, and then ride on together on Giorgio's bike.

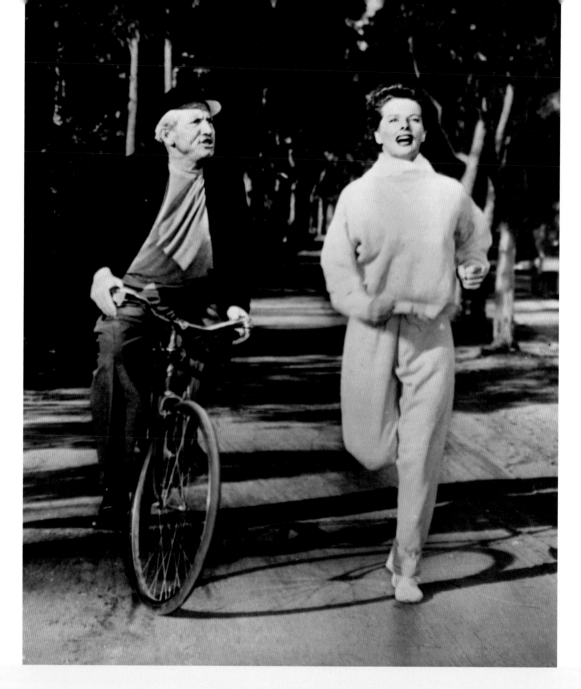

Spencer Tracy rides a bike. Katharine Hepburn runs alongside. In *Pat and Mike* (1952), Hepburn is Pat Pemberton, champion golfer *and* tennis pro. Tracy is Mike Conovan, a manager and promoter whose other key client is a heavyweight boxer (Aldo Ray). She's classy, he's a mug, and soon the two are falling hard for one another. Here, he's coasting alongside as she trains, discussing—among other things—marriage and his love of lobsters. The MGM hit hails from brilliant writing twosome, Garson Kanin and Ruth Gordon, and director George Cukor.

Lana Turner rides a bike. No, the "S" isn't for spy, it's for Simplex . . . For the MGM espionage drama *Betrayed* (1954), Turner returned to her roots (brunette) and headed for the Netherlands with Clark Gable and Victor Mature to shoot this torrid, World War II affair. She plays Fran Seelers, a Dutch resistance fighter who goes undercover to mingle with Nazi swine. This publicity still shows Turner, in her pedal pushers, on a 1940s-vintage Simplex bike.

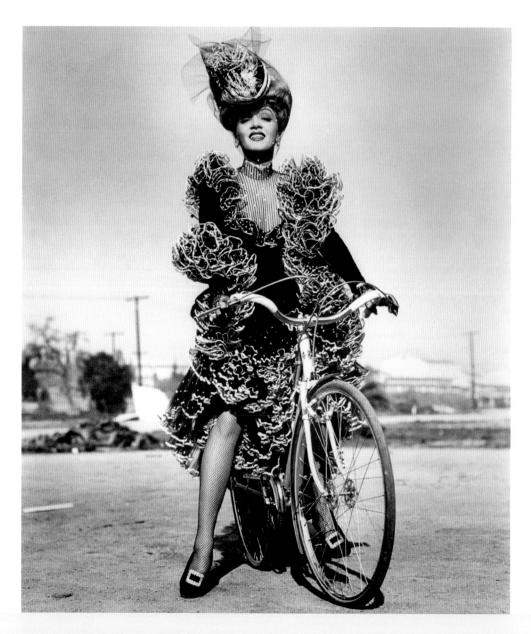

Marlene Dietrich rides a bike. Go west, young man . . . in a Vera West gown. Between takes on the Klondike Gold Rush western, *The Spoilers* (1942), Dietrich stands astride a Schwinn Paramount with Webb brakes, decked out in pretty much your typical saloon-owner cycling couture. Dietrich plays Cherry Malotte, a turn-of-the-century Nome bar-ista. John Wayne tumbles for her, of course, and then Randolph Scott puts the moves on her in her boudoir, which starts one of the most famous fight scenes in Hollywood history. The Duke and Scott duke it out, epically, and all because of the woman with the smoky German accent, aloof airs, and dreamy eyes.

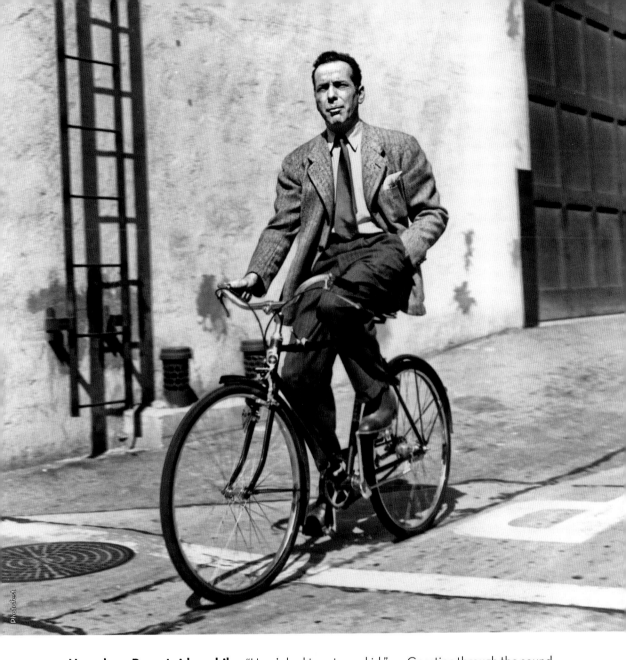

Humphrey Bogart rides a bike. "Here's looking at you, kid." . . . Coasting through the sound-stage canyons of the Warner Bros. backlot, circa mid-1940s, the star of *Casablanca* (1942), *To Have and to Have Not* (1944), and *The Big Sleep* (1946) looks as cool and casual as a tough guy can. Note the handkerchief sprouting nattily from the breast pocket; note the top-tube shifter on his Columbia Tourist.

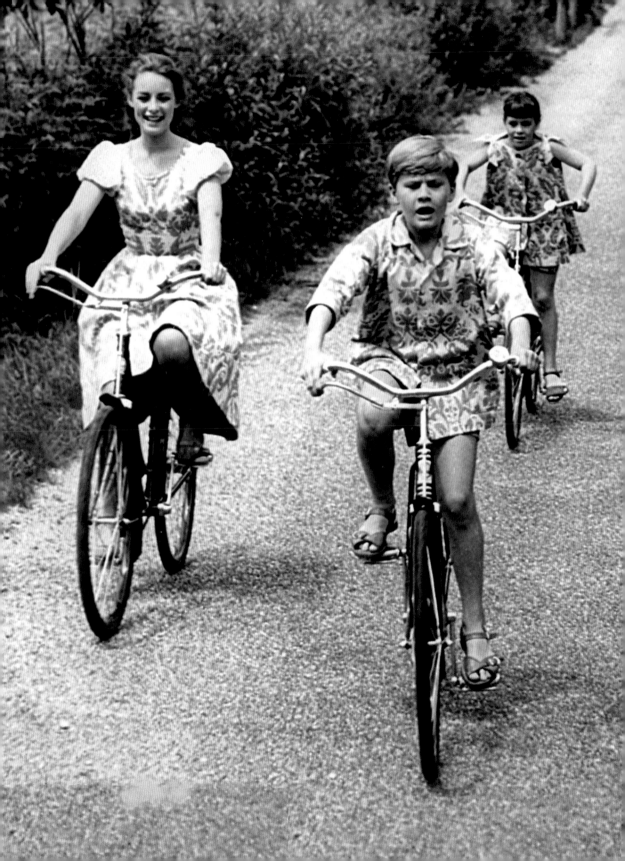

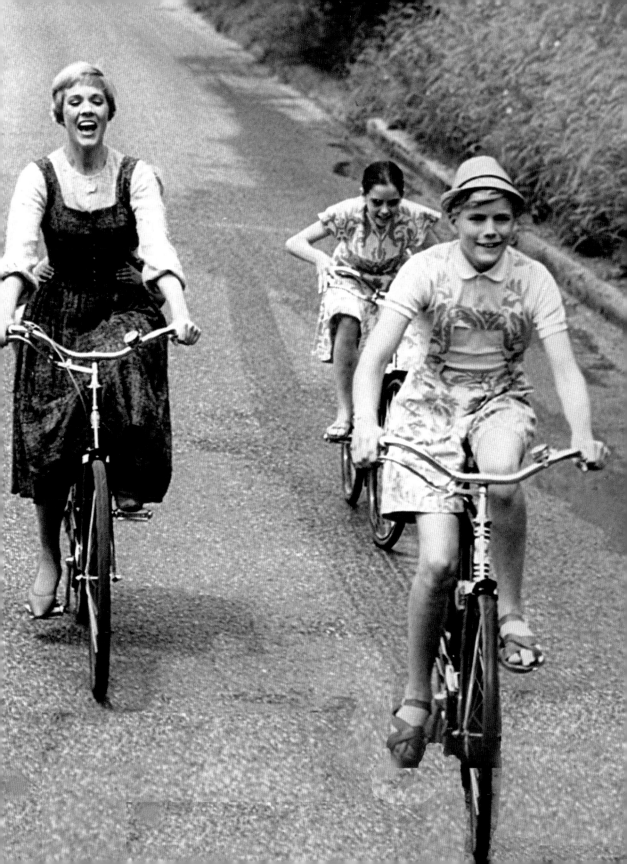

OVERLEAF:

Julie Andrews, Charmian Carr, Nicholas Hammond, Duane Chase, Angela Cartwright, Debbie Turner, and Kym Karath ride bikes. And sing "Do-Re-Mi." From the little-known release, *The Sound of Music* (1965), Andrews and her brood cycle along a Salzburg byway warbling the Rodgers and Hammerstein ditty with the lines "Doe, a deer, a female deer, Ray, a drop of golden sun . . ." The Academy Award best picture winner stands as one of the most popular movie musicals of all time. The bikes: a cool collection of 1940s German and Austrian plunger-brake models.

OPPOSITE:

Susan Peters rides a bike. And looks out to sea. This striking photo, taken when Peters (signed to MGM) was twenty-two, is heartbreakingly beautiful—not just for the Palisades Park vista, the glamorous portrait of a pretty star gazing over the Pacific, and the not-too-shabby Monark bicycle. Peters, who received a best supporting actress Oscar nomination for her role as the lovestruck young woman set to marry amnesiac Ronald Colman in *Random Harvest* (1942), was being groomed for great things. But then on a hunting trip in 1945 with her husband, actor Richard Quine, his gun went off, and a bullet lodged in Peters' spine—she was left paralyzed from the waist down. The actress attempted to continue with her career, appearing in several films, on stage, and on TV. But by 1948, her marriage was over, and by 1951, at age thirty-one, she was dead—a victim of depression and anorexia.

[VERSO:] STARDOM LOOMS . . . for Susan Peters, but she lives as simply as the girl next door in a one-room apartment in Santa Monica. Susan's work with Greer Garson and Ronald Colman in "Random Harvest" brought a Metro-Goldwyn-Mayer contract. Since then she has made four pictures at that studio, the latest being with Jean-Pierre Aumont in "Assignment in Brittany." The beach only a block away is a never-ending joy to Susan.

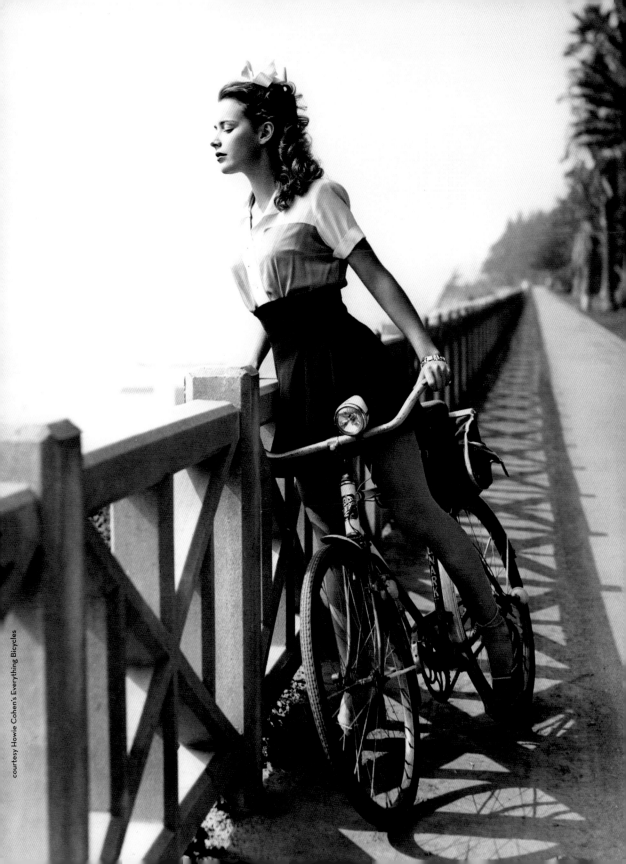

Vincent Price rides a bike. Known for his sinister turns in horror, both early in his career (*Tower of London* [1939], *The Invisible Man Returns* [1940]) and with his 1960s work for Roger Corman, Price played a different sort of monster—the corrupt New Yorker "Boss" Tweed, in the odd musical comedy, political romance, *Up In Central Park* (1948). Pursuing pigtailed Irish lass Deanna Durbin with a lecherous vigor, Price's Tammany Hall powerbroker bilks the city of millions by claiming Central Park is in need of extensive rehabbing. Here he is on a classic nineteenth-century high wheel, ostensibly taking a tour of the leafy retreat.

Deanna Durbin and Melvyn Douglas ride a bike. In Universal's Oscar-nominated *That Certain Age* (1938), Durbin is a teenager with a heavy crush on Douglas, portraying a dashing newsman who's twenty years her senior. Here they are, not exactly dashing around the lot, on a Colson tandem with matching rocket-shaped headlamp and horn. The bow-tied Douglas could be whistling "You're As Pretty As a Picture," one of the film's McHugh-Adamson ditties.

[VERSO:] On a bicycle built for two—Deanna Durbin and Melvyn Douglas, star and leading man of Deanna's new Universal picture "That Certain Age" pedal around the studio grounds.

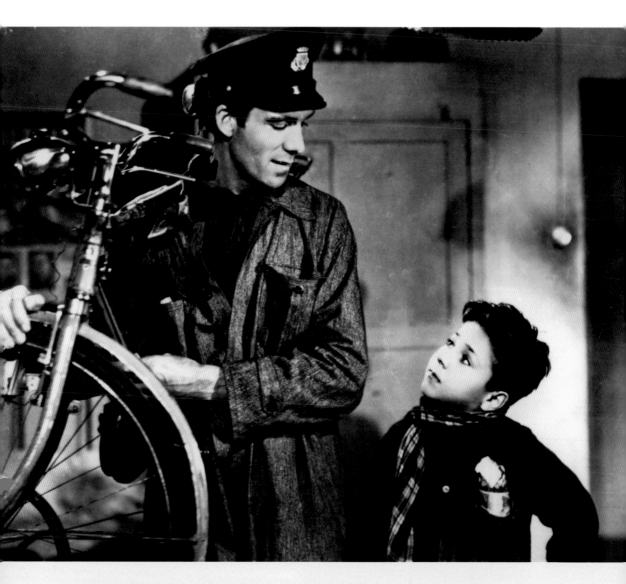

Lamberto Maggiorani hefts a bike. Enzo Staiola watches. Neorealism ensues. Vittorio De Sica's neorealist masterpiece, *Bicycle Thieves* (1948), a.k.a. *The Bicycle Thief* (U.S. release, 1949), is the haunting tale of Antonio Ricci (Maggiorani), desperately trying to reclaim the bike he needs to keep his job, while his son, Bruno (Staiola) struggles with his father's pain and despair. Set in post-war Rome, De Sica's film captures a world of poverty and moral confusion. Fides, the brand of Antonio's bike, means "faith" or "reliance" in Italian.

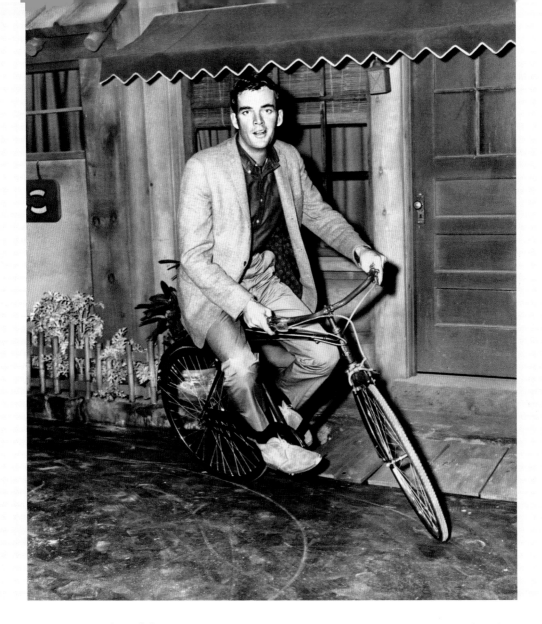

Jim Hutton rides a bike. Riding in circles in front of the backlot Tokyo apartment his character shares with Samantha Eggar and Cary Grant in the bedroom—make that futon—farce, *Walk Don't Run* (1966), Hutton does his best to keep his desert boots on the British three-speed's pedals. A tall (6′ 5″) and gifted actor in comedies and dramas, Hutton is perhaps best remembered for starring in the hit 1970s television mystery series, *Ellery Queen*. In this Columbia movie, he's on the USA's walking team at the Tokyo Olympics (no, not the cycling team) and ends up rooming with an eccentric British industrialist played by Grant (in his final film) and the redheaded Eggar, with whom he falls in love. Hutton died in 1979, at forty-five, of cancer. Timothy Hutton, his son (you can see the resemblance), dedicated his Academy Award (for *Ordinary People* [1980]) to his dad.

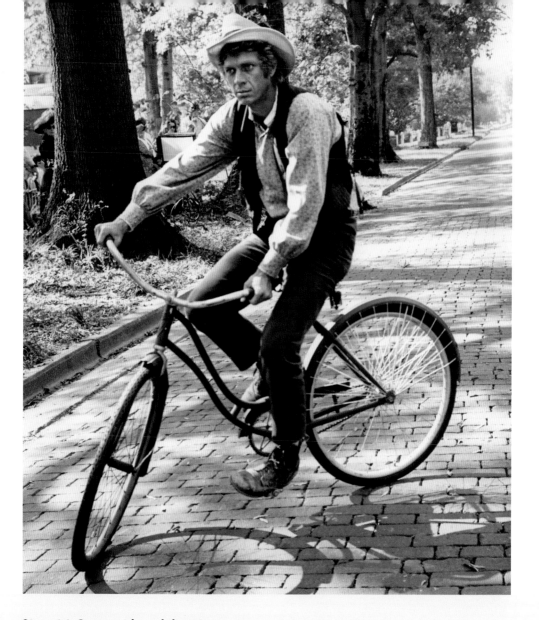

Steve McQueen rides a bike. They're iconic images—1960s/'70s screen star McQueen on his Triumph motorcycle or racing his Porches and Jags. Not so iconic—the topliner of *The Reivers* (1969) looking unsteady as he circles Carrolltown, Mississippi, on a turn-of-the-century safety bike. Adapted from the William Faulkner novel, Mark Rydell's colorful period-piece about Boon Hoggenbeck, an up-to-no-good Mississippi farmhand, offers various modes of transport—a gleaming yellow "Winton Flyer" automobile, a racehorse, and the Iver Johnson bicycle pictured herein.

[VERSO:] ON THE ROAD: Actor Steve McQueen rides a vintage bicycle in a scene from "The Reivers." McQueen, long known for his prowess on motorcycles, admitted he had to re-learn how to ride the pedal bike. "Too slow for me," he explained.

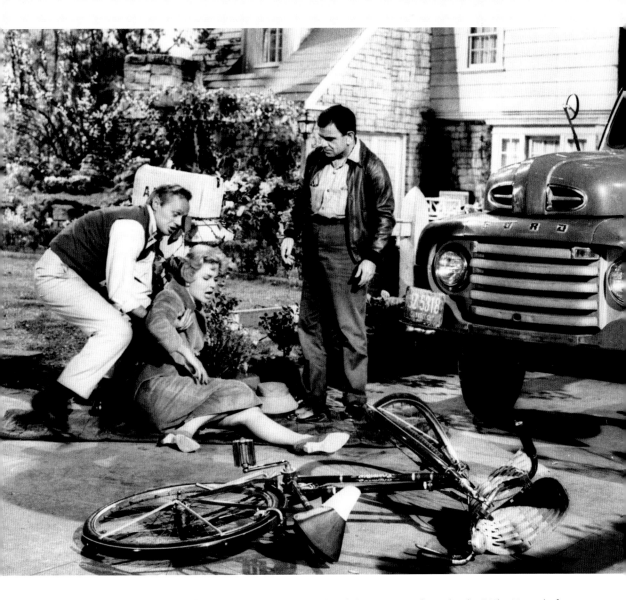

Doris Day crashes a bike. Advertised as a "battle of the sexes in the suburbs," *The Tunnel of Love* (1958) finds life-long bicyclist Day in a collision with Ford pickup driver Sid Melton. Richard Widmark plays the husband, August Poole, to Day's missus, Isolde, helping her back on her feet in this still. The Pooles live in Westport, Connecticut, and have been trying unsuccessfully to have a child. When the pretty adoption agency rep (Gia Scala) shows up with a baby, what should have been an occasion for great happiness turns into one of great suspicion: the infant looks just like Widmark (poor kid!), who had been in a motel with the young beauty barely nine months beforehand. (It's, all of course, an innocent misunderstanding.) Day climbs on her Schwinn and pedals off in a huff, and then, *kabong*. Gene Kelly directed the MGM marital romp, shot in CinemaScope and featuring Day singing "Run Away, Skidaddle, Skidoo."

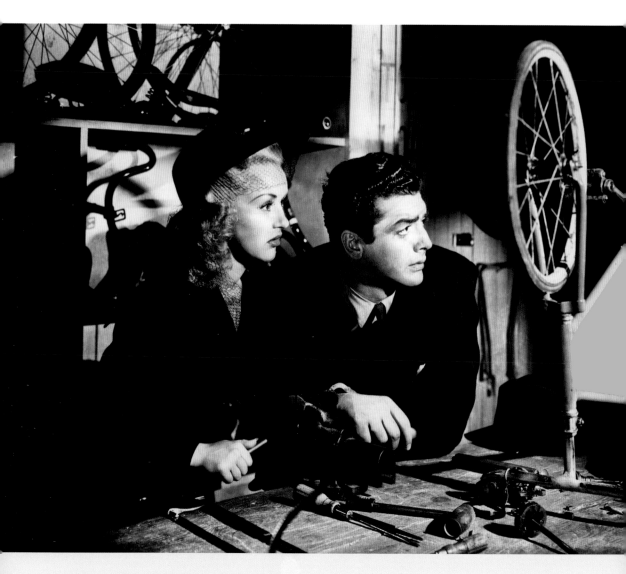

Betty Grable and Victor Mature huddle noirishly around bikes. "That wheel definitely needs truing." . . . In *I Wake Up Screaming* (1941)—often cited as the first real noir—Mature is suspected by police of killing Grable's sister, and the two of them go on the run, trying to prove his innocence. What to do? Hide out in a New York City bike shop, of course, where Grable can use a hacksaw to free Mature of his handcuffs—and where they can check out the disassembled parts of a New Departure Model A hub. There's a Raleigh Heron lamp bracket behind them, casting a distinctive shadow on the wall.

Jason Robards and Barbara Harris ride a bike. Robards and Harris take a break from wheeling their Rollfast tandem around New York—Greenwich Village, Central Park, Wall Street—and pull up in the middle of Park Avenue. Robards is an ex-TV scribe and serious slacker, reprising his role from Herb Gardner's Broadway hit in *A Thousand Clowns* (1965). Harris is the child-welfare worker investigating whether Robards' Murray Burns is responsible enough to be raising his nephew. Before long, the twosome are kissing madly, and then pedaling madly (with or without balloons) on this nifty Rollfast. Observe the flat-blade forks, 26x1.175-inch tires, and Bendix red band rear hub. Attention campers!

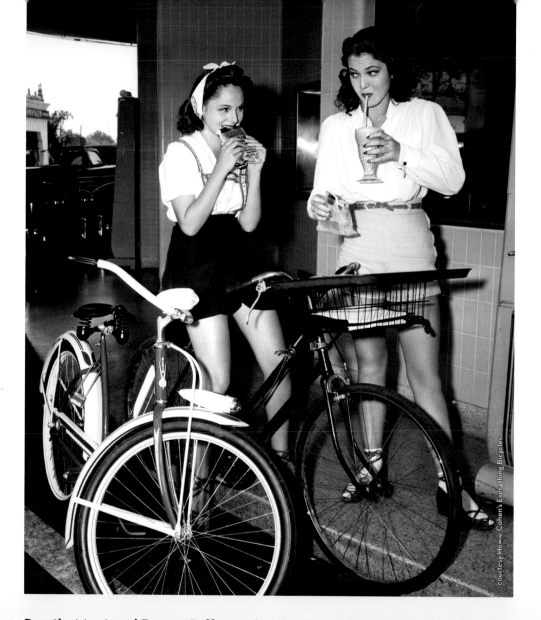

Dorothy Morris and Frances Rafferty take a break while biking. (1) "Where's the Bike-A-Thon lunch stop?" starlets Morris and Rafferty wonder, parking their Elgin balloon tire (with horn and headlight) and Rudge-Whitworth English three-speed at a drive-in joint in L.A. (There's a Chrysler dealership right next door.) Morris had a significant turn in *Our Vines Have Tender Grapes* (1945), Rafferty played the rape victim in *Dragon Seed* (1944), and both studied with famed acting coach Maria Ouspenskaya. Rafferty went on to success on TV, playing Ruth Henshaw, the daughter of Spring Byington, in the popular 1950s sitcom *December Bride*.

[VERSO:] THE PAUSE THAT FILLS—Dorothy Morris and Frances Rafferty pause while out bicycling to put away hamburgers and choc malts. The two Metro-Goldwyn-Mayer glamour girls will next be seen in "The War Against Mrs. Hadley."

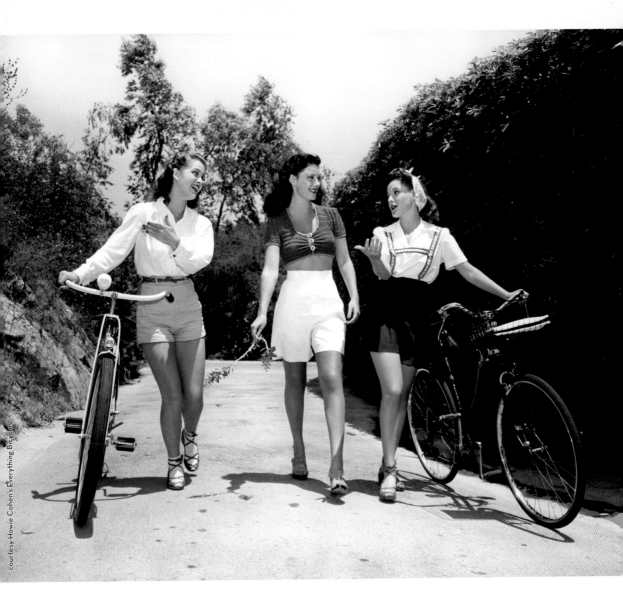

Frances Rafferty and Dorothy Morris walk bikes. Vicki Lane sashays. (2) "You could ride with me." "You could ride with me." "Thanks, think I'll just walk." . . . The trio of MGM contract girls with their Elgin, their Rudge-Whitworth, and their branch.

[VERSO:] Starlets Frances Rafferty and Dorothy Morris offer Vicki Lane a ride. Dorothy and Frances have come to visit the pretty new starlet, traveling the "Victory way." Vicki recently signed a long-term contract with Metro-Goldwyn-Mayer. Miss Rafferty and Miss Morris will be seen next in Metro-Goldwyn-Mayer's "The War Against Mrs. Hadley."

OVERLEAF:
Jeff Bridges rides a bike. Edward Furlong tags along. In *American Heart* (1992), Bridges is an ex-con just back on the streets of Seattle, where he's stalked by his twelve-year-old son. Begrudgingly, he lets his kid move into the $65-a-week room, if he follows three rules: "Don't trail me, shadow me, or any way, shape, or form jam me." Bridges' Jack buys a single-speed Schwinn at a pawn shop, hefts it up and down the flophouse stairs, and uses it to commute to his job as a high-rise window washer. Son Nick is told to go to school, but instead starts hanging with a pack of teens. Mary Ellen Mark was the still photographer on the production (and took this evocative shot); her husband, Martin Bell, directed. The gritty indie, which boasts one of Bridges' strongest, subtlest performances, was inspired by Bell and Mark's documentary about Seattle's young and homeless, *Streetwise* (1984). Furlong went on to star as John Connor in *Terminator 2: Judgment Day* (1991). Bridges made another Heart film—*Crazy Heart* (2009)—that finally won him the acting Oscar that had for so long eluded him.

OPPOSITE:
Spencer Tracy and Mickey Rooney ride a bike. Tracy won his second Oscar for his performance as Father Flanagan, the tough but tender-hearted priest who establishes a home for wayward boys in the tear-jerker, *Boys Town* (1938). Diminuitive Rooney is Whitey Marsh, the "young renegade" that Father Flanagan tries to save from a life of crime and conflict. Here's the duo, on a brand-new Rollfast, tooling around MGM's Culver City backlot. The two re-teamed for *Men of Boys Town* (1941).

Bob Hope and mannequin ride bikes. Straw sombrero, check! Bathrobe, check! Let's go for a ride! The film funnyman acts stiffer than usual in a still from *They Got Me Covered* (1943), the Samuel Goldwyn screwball caper. Hope is Robert "Kit" Kittredge, a bumbling reporter, who, with the help of a dishy Dorothy Lamour, uncovers an Axis spy ring working out of a deluxe day spa in Washington, D.C. Here, he's in the La Roche Salon showroom, disguised as a mannequin as the conspirators convene at a conference table right in front of his nose. When he accidentally rings the Schwinn-built bike's bell, they think it's a phone call. Director Otto Preminger plays the Nazi heavy who throws daggers at the female mannequin and then at Hope. The bike-centric climax is foreshadowed early on when Hope, in Moscow disguised as a Russian, dons a hefty fake handlebar mustache and quips, "What did you do with the rest of the bicycle?"

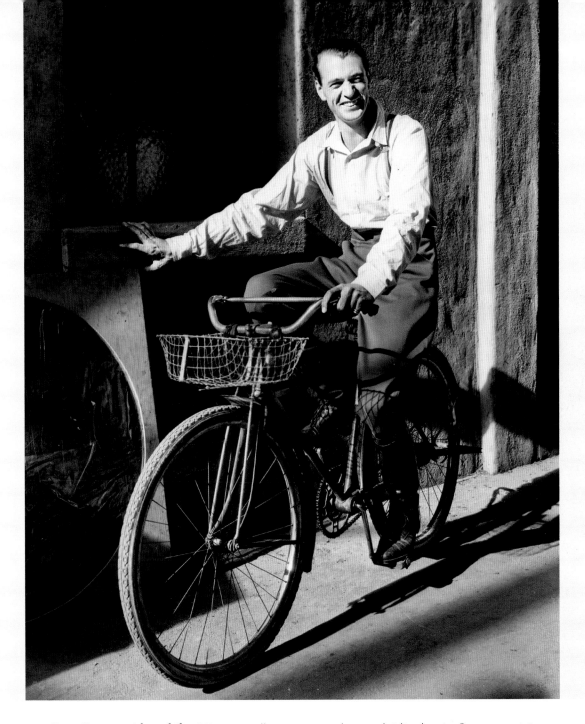

Gary Cooper rides a bike. Wearing jodhpurs, suspenders, and riding boots, Cooper squints into the sun—or into a backlot Klieg—on a Rollfast borrowed from Paramount's operations department. Coop is busy leading the charge for director Henry Hathaway on *The Lives of a Bengal Lancer* (1935).

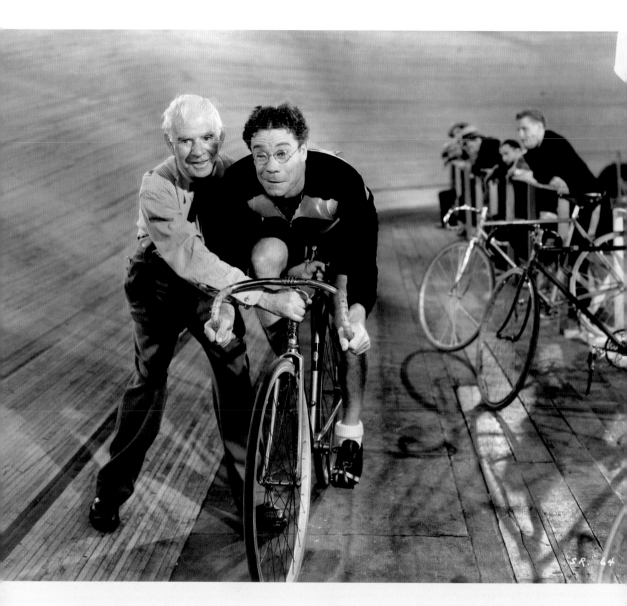

Joe E. Brown rides a bike. And rides, and rides, and rides. In *6 Day Bike Rider* (1934), the rubber-faced, slapstick star plays a track cyclist competing for a trophy in the marathon event—and for the heart of a girl, Maxine Doyle. Brown is perched atop a modified Automoto, the French track bike. Shot at the old Los Angeles Winter Garden, the First National release celebrates the non-stop mayhem of the then hugely popular six-day races, a grueling form of track racing that packed crowds into velodromes from the 1890s to the 1930s. Wild crashes and cycling stunts abound in the film's climactic rally. Some of the real-life cycling competitors who show up alongside Brown's "cycling cyclone of mirth" include 1932 California state track champ Neil Davidson, Canadian Olympic track cyclist Lou Rush, and Eddie Testa of the U.S. Olympic Track Team.

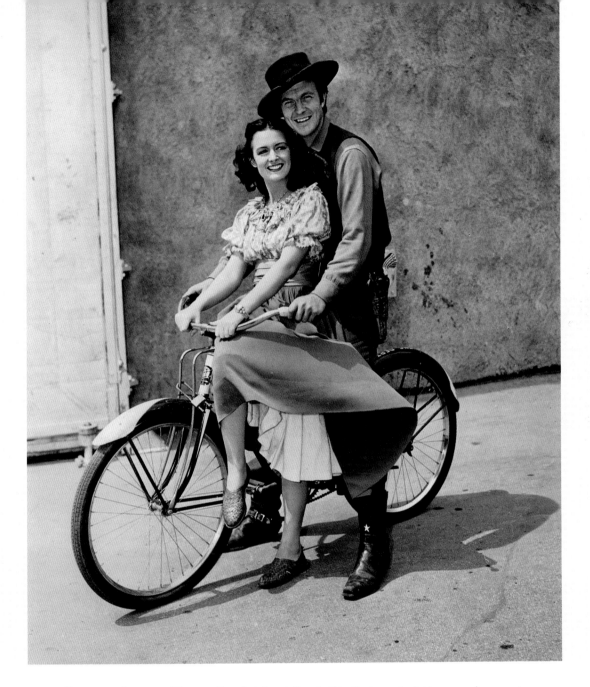

William Lundigan and Donna Reed ride a bike. Still in their work clothes—cowboy couture for the MGM western *Apache Trail* (1942)—William Lundigan and Donna Reed take a pleasant spin around the lot. He's a stagecoach station manager deep in Indian territory, and she's Rosalia Martinez, the lusty Latina daughter of the depot's cook. (Yes, Donna Reed, a lusty Latina!) The Monark bike is a loaner from the studio's fleet—you can make out "DEPT" painted on the rear fender.

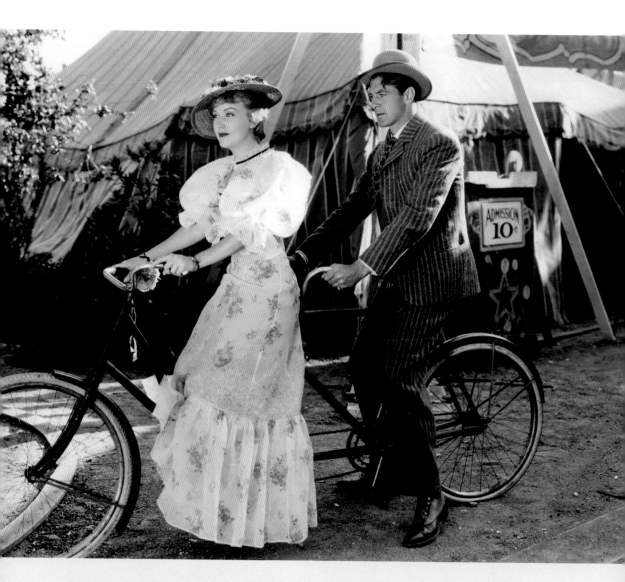

Fay Wray and Gary Cooper ride a bike. One of Cooper's earliest vehicles, *One Sunday Afternoon* (1933), was a quickie adaptation of a Broadway hit (it was still running when the Paramount pic came out) about a dentist who serves time in jail and resents the friend who set him up and walked off with his girlfriend (Wray). Here Cooper and Wray go for an idyllic, flashback ride on a vintage tandem, probably an Orient. It was one of the stars' five filmic affairs together.

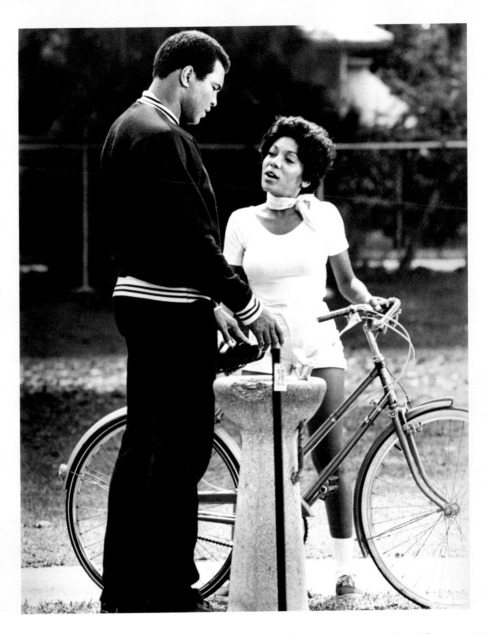

Mira Waters stops her bike. Muhammad Ali stops for Waters—er, water. "After you, Mr. Clay," actress Waters pauses at a water fountain and talks up a prizefighter. He likes the way she rides a bicycle; she likes the way he runs backwards down a Miami esplanade. Waters plays girlfriend Ruby Sanderson in the oddball biopic *The Greatest* (1977)—a reenactment of the world champion's life starring the world champ as himself. Waters, on a ladies' 26-inch wheel Dunelt three-speed, made her screen debut in Gordon Parks' *The Learning Tree* (1966). Although you can't see it in the photo, the water fountain here is marked "coloreds"—it's 1964, in the pre-Civil Rights Act South.

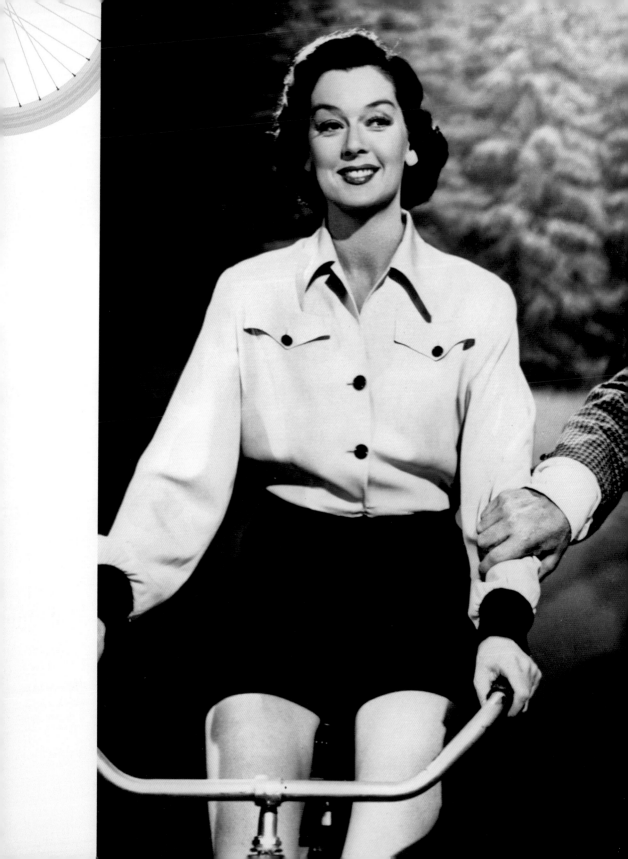

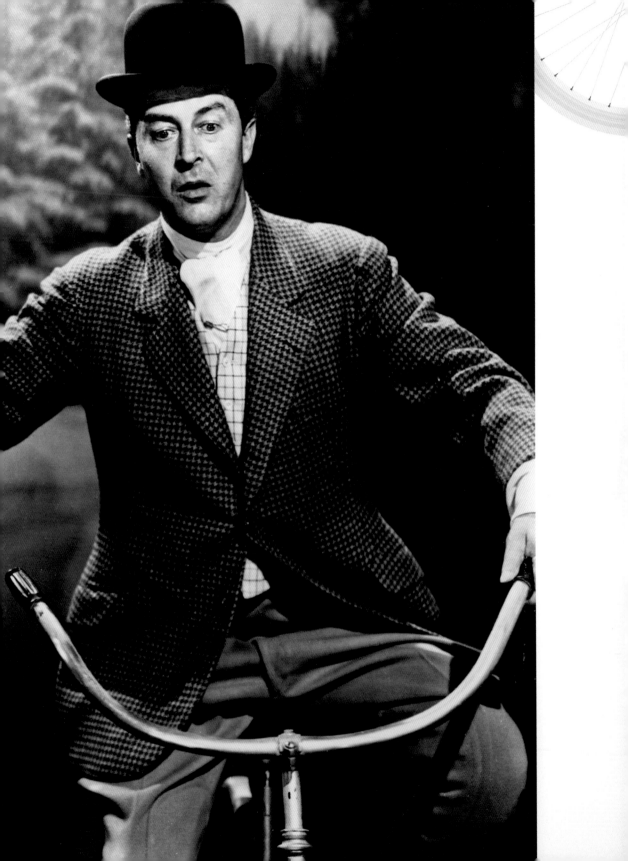

OVERLEAF:

Ray Milland and Rosalind Russell ride bikes. In Columbia's rom-com, *A Woman of Distinction* (1950), Milland is an astronomy professor and "dashing young Englishman" hired by the dean of a New England college—that would be Russell. She's all about her career, and so is he, which means neither has the time for amorous distractions—and so the next thing you know they're off on a romantic bike ride, which he doesn't quite manage without crashing into the dirt.

OPPOSITE:

Grace Kelly walks a bike. Looking over her shoulder, barefoot and beaming, Grace Kelly stands by her Roadmaster cruiser back when the bikes were still manufactured by the Cleveland Welding Company. Note the padlock attached to the front trusses. It's 1954. The following year, at Cannes, she meets a Monaco royal by the name of Rainier.

[VERSO:] Kelly charm and glamour is evident as Grace poses beside her bicycle. It's a family trait. For her mother was a magazine cover girl in 1919. Father Kelly, now a prosperous Philadelphia contractor, in his youth was a hod carrier.* And he got his dander up when, winner of Olympic oarsman honors, he was refused entry in an elite British event. Revenge came when son Jack later won that competition—twice.

* a brick worker

ICE Hollywood

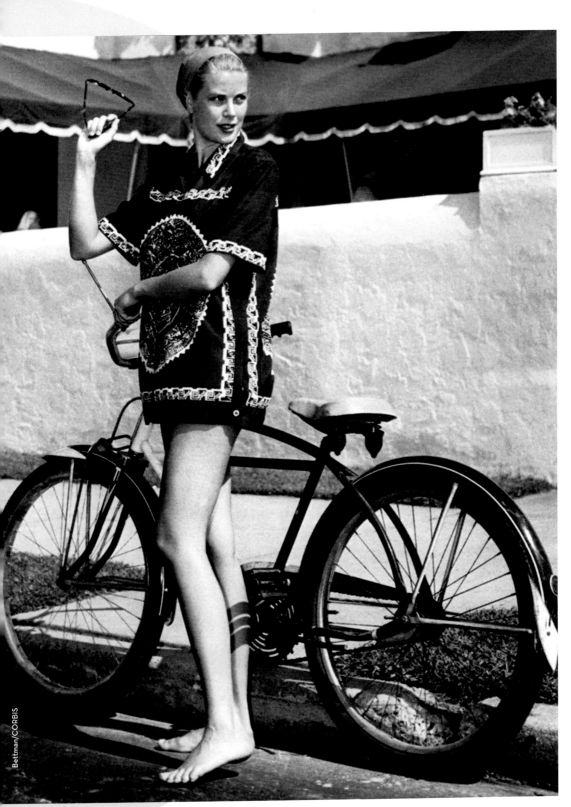

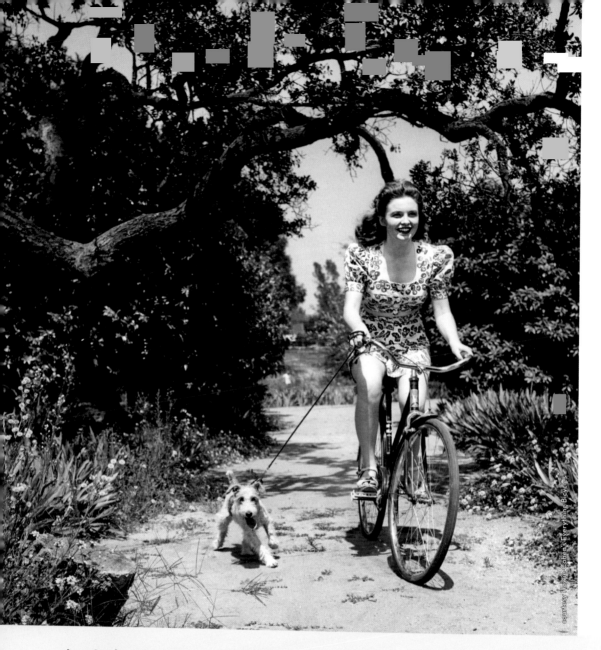

courtesy Howie Cohen's Everything Bicycles

Joan Leslie rides a bike. And walks the dog. "Nick, Nora, I'm taking Asta for a run . . ." Well, no, but actress Leslie—who played Velma, the girl with the deformed foot opposite Humphrey Bogart in *High Sierra* (1941)—takes her Elgin (with cool, double-sided pedals) and her own fox terrier out for some exercise. Leslie, who was still in her teens when she appeared as Jimmy Cagney's wife in *Yankee Doodle Dandy* (1942) and danced opposite Fred Astaire in *The Sky's the Limit* (1943), let the Warner Bros. photog shoot her here to promote her star turn opposite Ida Lupino in *The Hard Way* (1943). Here's the poster's tagline: "Sisters face to face . . . one burning with love . . . the other seething with hatred! A story of crushing power!"

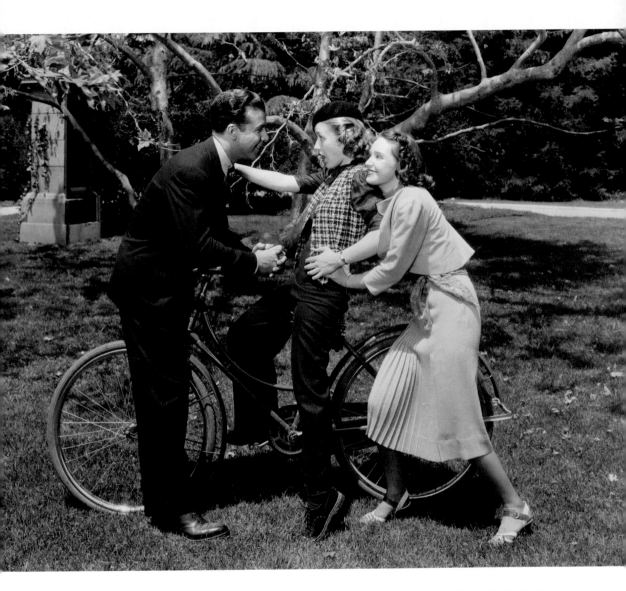

Dick Powell, Priscilla Lane, and Rosemary Lane tussle over a bike. Powell is a Winfield College alum who's now a Broadway star, returning to campus to help out with the "Quadrangle" varsity show. Rosemary Lane is the sorority girl who falls for Powell, and vice versa. In this Warner Bros. photo for the musical *Varsity Show* (1937)—which boasts an amazing Oscar-nominated final number staged and directed by Busby Berkeley—sister Priscilla comes between Powell and Rosemary. The Pomona College campus doubled for Winfield in the movie. Lola Lane, the third of the singing Lane Sisters, is nowhere to be found.

Billy Chapin walks a bike. Victor Mature tousles his hair. Set in an Arizona mining town, the tough, bank-heist melodrama *Violent Saturday* (1955) features Mature as the mine's manager, here rescuing his son—played by kid thespian Chapin—from a fist-fight with his best friend. The red Rollfast, with a rare spring-suspension fork, alarmingly gets thrown to the ground in the fracas, too. Lee Marvin heads the trio of hell-bent robbers, and Richard Fleischer directed the Twentieth Century Fox CinemaScope release. Chapin appeared that same year as the traumatized son in *Night of the Hunter* (1955) starring Robert Mitchum as the evil evangelist with LOVE and HATE tattooed on his knuckles.

Robert Goulet and Nancy Kwan ride a bike. "You gotta have a gal in your room!" goes the tagline for the poster of MGM's bedroom comedy *Honeymoon Hotel* (1964), and ". . . these boys arrive with no brides, no baggage . . . and absolutely no reservations!" Along with crooning thespian Goulet and *World of Suzie Wong* (1960) star Kwan, Robert Morse and Jill St. John topped the cast. Here Kwan and Goulet top a Murray Polaris X63 cruiser armed with a handlebar-mounted squeeze horn.

[VERSO] GOING HER WAY? Robert Goulet wheels up to Nancy Kwan's dressing room on the Metro-Goldwyn-Mayer set of "Honeymoon Hotel" as the vivacious star enters into the spirit of the prank and thumbs a ride. His is no bicycle-built-for-two, but that only makes things cosier!

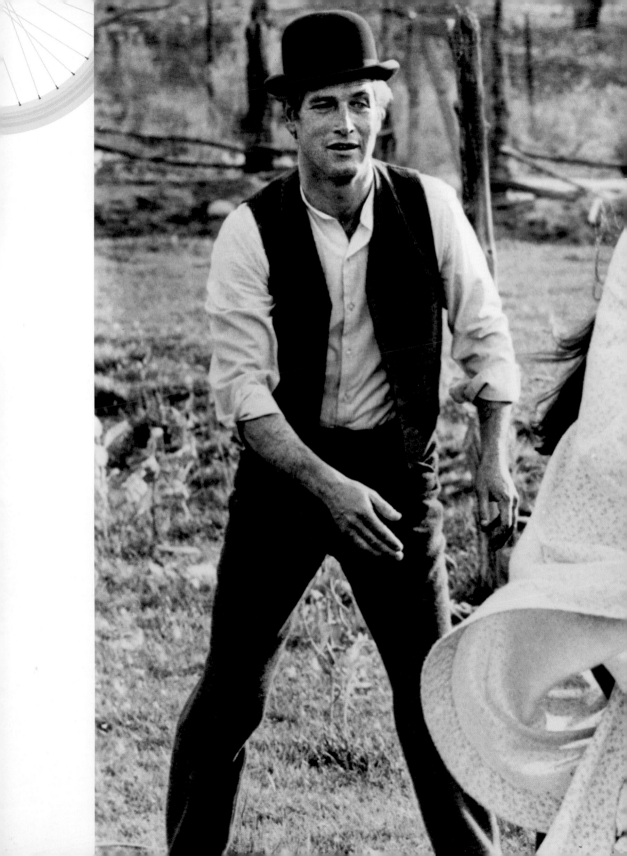

OVERLEAF:

Katharine Ross rides a bike. Paul Newman gives a push. "Meet the future," train robber Butch Cassidy says to Etta Place, introducing the girl he loves—and who's sleeping with his best friend and partner in crime—to his new-fangled two-wheel invention, the bicycle. It's late-nineteenth century Wyoming, and for a good seven minutes or so in the midst of *Butch Cassidy and the Sundance Kid* (1969), Newman and Ross ride around the farm, circling and cavorting, while B.J. Thomas sings "Raindrops Keep Falling on My Head." (The sun is out, so go figure.) Most of the time, Ross is perched on the handlebars, but here she is under her own pedal power. And Newman, who did all his own stunts, rides backwards, and stands on the handlebars, and stands on the seat, and belly-flat on the seat, too. Meanwhile, Robert Redford, a.k.a. Sundance, just sleeps.

OPPOSITE:

Alfred Hitchcock rides a bike. And signals. It's the Cannes Film Festival, 1972, and Hitch has arrived on the Croisette to spread the word about his latest—and, sadly, last—film, the British-made serial killer thriller, *Frenzy* (1972). The perp strangles his victims using a necktie. Here the iconic and ironic director is riding a Helium small-wheel folder, a low-end brand made and marketed by Peugeot. Note the spiffy banners dangling from the handlebars. Note the mast coming out of Hitch's head.

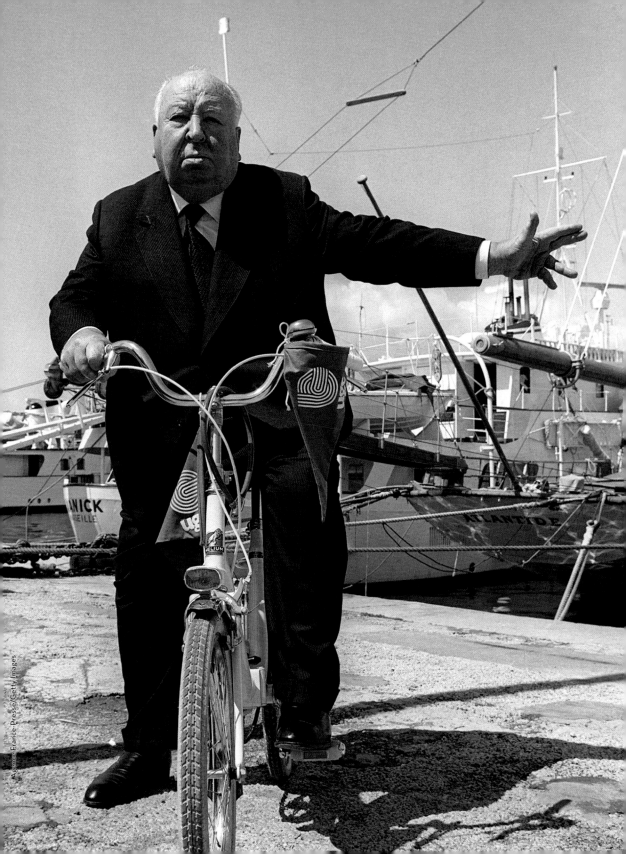

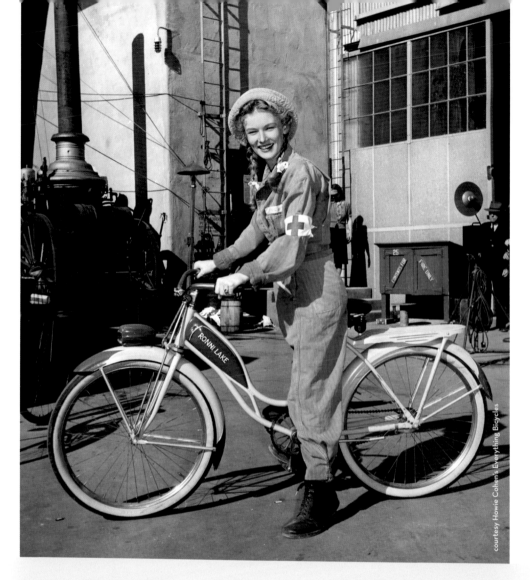

courtesy Howie Cohen's Everything Bicycles

Veronica Lake rides a bike. On her personalized "Ronni Lake" Shelby cruiser, 1940s star Lake—she of the famous "peekaboo" bangs—takes a break during the shooting of the patriotic Pacific Theater drama, *So Proudly We Hail* (1943). The drama centers around a trio of Army nurses in the Philippines. Joining her in the box office hit were Claudette Colbert and Paulette Goddard. Lake, just shy of five feet, starred opposite Joel McCrea two years earlier in the Preston Sturges classic, *Sullivan's Travels* (1941). In addition to riding bikes, Lake was also a licensed pilot and flew her own plane across the country.

[VERSO:] ARMY DUNGAREES are donned by Veronica Lake for her latest Paramount picture, "So Proudly We Hail." The famous Lake hair is braided in pigtails. The coverall suit and shoes are borrowed from the men's wardrobe department.

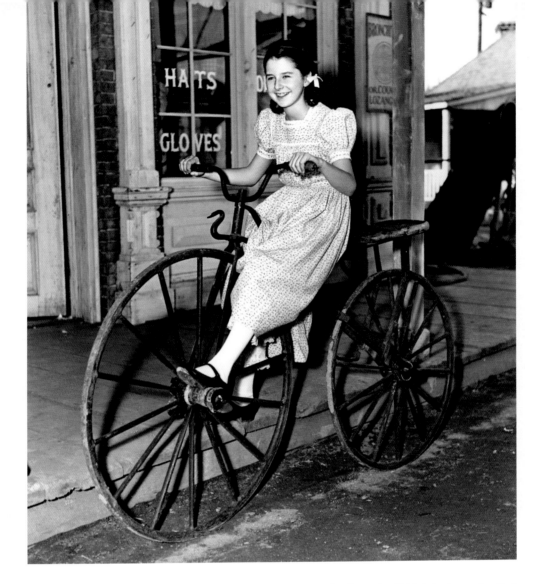

Virginia Weidler rides a bike. Raised in Eagle Rock, not far from the RKO lot where she first got in the biz, child actress Weidler appeared in a busy forty-five pictures between 1931 and 1943. Here she rides an early boneshaker with an ornate swan decoration, a prop from *Young Tom Edison* (1940), in which she played little sister Tannie to Mickey Rooney's Thomas Alva.

[Verso:] LOST AMERICA REVIVED . . . Those who remember "the good old days" remember them with a sincere nostalgia for they were glorious days when a full-course dinner couldn't be obtained merely by the use of a can opener and everything, including washing the baby, wasn't done by touching an electric switch. Many of this lost Americana is being used at Metro-Goldwyn-Mayer in "Young Tom Edison," starring Mickey ROONEY, because the story goes back to 1860. So this lay-out . . . shows Virginia Weidler, who portrays Tom's sister Tannie and who is far too young to ever remember any of the items she examines, getting a thrill out of doing what grandma did when she was a girl.

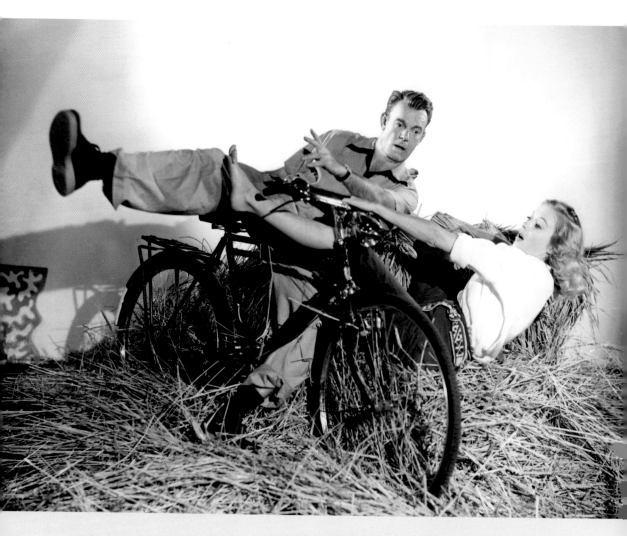

Evelyn Keyes and Dennis O'Keefe fall off a bike. A tumble in the hay . . . Falling in love in United Artists' rom-com *One Big Affair* (1952) are Keyes, as a teacher from Pomona College, and O'Keefe, as a lawyer from New York, who meet in Mexico City and travel onwards to Acapulco—a good part of the way on his rod brake, double-top-tubed tourist bike. Sitting on the back rack isn't the most comfortable setup, and it doesn't help that they keep getting sideswiped by a tour bus and crashing into the chaparral. "Are you hurt?" she asks after the fall that finally does the bike in. "No, I always get off a bicycle that way," he snaps back. Later, he gets nabbed for kidnapping the missing American. Not exactly *It Happened One Night* (1934). Keyes is best known for her role as Scarlet's sister, Suellen, in *Gone with the Wind* (1939). O'Keefe started his career in the 1930s as Bud Flanagan, signed a contract with MGM in 1937, and was re-dubbed Dennis O'Keefe. He worked steadily into the mid-1950s.

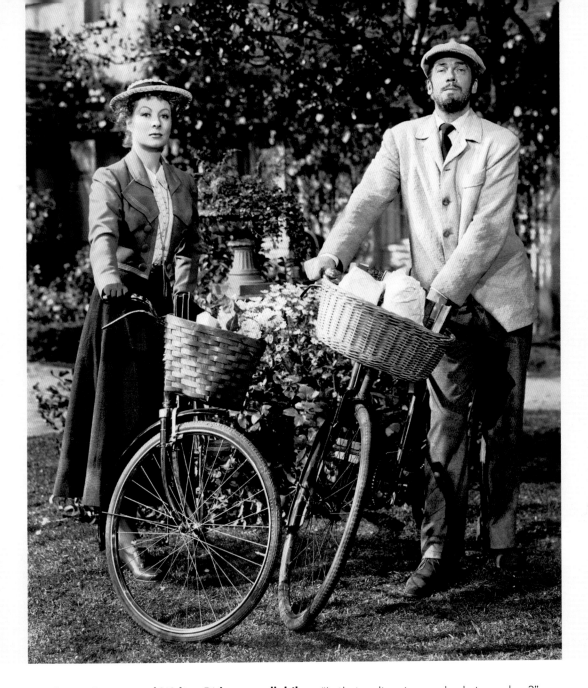

Greer Garson and Walter Pidgeon walk bikes. "Is that radium in your basket, my dear?"
. . . Garson and Pidgeon pose for the MGM photographer as Marie and Pierre Curie in
Mervyn LeRoy's biopic *Madame Curie* (1943), the story of the Polish Sorbonne-student Marie
Skłodowska and her discovery of polonium and radium. Pierre, her professor-turned-hus-
band, helped in the lab. The bikes are vintage, and probably single-gear. Garson and Pidgeon
both received best acting Oscar nominations for their work, though neither won.

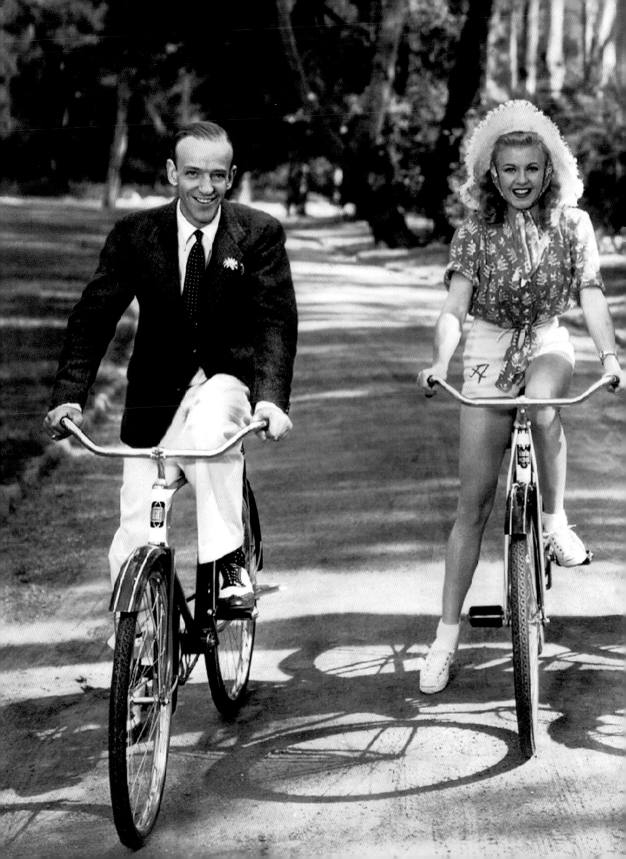

Fred Astaire, Ginger Rogers, Ralph Bellamy and Luella Gear ride bikes. In the Fred and Ginger romantic romp, *Carefree* (1938), he's a psychiatrist (and hypnotherapist), and she's a patient he's supposed to be helping overcome her fear of marriage. Of course, he tumbles for her—quite literally, when a leisurely ride in the park takes a turn down a steep path. Astaire, wearing two-tone oxfords, breaks the chain on his Shelby Flyer and crashes into a bush. The RKO musical is famous for introducing "The Yam," and also for the wonderful hypno-dance interpretation of "Change Partners."

Opposite:

Sandra Dee hides behind a bike. "Look at me, I'm Sandra Dee." . . . The perky teen star—born Alexandra Zuck in Bayonne, New Jersey—poses with a Raleigh-built ladies' Royal Enfield, the marque famous for the vintage motorcycles. Dee, who made her screen debut at fifteen in *Until They Sail* (1957) (see Jean Simmons, page 105) went on to play California surf-princess *Gidget* and the teenaged Suzie in Douglas Sirk's *Imitation of Life* (1959). In 1960, she married singer Bobby Darin—the beach party duo lasted most of the decade.

acknowledgments

First and foremost, this book wouldn't exist if it weren't for the encouragement, enthusiasm, and enlightened good humor of my wife. For that—and for everything—thanks, Connie. And to our daughter, Hillary Rea, who helped launch the *Rides A Bike* site and fielded my clueless tech questions with patience (or feigned patience, anyway) at every stage. Her *Rides A Bike* Father's Day card was pretty cool, too. And to Tom and Mary Rea for my first Raleigh Sports, way back when. (And for the second, when the first was stolen.)

Stuart Rome, a great photographer and great friend, didn't know what he was getting into when he agreed to ready these pictures for publication—he subjected himself to hours of work under crazy deadlines, and somehow managed to make lunches and coffee and put up with my backseat editing on top of it. He's taught me more than I ever thought I'd know about ferrotypes and CMYK files, and decided that, yes; it was a good idea to leave that yacht mast coming out of the top of Hitchcock's head. Thanks, too, to Catherine Bogart-Rome and Sarah Rome for relaying photos, and for letting me hang out in their home.

This book would have significant holes in it if it weren't for the generosity of Howie Cohen, a gracious gentleman with a direct link to old Hollywood cycle culture (his family owned three bike shops that serviced the studios in the 1940s and 1950s). Go to howiebike-man.com to see more wonderful vintage photos, to learn about Howie's vital contribution to *E.T.*, and to browse through his vast cache of cycling memorabilia. His site is called Howie Cohen's Everything Bicycles, and that's not an understatement.

Ron Mandelbaum and his colleagues at Photofest in New York also opened their files and came up with key, classic shots.

Michael Ochs, whose massive photo archive literally filled his Venice, California, home before he sold the collection to Getty Images, offered his sage counsel. I'm glad to have reconnected with an old friend, and I am grateful to Michael for putting me in touch with Nancy E. Wolff at Cowan, DeBeats, Abrahams & Sheppard, and with Jonathan Hyams at Getty Images.

For their *Antiques Roadshow*-like expertise in identifying many of the American cruisers, British roadsters. French track bikes, and now-obscure bikes, trikes, tandems and more, Curtis Anthony and Joel Flood of Philadelphia's one-of-a-kind Via Bicycle have been invaluable. (New Departure 2-speed hubs? Gormley & Jeffrey highwheels? Of course!) Brian Kenson, a longtime fellow traveler with an attic full of rare pedal-powered machines, contributed significant IDs as well.

For his early interest and advice, Jeffrey Goldman went above and beyond. Nancy Steele offered valuable publishing biz insight, as did Paul Dry of the eponymous Philadelphia imprint. And I owe a big thank you to siblings Genevieve and David McAuley, who displayed uncanny instinct and good taste, exerting their considerable influence on Angel City Press' powers-that-be. And speaking of said powers, Paddy Calistro and Scott McAuley have been dream publishers from the get-go. ACP's proofreader Lynn Relfe never missed a beat, Jim

Schneeweis fearlessly jumped into the fray, and Amy Inouye, aka Chicken Boy's mom, went all out on the book's design.

For their accessibility and input, thanks to Lauren Bacall and Johnnie Planco, to Emily Lloyd and Neil Howarth, and to Maria Janis Cooper, who alerted me to the existence of a photo of her father, wearing a bathrobe and a big grin, cycling around between scenes on *Ball of Fire*. (Alas, I'm still trying to hunt that one down—but Coop is well-represented, nonetheless.)

Thanks are hugely due to Dollie Banner and Bill Marlborough at Jerry Ohlinger's Movie Materials Store on 35th Street in Manhattan—they've been on the bicycle hunt through volumes and volumes of old 8x10 Hollywood press shots. Gratitude to the reliable eBay dealers in the U.S., the U.K., the Netherlands, Hungary, Chile, and Canada, where many of these photos were found (just the reliable and honest ones, mind you); and to the *Rides A Bike* fans who eagerly forwarded photos of (mostly) movie-connected folks (mostly) riding bikes.

To my friends and colleagues at the *Philadelphia Inquirer* who have supported this oddball side project (and to Bryan Grigsby and Ed Hille for taking the time to scan images for the website), and to my pal Howard Aaron, who has spread the word in Portland, Oregon, where more than a few people seem to have a jones for both bikes and movies. To Robert Kingsbury for his *sagacité* and support. To Irv Slifkin at Movies Unlimited, to Yair Solan (who runs the Charley Chase fan site charley-chase.com), and to Buster Keaton authorities Matthew C. Hoffman and Jeffrey Vance. To Richard Horgan at Mediabistro—the first journo to write about *Rides A Bike*; to Tien Homans, an early (and early-rising) *Rides A Bike* supporter; to Donna Bailey-Taylor at the Ava Gardner Museum; and to the Tumblr, Facebook, and Twitter followers who have shared, re-blogged, and re-tweeted many of these images.

Finally, while I've acknowledged as many photographers as possible, the majority of these images were released for distribution to newspapers and magazines by the respective publicity departments without photographer credits. And so, to the intrepid shooters responsible for the on-set stills, the backlot candids, and star portraits in these pages—to this anonymous gang of camera-toting studio employees, thank you, big time.

stars index

bike index

Published by
ANGEL CITY PRESS
2118 Wilshire Blvd. #880
Santa Monica, California 90403
310.395.9982
www.angelcitypress.com

Hollywood Rides a Bike:
Cycling with the Stars
By Steven Rea
Copyright © 2012
by Steven Rea

Design by Amy Inouye
www.futurestudio.com

10 9 8 7 6 5 4 3 2 1

ISBN-13 978-1-883318-63-5

Library of Congress Cataloging-in-Publication
Data is available

Printed in China

The Aloe

The Aloe

with Prelude
by

Katherine Mansfield

edited by Vincent O'Sullivan

Carcanet New Press

This edition first published
by the Port Nicholson Press Limited,
P.O. Box 11-838, Wellington,
New Zealand

Published in Great Britain in 1983 by
Carcanet New Press Limited
330 Corn Exchange, Manchester M4 3BQ

ISBN 0-85635-455-4

The Publisher acknowledges the financial assistance of the Arts Council of Great Britain.

The manuscript reproduced on the endpapers
will be found in transcription on p.141.
It is reproduced with the permission of
the Alexander Turnbull Library.

Designed by Lindsay Missen

British Library Cataloguing in Publication Data

Mansfield, Katherine
 The aloe.
 I. Title II. O'Sullivan, Vincent
 823[F] PR6025.A57

 ISBN 0-85635-455-4

SRP Ltd. Exeter

Contents

Introduction

There are few stories in English so well known, or so important for their influence on an entire tradition, as Katherine Mansfield's *Prelude*. It was a story she worked at intermittently, but also very deliberately, over a span of more than two years, turning the longer first version which she called *The Aloe* into the story which anticipated so much that is characteristic of twentieth century prose. In the present edition a reader for the first time may conveniently examine Mansfield in the heat of writing that story "straight off", scoring out and revising on the spot, changing direction and abandoning false starts, and see her too after the refining act of selection and omission. To read the two versions side by side offers a leisurely portrait, if you like, of Mansfield as the working artist.

Almost every Mansfield story can be taken back to some point of origin in the details of her life. The members of her own family, like the geographic features of Wellington, have passed into a kind of literary lore along with the characters based on them. Unlike the larger talents of many writers, Mansfield's simply does not move into anything like "pure fiction", into stories whose details and figures are so self-contained that if recognisable points of contact with life are proposed at all, their interest is only of a very minor kind. The identification of some detail in a story by Henry James remains in the realm of footnotes. With Katherine Mansfield, as with her friend and competitor Virginia Woolf, the strands of fiction and biography are not easily unwound. They *may* be, of course, and for literary assessment must be. Yet for most readers, an interest in one usually takes with it a curiosity about the other. Few of us read so purely that the author quite drops away, as theory frequently recommends.

There is a kind of prose which is not dissimilar to what we now call "confessional verse", and Mansfield was perhaps the first to shape it to the purposes she set herself as a story writer. It has no desire to move too far from verifiable places and events. It is less interested in "character" (in any full or traditional sense) than it is in the glancings of temperament, in the way symbol reverberates through the drift of narrative. Such prose is more concerned with how intuitions relate than it is in how a "story" proceeds, in the mining of suggestions rather than the set pieces of social behaviour. Another of its aims is to clarify, to illuminate, and often – for the writer – to preserve. ("I shall tell everything, even of how the laundry-basket squeaked at '75'.") Like the poetry some of Mansfield's contemporaries were then beginning to write, it offers a sense of order that embraces the apparently random. It is a prose that comes close to that of a *journal intime*, and Mansfield's first true tutor was Marie Bashkirtseff, the Russian painter who in 1884 died at twenty-four, and who kept in French vast journals in which she pored, fascinated, over the details of her own life. The line between a jotting in a Mansfield notebook and the first moving towards her own kind of fiction is at times a surprisingly fine one. Hers is a prose that eludes neat definition, one that tricks the reader into taking as warmly spontaneous the fabrication of cool skills. If critics can now say that "a good case could be made for the short story being the most flexible of all forms and, as such, the key to 'modernism'", and refer to its range as "analytical or lyrical, dramatic or rhapsodic",[1] that is partly because of what Mansfield did, and did for the first time in the two versions brought together in this edition.

As a girl of twenty, Mansfield proposed to herself a story set in Wellington, in which she would catch "the singular charm and barrenness of that place – with climatic effects – wind, rain, spring, night – the sea, the cloud pageantry. . . . A story – no, it would be a sketch, hardly that, more a psychological study." When she wrote those lines she had been reading Walter Pater's *The Child in the House*, an elaborate, plotless story of the emotions and responses that tie a certain kind of mind to a particular place,

1. Howard Moss, "Literary Lives", *The New York Times Book Review*, 9 March 1980, p. 1.

to a vanished time. "I should like to write a life much in [that] style."[2]

Between Pater and Mansfield there had been the whole tide of Impressionism, with the thought always not very far behind that a painting captures an object under the play of light as it is once, but can never be again; that what one pair of eyes looks at is both very private, and yet the world as indeed it is. In 1908 Mansfield knew little of painting, but had picked up the *ambiance* of the late nineteenth century. Art simply had defined most clearly what was permeating European consciousness. She did not in fact attempt that story. Yet years later, when she began on something similar in *The Aloe*, she still shared with Pater the feeling that one is only peripherally, as it were, in relation to other minds. The sense of "mystery" in so much of Mansfield's work is the intensity of one mind's perceiving freshly, crossed with that different, disconcerting sense that others, however vivid to themselves, exist remotely.

At first in *The Aloe*, then with more certainty in *Prelude*, Mansfield is discovering a new way to tell a story. It is not so much a narrative about events shared by several people, as one where several temperaments unfold in the slantings of perspective, in the tilting gradations of time. Various minds in turn are entered into, then drawn back from. Anything like "reality" is in how they converge, drift apart, lose touch, come back – the intricacies of time on the point of becoming memory. The story itself has become how it is being told.

II The history of the two stories printed here begins with Mansfield meeting her only brother in early February 1915. Always her favourite in the family, Leslie Beauchamp was just under twenty-one, full of jingoism and enthusiasm, and had arrived in England the day before to join up with the British Army. They ran into each other at the London branch of the Bank of New Zealand in Queen Victoria Street, and Katherine told him several things which were not true, but presumably realised they would be reported back home as if they were. Leslie duly wrote to the family in Wellington:

2. *Journal of Katherine Mansfield*, edited J. M. Murry, Definitive Edition, 1954, pp. 37–38.

I thought she was looking wonderfully fit – quite pink cheeks which she has gained since living in a cottage near Harrow. We went off to lunch together and picture her happiness at seeing one of the family, not having the faintest idea that I was coming over. She is more in love than ever with J. M. Murry which is a thing to be grateful for and with a new contract with one of the Monthlies for a series of war sketches, they have prospects of a little money coming in. . . . They are going over to Paris at the end of this week to collect materials for the new job.[3]

The facts were quite otherwise. Recently she had been ill with her vaguely defined "rheumatism", and there was no "Monthly" she worked for, no Paris job to attend to. Also, she felt that her days with Murry were running out. A few months earlier she had confided to one of her notebooks, "Jack, Jack, we are not going to stay together. I know that as well as you do. . . . What we have got each to kill – is my *you* and your *me*. That's all. Let's do it nicely and go to the funeral in the same carriage and hold hands hard over the new grave and smile and wish each other luck." She did not make clear to Murry, however, that considerately waiting for her at the graveside would be their Parisian friend, Francis Carco.

Carco was a writer, a committed Bohemian, a close friend of Murry's for the past five years, and had known Mansfield since their meeting in Paris in 1914. He had been born in New Caledonia, a fact which Mansfield thought placed them both as "Pacific" people. At that moment he offered what Murry, self-absorbed and remote, could not – "his warm sensational life. . . . His personality comes right through his letters to Jack and I want to laugh and run into the road." By the New Year they were exchanging love letters. Carco already was serving in the French army and feared he would soon be posted to active service. "Je ne veux que vous", he told her. "Vous êtes et vous serez toute ma vie."[4]

What brought France closer was that meeting with her brother. Leslie gave Katherine £10 for her fare, and she crossed the Channel in the middle

3. 11 February 1915, Beauchamp Papers, Alexander Turnbull Library.
4. *Journal*, pp. 63, 62.

of the month. Her entering the *Zone des Armées* led to one of the most publicly thumbed *affaires* of the Great War – there in detail in her own notebook entries, in her story *An Indiscreet Journey*, in the attentions of biographers, in the mileage Carco himself derived from it in later years.

Within a few days, a *grande passion* turned out to be not much more than an escapade, and Mansfield was back in England, reconciled with Murry but again physically ill. Happier, but still restless, she went back to Paris a month later, determined to begin writing after many months' silence. Her notebook entry for 24 March reads simply "Kick off". The next day she was more expansive in a letter to Murry.

I had a great day yesterday. The Muses descended in a ring like the angels on the Botticelli Nativity roof – or so it seemed to "humble" little Tig and I fell into the open arms of my first novel. I have finished a huge chunk but I shall have to copy it on thin paper for you. I expect you will think I am a dotty when you read it – but – tell me what you think – wont you? It's queer stuff. It's the spring makes me write like this. [5]

That "huge chunk" was the opening section of *The Aloe*. But she may not have got much further with it. She was back in London by the end of the month, stayed with Murry for five weeks in their new flat in Notting Hill, and for the third time in three months returned to France. She told her friend S. S. Koteliansky "I *cannot* write my book living in these two rooms. It is impossible – and if I do not write this book I shall die." [6]

This time she was away for a fortnight. A few days after she arrived she wrote to Murry "I am writing my book. Ça marche, ça va, ça se dessine – it's good." The same evening, "I have been writing my book all the afternoon. How good the fatigue is that follows after!" On 12 May she mentions that "My book *marche bien* – I feel I could write it anywhere it goes so easily – and I know it so well. It will be a funny book – ". But by now what she called her rheumatism was "simply dreadful", she had turned against Paris as she so often turned after a couple of weeks in some place she had set her heart

5. *Katherine Mansfield's Letters to John Middleton Murry*, edited J. M. Murry, 1951, p. 26.
6. *The Letters of Katherine Mansfield*, edited J. M. Murry, 1928, Vol. I, p. 7.

on, and as well – another recurring pattern – the tone of her letters to Murry was alternately affectionate and carping. "I am ill and alone voilà tout." When she said she was now determined to come home, she added "My work is finished my freedom gained. . . . it's all really accompli".[7]

Mansfield often used the words "book", "work", "story", interchangeably. She meant in her last letter from Paris that she was bringing back with her fifty pages of manuscript, which took the story as far as the end of that episode in Chapter II, when Stanley Burnell sits on the stairs with Linda Fairfield after they have danced. When she said she was finished, one must take that as "for the time being".

Back in England, Mansfield was caught up with again shifting house, with Murry's rather sycophantic enthusiasm for D. H. Lawrence (they were planning together the short-lived magazine *The Signature*), and with the pleasure she took in her brother's company. He had received his commission as lieutenant with the South Lancashire Regiment – "The Prince of Wales Volunteers" – and for part of August stayed with his sister at her newly rented house in St John's Wood. At the beginning of October came the severest emotional crisis of her life, when Leslie was killed in a hand-grenade accident near Armentières, a week after crossing to the Front. In mid-November, in the expectation that travel in itself would make life more tolerable, she and Murry settled on Bandol in the South of France. They came back to England at the beginning of April.

In Bandol Mansfield brooded over her grief. Her brother stood as a presence between herself and Murry, and soon after she arrived she noted how "The present and the future mean nothing to me. I am no longer 'curious' about people; I do not wish to go anywhere and the only possible value that anything can have for me is that it should put me in mind of something that happened or was when we were alive."

Through the next couple of months, she wrote nothing apart from letters, and occasionally jotting down memories of Leslie, imaginary conversations, records of her despair – "why don't I commit suicide? Because I feel I have a duty to perform to the lovely time when we were

7. *Letters to John Middleton Murry*, pp. 33, 35, 40.

12

both alive." By January 1916, she understood that if she were to write again, to write so that she both preserved a memory for herself, yet gave it radiance and solidity as a work of art, then she would need to find a new method — "the form that I would choose has changed utterly. I feel no longer concerned with the same appearances of things". She rejected the people of her earlier stories, the plots she had placed them in. "Why should *I* write about them? They are not near me." What she set herself now was "to write recollections of my own country. . . . Oh, I want for one moment to make our undiscovered country leap into the eyes of the old world. It must be mysterious, as though floating – it must take the breath. It must be 'one of those islands . . .' I shall tell everything, even of how the laundry-basket squeaked at '75'. But all must be told with a sense of mystery, a radiance, an afterglow because you, my little sun of it, are set. You have dropped over the dazzling brim of the world. Now I must play my part."

To do quite what she wanted would take something new. "But especially I want to write a kind of long elegy to you . . . perhaps not in poetry. No, perhaps in prose. Almost certainly in a kind of special prose." That was near the end of January. Three weeks later she still had not begun, although constantly she was thinking about their "book". Then in the middle of February she must have gone through the sheaf of manuscript she had put aside for almost eight months.

I found The Aloe *this morning. And when I had reread it I knew I was not quite "right" yesterday. No, dearest, it was not just the spirit. The Aloe is right. The Aloe is lovely. It simply fascinates me, and I know that it is what you would wish me to write. And now I know what the last chapter is. It is your birth – your coming in the autumn. You in Grandmother's arms under the tree. . . . That chapter will end the book. The next book will be yours and mine.* [8]

The Aloe did not develop quite as she supposed, nor did *Prelude* which was drawn from it. With the birth of her brother, she already anticipated an

8. *Journal*, pp. 89, 90, 93, 94, 97-98. 75 Tinakori Road was where the Beauchamp family lived from late 1898 to the middle of 1907.

episode not written until five years later in *At the Bay*. But within a few days she was at work. Over the next three weeks, she filled several exercise books with the story, and just after the middle of March she left it with Kezia tip-toeing from her aunt's room. This was the "completed" story she took back with her to England.

After the quiet satisfactions of their months in Bandol, Mansfield and Murry returned to yet another year in which they almost separated. It was the year too of an abortive effort to live near the Lawrences in Cornwall, of new friendships in Bloomsbury and at Garsington, and then, in February 1917, the decision to take her own studio in Chelsea, with Murry settled separately but within walking distance. She had written very little for almost a year. One cannot say when she once more picked up *The Aloe*, but she must have reworked and typed at least sections of it by early summer. It was then that her new friend Virginia Woolf, looking for copy for the hand press recently set up at Hogarth House, Richmond, told her sister that they had promised to do Katherine Mansfield's story, and Mansfield wrote to Woolf saying "It makes me *very* happy that you liked my little story".[9]

Mansfield delivered the story in August 1917, asked for sections of it back, and let the Hogarth Press have it in its final form by early October. It was Murry who suggested that she call the new version *Prelude*, and she wrote to her friend Dorothy Brett in one of the fullest statements she made about her work:

I threw my darling to the wolves and they ate it up and served me up so much praise in such a golden bowl that I couldn't help feeling gratified. I did not think they would like it at all and I am still astounded that they do. What form is it? you ask. Ah, Brett, it's so difficult to say. As far as I know it's more or less my own invention. And how have I shaped it? This is about as much as I can say about it. You know, if the truth were known I have a perfect passion for the island where I was born. ... Well, in the early morning there I always

9. *The Letters of Virginia Woolf*, edited Nigel Nicolson and Joanne Trautmann, Vol. II, 1972, p. 168; *Adam*, Nos. 370–75, 1972–73, p. 23.

14

remember feeling that this little island has dipped back into the dark blue sea during the night only to rise again at beam of day, all hung with bright spangles and glittering drops – (When you ran over the dewy grass you positively felt that your feet tasted salt.) I tried to catch that moment – with something of its sparkle and its flavour. And just as on those mornings white milky mists rise and uncover some beauty, then smother it again and then again disclose it. I tried to lift that mist from my people and let them be seen and then to hide them again. . . .[10]

Again, Mansfield's mind seems to have leaped forward to *At the Bay*, for that image of mist she uses in writing to Brett becomes the opening of the later story. The enthusiasm of "the wolves", incidentally, may have been a little more muted behind Mansfield's back. Virginia later told Clive Bell that "I only maintain that K.M.'s story has a certain quality as a work of art besides the obvious cleverness, which made it worth printing, and a good deal better than most stories anyhow". Leonard considered "her gifts were those of an intense realist, with a superb sense of ironic humour and fundamental cynicism. She got enmeshed in the streaky sentimentality of Murry and wrote against the grain of her own nature."[11]

The first sheets were printed by November, and by 25 January the job was as far as the beginning of Section V, for on that day Virginia had to make a special trip into Richmond "to discover the right way of spelling Mynah". She believed the book would be out by Easter. But the task of printing a long story on their own hand press became too demanding. As well, Leonard Woolf was heavily engaged in political work against the War, and Virginia busy with her novel *Night and Day* and her constant stream of reviewing. Mansfield, whose ill-health had driven her back to France, heard nothing of the book's progress. She told Lady Ottoline Morrell in March that "I think the Woolves must have eaten the Aloe root and branch or made jam of it". At home again in May, she dined with Virginia – who found

10. *The Letters of Katherine Mansfield*, Vol. I, pp. 83–84.
11. *The Letters of Virginia Woolf*, Vol. II, p. 262; Leonard Woolf, *An Autobiography*, O.U.P. 1980, Vol II, p. 148.

her "marmoreal, as usual" – and reported to Brett that "My poor dear Prelude is still piping away in their little cage and not out yet. I read some pages of it and scarcely knew it again. It all seems so once upon a time. But I am having some notices printed and they say it will be ready by June. And won't the 'Intellectuals' just hate it. They'll think it's a New Primer for Infant Readers. Let 'em."[12]

Virginia Woolf set the last words of the story on 24 June, and two weeks later Leonard printed off the final pages. The first copies were sent out on 10 July 1918.

12. *The Diary of Virginia Woolf*, edited Anne Olivier Bell, Vol. I, p. 112; *The Letters of Katherine Mansfield*, Vol. I, p. 158; *The Diary of Virginia Woolf*, Vol. I, p. 150; *The Letters of Katherine Mansfield*, Vol. I, p. 164.

Textual note

Soon after Mansfield began work on *The Aloe* in Paris in late March 1915, she transcribed a fair copy of the first section onto thin loose sheets of typing paper, intending to post these off to Murry. After twenty-three pages, she changed to sheets from a smaller ruled pad, then sixteen pages later, went back to the paper she had first used. It was this bundle of fifty-one pages that she took back to England with her in the middle of May, and apparently put aside until she read them again in Bandol in February the following year. She then resumed work on the story, in the next few weeks partly filling five school exercise books with the brand name *L'Epatant*, "cahiers de 50 pages", and a sixth, with the commercial name *Massilia* emblazoned beneath a classical female figure on its cover. She completed the spaces left for dates on the covers, and hence we can follow if not quite what she wrote day by day, at least the shape her story took with each successive week. These dates are entered in the margin of the printed text in this edition, at the point where each notebook begins. Particularly in the last notebook begun on March 12, bringing *The Aloe* to its conclusion, there are many pages given to other material – reading notes on Dostoevsky (Murry was writing his study of the Russian novelist at Bandol), the fragment which survives in the *Journal* as "Saunders Lane", notes on her feelings towards both Murry and her brother, and occasional entries which remain indecipherable. A few of her jottings are directly related to the story, and these are reproduced in the notes at the end of the text.

The first pages of the Paris manuscript – as far as p. 45 in the printed text – are clearly a fair copy. After that, in most of the later loose sheets, and

through most of the exercise books, Mansfield is clearly writing "straight off". The purpose of this edition is to give a full and accurate text without making the claims of a facsimile. Mansfield's excisions, false starts, and undecided thoughts are given as correctly as possible, although as always with her manuscripts one makes the covering caveat that her handwriting is very difficult, and in a few places, impossible. Only a very rash editor would claim anything like certainty on her precise use of the comma, the stop, and the dash.

In the following pages, a line ruled through a word, or through a group of words, indicates that Mansfield cancelled these in her manuscript. With most of the text, the occurrence of an indecipherable word or phrase is indicated in square brackets, although with cancelled sections this practice is not followed. Simply to indicate that one could not read part of a scored out passage seemed pedantic. Very occasionally, a word in square brackets indicates an inadvertently omitted word, or one which cannot be read but may reasonably be guessed at.

The paragraphing, spelling (apart from obvious slips of the pen), and capitalisation of the manuscript have been followed throughout. Mansfield's punctuation has been adhered to, with the exception that apostrophes and quotation marks, very often omitted in the run of her first drafts, but invariably added in any final copy, have been added here in the certainty that her own practice is justification, and because to omit them would create a pointless distraction for the reader. By the same argument, ampersands, which were never retained in a fair copy, have been expanded into the conventional "and", while full stops have been provided where, at times, Mansfield omitted them. Very occasionally, one proper name was used when another clearly was intended, and the error has been corrected.

When John Middleton Murry edited *The Aloe* for Constable and Co. in 1930, completing what he felt to be the *oeuvre* of his wife's fiction, he pieced together the various manuscripts with his usual editorial flair. His intention was to make available what could not "fairly be included in the ordinary edition of Katherine Mansfield's work, because it repeats, in a less

perfect form, the material of *Prelude*".¹ But in presenting that longer and original story, Murry also tidied it up. He made hundreds of minor changes and corrections, so that while what he gave the reader may have been Mansfield, it was Mansfield with the stylistic impositions of another hand. The decision now, to print the text as accurately as possible, with its excisions and the wealth of personal touches that the manuscripts contain, is made in the belief that if a reader wishes to know what *Prelude* came from, then it is better that he knows rather more exactly.

Prelude* was published by the Hogarth Press in July 1918, an edition of 300 copies, selling at 3s. 6d. It was a book of 68 pages, 19 × 14½ cm, set in Caslon and bearing the dedication "To L. H. B. and J. M. M." The early pages had been set by Barbara Hiles, a former student at the Slade who now worked for the Press, then mostly by Virginia Woolf, who recorded that her top speed at hand-setting was one page in an hour and a quarter. The book finally was not run off on the hand press at Hogarth House, but at a jobbing printer's in Richmond, with Leonard Woolf himself working the machine.

The book was clearly the work of amateurs, but cleanly done and unpretentious. The Woolfs misnamed the story *The Prelude* in both the heading preceding section 1, and in the running head as far as p. 19. After the first few copies, they removed from the front of the dark blue paper jacket the line block of a woman's head, surrounded by the spiky leaves and the flowers of the aloe (reproduced on p. 16), and from the back cover another head, with the leaves now fallen into rather a Medusa-like severity, which had been designed by Mansfield's friend, the Scottish painter J. D. Fergusson.

No manuscript or typescript of *Prelude* survives, although it seems that as well as the handwritten copy she must have made in quarrying *The Aloe*, Mansfield typed out the story herself, before again having it professionally typed for the Woolfs to work from.

Mansfield later made a few slight corrections to the Hogarth Press text before the story was included in *Bliss and Other Stories*, brought out by

1. *The Aloe*, 1930, p. v.

Constable in 1920. Her erratically spelled "tea cosey" is corrected, "nursery" is replaced by Mrs Samuel Josephs' "dursery", a "notch of wood" is changed to "knot", and Pip's almonds, "shelled" in the earlier printing, are now "skinned". The present text is taken from *Bliss*.

The quotations from letters and notebooks in the Introduction have been checked against the original manuscripts, hence they occasionally differ from the texts in Murry's editions.

Acknowledgements

This edition is possible thanks to permissions from the Newberry Library, Chicago, where the greater part of *The Aloe* manuscript is held, and the Alexander Turnbull Library, Wellington, which owns the *Massilia* notebook with the last section of the text.

I am grateful to Mrs Margaret Scott for reading with me a few portions of the manuscript, and am very particularly indebted to Professor Antony Alpers of Queen's University, Ontario, always as generous as he is informed.

The Aloe and Prelude

There was not an inch of room for Lottie and Kezia in the buggy. When Pat swung them on top of the luggage they wobbled; the grandmother's lap was full and Linda Burnell could not possibly have held a lump of a child on hers for any distance. Isabel, very superior, was perched beside the new handy-man on the driver's seat. Hold-alls, bags and boxes were piled upon the floor. "These are absolute necessities that I will not let out of my sight for one instant," said Linda Burnell, her voice trembling with fatigue and excitement.

Lottie and Kezia stood on the patch of lawn just inside the gate all ready for the fray in their coats with brass anchor buttons and little round caps with battleship ribbons. Hand in hand, they stared with round solemn eyes, first at the absolute necessities and then at their mother.

"We shall simply have to leave them. That is all. We shall simply have to cast them off," said Linda Burnell. A strange little laugh flew from her lips; she leaned back against the buttoned leather cushions and shut her eyes, her lips trembling with laughter. Happily at that moment Mrs. Samuel Josephs, who had been watching the scene from behind her drawing-room blind, waddled down the garden path.

"Why nod leave the chudren with be for the afterdoon, Brs. Burnell? They could go on the dray with the storeban when he comes in the eveding. Those thigs on the path have to go, dod't they?"

"Yes, everything outside the house is supposed to go," said Linda Burnell, and she waved a white hand at the tables and chairs standing on their heads on the front lawn. How absurd they looked! Either they ought to be the other way up, or Lottie and Kezia ought to stand on their heads, too. And she longed to say: "Stand on your heads, children, and wait for the storeman." It seemed to her that would be so exquisitely funny that she could not attend to Mrs. Samuel Josephs.

The fat creaking body leaned across the gate, and the big jelly of a face smiled. "Dod't you worry, Brs. Burnell. Loddie and Kezia can have tea with by chudren in the dursery, and I'll see theb on the dray afterwards."

Chapter One

There was not an inch of room for Lottie and Kezia in the buggy. When Pat swung them on top of the luggage they wobbled; the Grandmother's lap was full and ~~Mrs.~~ Linda Burnell could *not possibly* have held a lump of a child on hers for such a distance. Isabel, very superior perched beside Pat on the driver's seat. Hold-alls, bags and band boxes were piled upon the floor.[1]

"These are *absolute* necessities that I will not let out of my sight for *one instant*," said ~~Mrs.~~ Linda Burnell, her voice trembling with fatigue and over excitement.

Lottie and Kezia stood on the patch of lawn just inside the gate all ready for the fray in their reefer coats with brass anchor buttons and little round caps with battle ship ribbons. Hand in hand. They stared with round inquiring eyes first at the "absolute necessities" and then at their Mother.

"We shall simply have to leave them. That is all. We shall simply have to cast them off" said ~~Mrs.~~ Linda Burnell. A strange little laugh flew from her lips; she leaned back upon the buttoned leather cushions and shut her eyes . . . laughing silently.

Happily, at that moment, Mrs. Samuel Josephs, who lived next door and had been watching the scene from behind her drawing room blind, rustled down the garden path.

"Why nod leave the children with *be* for the afterdoon, Brs. Burnell. They could go on the dray with the storeban when he comes in the eveding. Those thigs on the path have to go. Dodn't they?"

"Yes, everything outside the house has to go," said ~~Mrs.~~ Linda Burnell, waving a white hand at the tables and chairs that stood, impudently, on their heads in front of the empty house.

"Well, dodn't you worry, Brs. Burnell. Loddie and Kezia can have tea with by children and I'll see them safely on the dray afterwards."

She leaned her fat, creaking body across the gate and smiled reassuringly. ~~Mrs.~~ Linda Burnell pretended to consider.

The grandmother considered. "Yes, it really is quite the best plan. We are very obliged to you, Mrs. Samuel Josephs. Children, say 'thank you' to Mrs Samuel Josephs."

Two subdued chirrups: "Thank you, Mrs. Samuel Josephs."

"And be good little girls, and — come closer — " they advanced, "don't forget to tell Mrs. Samuel Josephs when you want to . . ."

"No, granma."

"Dod't worry, Brs. Burnell."

At the last moment Kezia let go Lottie's hand and darted towards the buggy.

"I want to kiss my granma good-bye again."

But she was too late. The buggy rolled off up the road, Isabel bursting with pride, her nose turned up at all the world, Linda Burnell prostrated, and the grandmother rummaging among the very curious oddments she had had put in her black silk reticule at the last moment, for something to give her daughter. The buggy twinkled away in the sunlight and fine golden dust up the hill and over. Kezia bit her lip, but Lottie, carefully finding her handkerchief first, set up a wail.

"Mother! Granma!"

Mrs. Samuel Josephs, like a huge warm black silk tea-cosy, enveloped her.

"It's all right, by dear Be a brave child. You come and blay in the dursery!" She put her arm round weeping Lottie and led her away. Kezia followed, making a face at Mrs. Samuel Josephs' placket which was undone as usual, with two long pink corset laces hanging out of it

24

"Yes, it really is quite the best plan. I am *extremely* obliged to you, Mrs. *The Aloe*
Samuel Josephs, I'm *sure*. Children, say 'Thank you' to Mrs. Samuel
Josephs." . .

(Two subdued chirrups: "Thank you, Mrs. Samuel Josephs.")

"And be good obedient little girls and – come closer – " – they
advanced – "do not forget to tell Mrs. Samuel Josephs when you want
to". . .

"Yes, Mother."

"Dodn't worry, Brs. Burnell."

At the last moment Kezia let go Lottie's hand and darted towards the
buggy.

"I want to kiss Grandma 'good-bye' again." Her heart was bursting.

"Oh, *dear* me!" wailed ~~Mrs.~~ Linda Burnell.

But the grandmother leant her charming head in the lilac flowery
bonnet towards Kezia and when Kezia searched her face she said – "It's
alright, my darling. Be good." The buggy rolled off up the road, Isabel,
proudly sitting by Pat, her nose turned up at all the world, ~~Mrs.~~ Linda
Burnell, prostrate, and crying behind her veil, and the Grandmother
rumminaging among the curious oddments she had put in her black silk
reticule at the last moment for lavender smelling salts to give her
daughter.

The buggy twinkled away in the sunlight and fine golden dust – up the
hill and over. Kezia bit her lip hard, but Lottie, carefully finding her
handkerchief first, set up a howl.

"Mo-ther! Gran'*ma!*"

Mrs. Samuel Josephs, like an animated black silk tea-cosey, waddled to
Lottie's rescue.

"It's alright, by dear. There-there, ducky! Be a brave child. You come
and blay in the nursery."

She put her arm round weeping Lottie and led her away. Kezia
followed, making a face at Mrs. Samuel Josephs' placket, which was
undone *as* usual with two long pink corset laces hanging out of it.

25

Lottie's weeping died down as she mounted the stairs, but the sight of her at the nursery door with swollen eyes and a blob of a nose gave great satisfaction to the S. J.'s, who sat on two benches before a long table covered with American cloth and set out with immense plates of bread and dripping and two brown jugs that faintly steamed.

"Hullo! You've been crying!"

"Ooh! Your eyes have gone right in."

"Doesn't her nose look funny."

"You're all red-and-patchy."

Lottie was quite a success. She felt it and swelled, smiling timidly.

The Samuel Josephs were not a family. They were a swarm. The moment you entered the house they cropped up and jumped out at you from under the tables, through the stair rails, behind the doors, behind the coats in the passage. Impossible to count them: impossible to distinguish between them. Even in the family groups that Mrs. Samuel Josephs caused to be taken twice yearly – herself and Samuel in the middle – Samuel with parchment roll clenched on knee and she with the youngest girl on hers – you never could be sure how many children really were there. You counted them and then you saw another head or another small boy in a white sailor suit perched on the arm of a basket chair. All the girls were fat, with black hair tied up in red ribbons and eyes like buttons. The little ones had scarlet faces but the big ones were white with blackheads and dawning moustaches. The boys had the same jetty hair, the same button eyes but they were further ~~ornamented~~ adorned with ink black finger nails. (The girls bit theirs, so the black didn't show.) And every single one of them started a pitched battle as soon as possible after birth with every single other.

When Mrs. Samuel Josephs was not turning up their clothes or down their clothes (as the sex might be) and beating them with a hair brush she called this pitched battle "airing their lungs". She seemed to take a pride in it and to bask in it from far away like a fat General watching through field glasses his troops in violent action . .

Lottie's weeping died down as she ascended the Samuel Josephs' stairs, but the sight of her at the nursery door with swollen eyes and a blob of a nose gave great satisfaction to the little S.J.'s, who sat on two benches before a long table covered with american cloth and set out with immense platters of bread and dripping and two brown jugs that faintly steamed.

"Hullo! You've been crying!"

"Ooh! Your eyes have gone right in!"

"Doesn't her nose look funny!"

"You're all red-an'-patchy!"

Lottie was quite a success. She felt it and swelled, smiling timidly.

"Go and sid by Zaidee, ducky," said Mrs. Samuel Josephs, "and Kezia, you sid ad the end by Boses."

Moses grinned and gave her a nip as she sat down; but she pretended not to notice. She did hate boys.

"Which will you have?" asked Stanley, leaning across the table very politely, and smiling at her. "Which will you have to begin with – strawberries and cream or bread and dripping?"

"Strawberries and cream, please," said she.

"Ah-h-h-h." How they all laughed and beat the table with their teaspoons. Wasn't that a take-in! Wasn't it now! Didn't he fox her! Good old Stan!

"Ma! She thought it was real."

Even Mrs. Samuel Josephs, pouring out the milk and water, could not help smiling. "You bustn't tease theb on their last day," she wheezed.

But Kezia bit a big piece out of her bread and dripping, and then stood the piece up on her plate. With the bite out it made a dear little sort of a gate. Pooh! She didn't care! A tear rolled down her cheek, but she wasn't crying. She couldn't have cried in front of those awful Samuel Josephs. She sat with her head bent, and as the tear dripped slowly down, she caught it with a neat little whisk of her tongue and ate it before any of them had seen.

"Go and sit by Zaidee, ducky," said Mrs. Samuel Josephs, "and Kezia –
you sit at the end by Boses."

Moses grinned and pinched her behind as she sat down but she
pretended to take no notice. She did hate boys!

"Which will you have," asked Stanley, (a big one,) leaning across the
table very politely and smiling at Kezia. "Which will you have to begin
with – Strawberries and cream or bread and dripping?"

"Strawberries and cream, please," said she.

"Ah-h-h!" How they all laughed and beat the table with their tea
spoons. Wasn't that a take in! Wasn't it! Wasn't it now! Didn't he fox her!
Good old Stan!

"Ma! She thought it was real!"

Even Mrs. Samuel Josephs, pouring out the milk and water, smiled
indulgently. It was a merry tea.

After tea the young Samuel Josephs were turned out to grass until
summoned to bed by their servant girl standing in the yard and banging on
a tin tray with a potato masher.

"Know what we'll do," said Miriam. "Let's go an play hide-an-seek all
over Burnells. Their back door is still open because they haven't got the
side board out yet. I heard Ma tell Glad Eyes *she* wouldn't take such ole
rubbish to a new house! Come on! Come on!"

"No, I don't want to," said Kezia, shaking her head.

"Ooh! Don't be soft. Come on – do!"

Miriam caught hold of one of her hands; Zaidee snatched at the other.

"I don't not want to either, if Kezia doesn't," said Lottie, standing firm.
But she, too, was whirled away . . Now the whole fun of the game for the
S.J.s was that the Burnell kids didn't want to play. In the yard they paused.
Burnells' yard was small and square with flower beds on either side. All
down one side big clumps of arum lilies aired their rich beauty, on the
other side there was nothing but a straggle of what the children called
"grandmother's pin cushions", a dull, pinkish flower, but so strong it
would push its way and grow through a crack of concrete.

29

Prelude

30

"You've only got one w. at your place," said Miriam scornfully. "We've got two at ours. One for men and one for ladies. The one for men hasn't got a seat."

"Hasn't got a seat!" cried Kezia. "I *don't* believe you."

"It's-true-it's-true-it's-true! Isn't it Zaidee?" And Miriam began to dance and hop showing her flannelette drawers.

"Course it is," said Zaidee. "Well, you *are* a baby, Kezia!"

"I don't not believe it either if Kezia doesn't," said Lottie, after a pause.

But they never paid any attention to what Lottie said. Alice Samuel Josephs tugged at a lily leaf, twisted it off, turned it over. It was covered on the under side with tiny blue and grey snails.

"How much does your Pa give you for collecting snails," she demanded.

"Nothing!" said Kezia.

"Reely! Doesn't he give you anything? Our Pa gives us ha'penny a hundred. We put them in a bucket with salt and they all go bubbly like spittle. Don't you get any pocket money?"

"Yes, I get a penny for having my hair washed," said Kezia.

"An' a penny a tooth," said Lottie, softly.

"My! Is that *all*! One day Stanley took the money out of all our money boxes and Pa was so mad he rang up the police station."

"No, he didn't. Not reely," said Zaidee. "He only took the telephone down an spoke in it to frighten Stan."

"Ooh, you fibber! Ooh, you are a fibber," screamed Alice, feeling her story totter. "But Stan was so frightened he caught hold of Pa and screamed and bit him and then he lay on the floor and banged with his head as hard as ever."

"Yes," said Alice Zaidee, warming. "And at dinner when the door bell rang an' Pa said to Stan – 'There they are – they've come for you – ' do you know what Stan did?" Her button eyes snapped with joy. "He was sick – all over the table!"

"How perfeckly *horrid*," said Kezia, but even as she spoke she had one of her "ideas". It frightened her so that her knees trembled but it made

31

II After tea Kezia wandered back to their own house. Slowly she walked up the back steps, and through the scullery into the kitchen. Nothing was left in it but a lump of gritty yellow soap in one corner of the kitchen window-sill and a piece of flannel stained with a blue bag in another. The fire-place was choked up with rubbish. She poked among it but found nothing except a hair-tidy with a heart painted on it that had belonged to the servant girl. Even that she left lying, and she trailed through the narrow

her so happy she nearly screamed aloud with joy.

"Know a new game," said she. "All of you stand in a row and each person holds a narum lily head. I count one – two – three and when 'three' comes all of you have to bite out the yellow bit and scrunch it up – and who swallows first – wins."

The Samuel Josephs suspected nothing. They liked the game. A game where something had to be destroyed always fetched them. Savagely they broke off the big white blooms and stood in a row before Kezia.

"Lottie can't play," said Kezia.

But any way it didn't matter. Lottie was still patiently bending a lily head this way and that – it would not come off the stem for her.

"One – two – three," said Kezia.

She flung up her hands with joy as the Samuel Josephs bit, chewed, made dreadful faces, spat, screamed, and rushed to Burnells' garden tap. But that was no good – only a trickle came out. Away they sped, yelling.

"Ma! Ma! Kezia's poisoned us."

"Ma! Ma! Me tongue's burning off."

"Ma! Ooh, Ma!"

"Whatever *is* the matter," asked Lottie, mildly, still twisting the frayed, oozing stem. "Kin I bite my lily off like this, Kezia?"

"No, silly." Kezia caught her hand. "It burns your tongue like anything."

"Is that why they all ran away," said Lottie. She did not wait for an answer. She drifted to the front of the house and began to dust the chair legs on the lawn with a corner of her pinafore.

Kezia felt very pleased. Slowly she walked up the back steps and through the scullery into the kitchen. Nothing was left in it except a lump of gritty yellow soap in one corner of the window sill and a piece of flannel stained with a blue bag in another. The fire place was choked with a litter of rubbish. She poked among it for treasure but found nothing except a hair tidy with a heart painted on it that had belonged to the servant girl. Even that she left lying, and she slipped through the narrow passage into the

passage into the drawing-room. The Venetian blind was pulled down but not drawn close. Long pencil rays of sunlight shone through and the wavy shadow of a bush outside danced on the gold lines. Now it was still, now it began to flutter again, and now it came almost as far as her feet. Zoom! Zoom! a blue-bottle knocked against the ceiling; the carpet-tacks had little bits of red fluff sticking to them.

The dining-room window had a square of coloured glass at each corner. One was blue and one was yellow. Kezia bent down to have one more look at a blue lawn with blue arum lilies growing at the gate, and then at a yellow lawn with yellow lilies and a yellow fence. As she looked a little Chinese Lottie came out on to the lawn and began to dust the tables and chairs with a corner of her pinafore. Was that really Lottie? Kezia was not quite sure until she had looked through the ordinary window.

Upstairs in her father's and mother's room she found a pill box black and shiny outside and red in, holding a blob of cotton wool.

"I could keep a bird's egg in that," she decided.

In the servant girl's room there was a stay-button stuck in a crack of the floor, and in another crack some beads and a long needle. She knew there was nothing in her grandmother's room; she had watched her pack. She went over to the window and leaned against it, pressing her hands against the pane.

Kezia liked to stand so before the window. She liked the feeling of the cold shining glass against her hot palms, and she liked to watch the funny white tops that came on her fingers when she pressed them hard against the pane. As she stood there, the day flickered out and dark came. With

drawing room. The venetian blind was pulled down but not drawn close.
Sunlight, piercing the green chinks, shone once again upon the purple
urns brimming over with yellow chrysanthemums that patterned the
walls – The hideous box was quite bare, so was the dining room except
for the side board that stood in the middle, forlorn, its shelves edged with
a scallop of black leather. But this room had a "funny" smell. Kezia lifted
her head and sniffed again, to remember. Silent as a kitten she crept up
the ladderlike stairs ~~into.~~ In Mr. and Mrs. Burnell's room she found a pill
box, black and shiny outside and red in, holding a blob of cotton wool.
"I could keep a bird's egg in that," she decided. The only other room in
the house (the little tin bathroom did not count) was *their* room where
Isabel and Lottie had slept in one bed and she and Grandma in another.
She knew there was nothing there – she had watched Grandma pack –
Oh, yes, there was! A stay button stuck in a crack of the floor and in
another crack some beads and a long needle. She went over to the
window and leaned against it pressing her hands against the pane.

From the window you saw beyond the yard a deep gully filled with
tree ferns and a thick tangle of wild green, and beyond that there
stretched the esplanade bounded ~~with~~ by a broad stone wall against
which the sea chafed and thundered. (Kezia had been born in that room.
She had come forth squealing out of a reluctant mother in the teeth of a
"Southerly Buster". The Grandmother, shaking her before the window
had seen the sea rise in green mountains and sweep the esplanade – The
little house was like a shell to its loud booming. Down in the gully the wild
trees lashed together and big gulls wheeling and crying skimmed past the
misty window.)
~~No wonder Kezia squealed!~~

Kezia liked to stand so before the window. She liked the feeling of the
cold shining glass against her hot little palms and she liked to watch the
funny white tops that came on her fingers when she pressed them hard
against the pane –

As she stood the day flickered out and sombre dusk entered the empty

the dark crept the wind snuffling and howling. The windows of the empty house shook, a creaking came from the walls and floors, a piece of loose iron on the roof banged forlornly. Kezia was suddenly quite, quite still, with wide open eyes and knees pressed together. She was frightened. She wanted to call Lottie and to go on calling all the while she ran downstairs and out of the house. But IT was just behind her, waiting at the door, at the head of the stairs, at the bottom of the stairs, hiding in the passage, ready to dart out at the back door. But Lottie was at the back door, too.

"Kezia!" she called cheerfully. "The storeman's here. Everything is on the dray and three horses, Kezia. Mrs. Samuel Josephs has given us a big shawl to wear round us, and she says to button up your coat. She won't come out because of asthma."

Lottie was very important.

"Now then, you kids," called the storeman. He hooked his big thumbs under their arms and up they swung. Lottie arranged the shawl "most beautifully" and the storeman tucked up their feet in a piece of old blanket.

"Lift up. Easy does it."

house, thievish dusk stealing the shapes of things, sly dusk painting the
shadows. At her heels crept the wind, snuffling and howling. The
windows shook – a creaking came from the walls and floors, a piece of
loose iron on the roof banged forlornly – Kezia did not notice these things
severally but she was suddenly quite, quite still with wide open eyes and
knees pressed together – terribly frightened. Her old bogey, the dark,
had overtaken her, and now there was no lighted room to make a
despairing dash for – useless to call "Grandma" – useless to wait for the
servant girl's cheerful stumping up the stairs to pull down the blinds and
light the bracket lamp . . There was only Lottie in the garden. If she began
to call Lottie *now* and went on calling her loudly all the while she flew
down stairs and out of the house she might escape from *It* in time – escape
from exactly what? . . It was round like the sun. It had a face. *It* smiled, but
It had no eyes. *It* was yellow. When she was put to bed with two drops of
aconite in the medicine glass *It* breathed very loudly and firmly and *It* had
been known on certain particularly fearful occasions to turn round and
round. *It* hung in the air. That was all she knew and even that much had
been very difficult to explain to the Grandmother. Nearer came the
terror and more plain to feel the "silly" smile. She snatched her hands
from the window pane, opened her mouth to call Lottie, and fancied that
she did call loudly, though she made no sound . . . *It* was at the top of the
stairs; *It* was at the bottom of the stairs, waiting in the little dark passage,
guarding the back door – But Lottie was at the back door, too.

"Oh, there you are," she said cheerfully. "The storeman's here.
Everything's on the dray – and *three* horses, Kezia – Mrs. Samuel Josephs
has given us a big shawl to wear round us, and she says button up your
coat. She won't come out because of asthma, and she says 'never do it
again' " – Lottie was very important –

"Now then, you kids," called the storeman. He hooked his big thumbs
under their arms. Up they swung. Lottie arranged the shawl "most
beautifully", and the storeman tucked up their feet in a piece of old
blanket.

"*Lift* up – Easy does it – " They might have been a couple of young

37

They might have been a couple of young ponies. The storeman felt over the cords holding his load, unhooked the brake-chain from the wheel, and whistling, he swung up beside them.

"Keep close to me," said Lottie, "because otherwise you pull the shawl away from my side, Kezia."

But Kezia edged up to the storeman. He towered beside her big as a giant and he smelled of nuts and new wooden boxes.

III It was the first time that Lottie and Kezia had ever been out so late. Everything looked different—the painted wooden houses far smaller than they did by day, the gardens far bigger and wilder. Bright stars speckled the sky and the moon hung over the harbour dabbling the waves with gold. They could see the lighthouse shining on Quarantine Island, and the green lights on the old coal hulks.

"There comes the Picton boat," said the storeman, pointing to a little steamer all hung with bright beads.

But when they reached the top of the hill and began to go down the other side the harbour disappeared, and although they were still in the town they were quite lost. Other carts rattled past. Everybody knew the storeman.

"Night, Fred."

"Night O," he shouted.

Kezia liked very much to hear him. Whenever a cart appeared in the distance she looked up and waited for his voice. He was an old friend; and she and her grandmother had often been to his place to buy grapes. The storeman lived alone in a cottage that had a glasshouse against one wall built by himself. All the glasshouse was spanned and arched over with one beautiful vine. He took her brown basket from her, lined it with three large leaves, and then he felt in his belt for a little horn knife, reached up and

ponies.

The store man felt over the cords holding his load, unhooked the brake chain from the wheel, and whistling, he swung up beside them.

"Keep close to *me*" said Lottie, "because otherwise you pull the shawl away from my side, Kezia."

But Kezia edged up to the storeman – He towered up, big as a giant, and he smelled of nuts and wooden boxes.

Chapter II

It was the first time that Lottie and Kezia had ever been ~~out of~~ out so late. Everything looked different – the painted wooden houses much smaller than they did by day, the trees and the gardens far bigger and wilder. Bright stars speckled the sky and the moon hung over the harbour dabbling the waves with gold. They could see the light house shining from Quarantine Island, the green lights fore and aft the old black coal hulks ~~that lived in the harbour~~ –

"There comes the Picton boat," said the store man, pointing with his whip to a little steamer all hung with bright beads.

But when they reached the top of the hill and began to go down the other side, the harbour disappeared and although they were still in the town they were quite lost. Other carts rattled past. Everybody knew the storeman.

"Night, Fred!"

"Night-O!" he shouted.

Kezia liked very much to hear him. Whenever a cart appeared in the distance she looked up and waited for his voice. In fact she liked him altogether; he was an old friend; she and the grandmother had often been to his place to buy grapes. The storeman lived alone in a cottage with a glass house that he had built himself leaning against it. All the glasshouse was spanned and arched over with one beautiful vine. He took her brown basket from her, lined it with three large leaves and then he felt in his belt for a little horn knife, reached up and snipped off a big blue cluster and laid

snapped off a big blue cluster and laid it on the leaves so tenderly that Kezia held her breath to watch. He was a very big man. He wore brown velvet trousers, and he had a long brown beard. But he never wore a collar, not even on Sunday. The back of his neck was burnt bright red.

"Where are we now?" Every few minutes one of the children asked him the question.

"Why, this is Hawk Street, or Charlotte Crescent."

"Of course it is," Lottie pricked up her ears at the last name; she always felt that Charlotte Crescent belonged specially to her. Very few people had streets with the same name as theirs.

"Look, Kezia, there is Charlotte Crescent. Doesn't it look different?" Now everything familiar was left behind. Now the big dray rattled into unknown country, along new roads with high clay banks on either side, up steep, steep hills, down into bushy valleys, through wide shallow rivers. Further and further. Lottie's head wagged; she drooped, she slipped half into Kezia's lap and lay there. But Kezia could not open her eyes wide enough. The wind blew and she shivered; but her cheeks and ears burned.

"Do stars ever blow about?" she asked.

"Not to notice," said the storeman.

"We've got a nuncle and a naunt living near our new house," said Kezia. "They have got two children, Pip, the eldest is called, and the youngest's

it on the leaves as tenderly as you might put a doll to bed. He was a very _The Aloe_
big man. He wore brown velvet trousers and he had a long brown beard,
but he never wore a collar – not even on Sundays. The back of his neck
was dark red.

"Where are we now?" Every few minutes one of the children asked him
the question, and he was patient –
 "Why! this is Hawstone Street," or "Hill Street" or "Charlotte
Crescent" –
 "Of course it is." Lottie pricked up her ears at the last name; she
always felt that Charlotte Crescent belonged specially to her. Very few
people had streets with the same name as theirs –
 "Look, Kezia! There is Charlotte Crescent. Doesn't it look different."
They reached their last boundary marks – the fire alarm station – a little
wooden affair painted red and sheltering a huge bell – and the white gates
of the Botanical Gardens, gleaming in the moonlight. Now everything
familiar was left behind; now the big dray rattled into unknown country,
along the new roads with high clay banks on either side, up the steep,
towering hills, down into valleys where the bush drew back on either side
just enough to let them past, through a wide shallow river – the ~~riv~~ horses
pulled up to drink – and made a rare scramble at starting again – on and on
– further and further. Lottie drooped; her head wagged – she slipped half
onto Kezia's lap and lay there. But Kezia could not open her eyes wide
enough. The wind blew on them; she shivered but her cheeks and her
ears burned. She looked up at the stars.
 "Do stars ever blow about?" she asked.
 "Well, I never _noticed_ 'em," said the storeman.
 Came a thin scatter of lights and the shape of a tin Church, rising out of
a ring of tombstones.
 "They call this place we're coming to – 'The Flats'," said the storeman.
 "We got a nuncle and a naunt living near here," said Kezia – "Aunt
~~Bessie~~ Doady and Uncle ~~Stanley~~ Dick. They've got two children, ~~Laurie~~
Pip, the eldest is called and the youngest's name is Rags. He's got a ram.

41

name is Rags. He's got a ram. He has to feed it with a nenamuel teapot and a glove top over the spout. He's going to show us. What is the difference between a ram and a sheep?"

"Well, a ram has horns and runs for you."

Kezia considered. "I don't want to see it frightfully," she said. "I hate rushing animals like dogs and parrots. I often dream that animals rush at me — even camels — and while they are rushing, their heads swell e-enormous."

The storeman said nothing. Kezia peered up at him, screwing up her eyes. Then she put her finger out and stroked his sleeve; it felt hairy. "Are we near?" she asked.

"Not far off, now," answered the storeman. "Getting tired?"

He has to feed it with a nenamel saucepan teapot and a glove top over the
spout. He's going to show us. What is the difference between a ram and a
sheep."

"Well, a ram has got horns and it goes for you."

Kezia considered.

"I don't want to see it *fright*fully," she said. "I hate *rushing* animals like
dogs and parrots – don't you? I often dream that animals rush at me –
even camels, and while they're rushing, their heads swell – e-normous!"

"My word!" said the storeman.

A very bright little place shone ahead of them and in front of it was
gathered a collection of traps and carts. As they drew near some one ran
out of the bright place and stood in the middle of the road, waving his
apron –

"Going to Mr. Burnell's," shouted the some one.

"That's right," said Fred and drew rein.

"Well I got a passel for them in the store. Come inside half a jiffy – will
you?"

"We-ell! I got a couple of little kids along with me," said Fred. But
the storeman some one had already darted back, across his verandah and
through the glass door. The storeman muttered something about
"stretching their legs" and swung off the dray.

"Where *are* we," said Lottie, raising up. The bright light from the shop
window shone over the little girls, Lottie's reefer cap was all on one side
and on her cheek there was the print of an anchor button she had pressed
against while sleeping. Tenderly the storeman lifted her, set her cap
straight and pulled down her crumpled clothes. She stood, blinking on the
verandah, watching Kezia who seemed to come flying through the air to
her feet. Into the warm smoky shop they went – Kezia and Lottie sat on
two barrels, their legs dangling.

"Ma," shouted the man in the apron. He leaned over the counter.
"Name of Tubb!" he said, shaking hands with Fred. "Ma!" he bawled.
"Gotter couple of young ladies here." Came a wheeze from behind a
curtain. "Arf a mo, dearie."

Prelude

44

Everything was in that shop. Bluchers and sand shoes, straw hats and
onions were strung across the ceiling, mixed with bunches of cans and tin
teapots and broom heads and brushes. There were bins and canisters
against the walls and shelves of pickles and jams and things in tins. One
corner was fitted up as drapers – you could smell the rolls of flannelette
and one as a chemist's with cards of rubber dummies and jars of worm
chocolate. One barrel brimmed with apples – one had a tap and a bowl
under it half full of mollasses, a third was stained deep red inside and a
wooden ladle with a crimson handle was balanced across it. It held
raspberries. And every spare inch of space was covered with a fly paper
or an advertisement. Sitting on stools or boxes, or lounging against things
a collection of big untidy men yarned and smoked. One, very old one with
a dirty beard sat with his back half turned to the other, chewing tobacco
and spitting a long distance into a huge round spitoon pepered with
sawdust – After he had spat he combed his beard with a shaking hand.
"We-ell! that's how it is!" or – "that's 'ow it 'appens" – or "there
you've got it, yer see," he would mutter quaver. But nobody paid any
attention to him but Mr. Tubb who cocked an occasional eye and roared
"now, then Father" – And then the combing hand would be curved over
the ear, and the silly face tighten screw up – "Ay?" to droop again and
again start chewing.

From the store the road completely changed – very slowly, twisting as if
loath to go, turning as if shy to follow it slipped into a deep valley. In front
and on either side there were paddocks and beyond them the bush
covered hills thrust up into the moonlit air were like dark heaving water
– you could not imagine that the road led beyond the valley. Here it
seemed to reach its perfect end – the valley knotted upon the bend of the
road like a big jade tassel –
 "Can we see the house from here the house from here" – piped the
children. Houses were to be seen – little houses – they counted three –
but not their house. The storeman knew – He had made the journey
twice before that day – then At last he raised his whip and pointed.

"Well, I'm not an atom bit sleepy," said Kezia. "But my eyes keep curling up in such a funny sort of way." She gave a long sigh, and to stop her eyes from curling she shut them. . . . When she opened them again they were clanking through a drive that cut through the garden like a whip-lash, looping suddenly an island of green, and behind the island, but out of sight until you came upon it, was the house. It was long and low built, with a pillared veranda and balcony all the way round. The soft white bulk of it lay stretched upon the green garden like a sleeping beast. And now one and now another of the windows leaped into light. Someone was walking through the empty rooms carrying a lamp. From the window downstairs the light of a fire flickered. A strange beautiful excitement seemed to stream from the house in quivering ripples.

"Where are we?" said Lottie, sitting up. Her reefer cap was all on one side and on her cheek there was the print of an anchor button she had pressed against while sleeping. Tenderly the storeman lifted her, set her cap straight, and pulled down her crumpled clothes. She stood blinking on the lowest veranda step watching Kezia, who seemed to come flying through the air to her feet.

"Ooh!" cried Kezia, flinging up her arms. The grandmother came out of the dark hall carrying a little lamp. She was smiling.

"You found your way in the dark?" said she.

"Perfectly well."

But Lottie staggered on the lowest verandah step like a bird fallen out of the nest. If she stood still for a moment she fell asleep; if she leaned against anything her eyes closed. She could not walk another step.

"Kezia," said the grandmother, "can I trust you to carry the lamp?"

"That's one of your paddocks belonging," he said "and the next and the next" – over the edge of the last paddock ~~spilled~~ pushed tree boughs and bushes from an immense garden –

A corrugated iron fence painted white held back the garden from the road – In the middle there was a ~~big~~ gap – the iron gates were open wide – They clanked through up a drive cutting through the garden like a whip lash, looping suddenly an island of green and ~~a lawn~~ behind the island out of sight until you came upon it was the house. It was long and ~~white~~ low built with a pillared verandah and balcony running all the way round – shallow steps led to the door – The soft white bulk of it lay stretched upon the green garden like a sleeping beast – and now one and now another of the windows leaped into light – Some one was walking through the empty rooms carrying a lighted candle. From a window downstairs the ~~fire~~ light of a fire ~~leaped and~~ flickered – a strange beautiful excitement seemed to stream from the house in quivering ripples. ~~Over~~ its roofs the verandah poles, the window sashes ~~The~~ moon swung her ~~silver~~ lantern.

"Ooh" ~~cried Kezia flinging~~ Kezia flung out her arms – The Grandmother had appeared on the top step – she carried a little lamp – ~~in her big white shawl she was like a moth~~ – she was smiling. "Has this house got a name" – asked Kezia fluttering for the last time out of the storeman's ~~arms~~ hands.

"Yes," said the Grandmother, "it is called Tarana." "Tarana" she repeated and put her hands upon the big glass door knob.

"Stay where you are one moment children." The Grandmother turned to the storeman. "Fred – these things can be unloaded and left on the verandah for the night. Pat will help you" – She turned and called into the hollow hall – "Pat are you there" – "I *am*" came a voice, and the irish handy man squeaked in new boots over the bare boards. But Lottie staggered over the verandah like a bird fallen out of a nest – ~~She even~~ If she stood still for a moment ~~she fell fast asleep~~ her eyes closed – if she leaned – she fell asleep ~~too.~~ She could not walk another step – "Kezia" said the Grandmother "can I trust you to carry the lamp." "Yes, my

47

"Yes, my granma."

The old woman bent down and gave the bright breathing thing into her hands and then she caught up drunken Lottie. "This way."

Through a square hall filled with bales and hundreds of parrots (but the parrots were only on the wall-paper) down a narrow passage where the parrots persisted in flying past Kezia with her lamp.

"Be very quiet," warned the grandmother, putting down Lottie and opening the dining-room door. "Poor little mother has got such a headache."

Linda Burnell, in a long cane chair, with her feet on a hassock and a plaid over her knees, lay before a crackling fire. Burnell and Beryl sat at the table in the middle of the room eating a dish of fried chops and drinking tea out of a brown china teapot. Over the back of her mother's chair leaned Isabel. She had a comb in her fingers and in a gentle absorbed fashion she was combing the curls from her mother's forehead. Outside the pool of lamp and firelight the room stretched dark and bare to the hollow windows.

"Are those the children?" But Linda did not really care; she did not even open her eyes to see.

"Put down the lamp, Kezia," said Aunt Beryl, "or we shall have the house on fire before we are out of the packing cases. More tea, Stanley?"

"Well, you might just give me five-eighths of a cup," said Burnell, leaning across the table. "Have another chop, Beryl. Tip-top meat isn't it? Not too lean and not too fat." He turned to his wife. "You're sure you won't change your mind, Linda darling?"

"The very thought of it is enough." She raised one eyebrow in the way she had. The grandmother brought the children bread and milk and they sat up to table, flushed and sleepy behind the wavy steam.

"I had meat for my supper," said Isabel, still combing gently.

"I had a whole chop for my supper, the bone and all and Worcester sauce. Didn't I, father?"

"Oh, don't boast, Isabel," said Aunt Beryl.

Grandma" – The old woman knelt and gave the bright breathing thing into her hands and then she raised herself and caught up Lottie. "This way" – Through a square hall filled with furniture bales and hundreds of parrots (but the parrots were only on the wallpaper) down a narrow passage where the parrots persisted on either side walked Kezia with her lamp.

"You are to have some supper before you go to bed" said the Grandmother standing putting down Lottie and to open the dining room door – "Be very quiet," she warned – "poor little mother has got such a headache."

Mrs. Linda Burnell lay to the side before a crackling fire in a long cane chair her feet on a hassock a plaid rug over her knees – Burnell and Beryl, Mrs. Burnell's sister, sat at a table in the middle of the room eating a dish of fried chops and drinking tea out of a brown china tea pot – Over the back of her Mother's chair leaned Isabel – She had a white comb in her fingers and in a gentle absorbed way she was combing back the curls from her Mother's forehead – Outside the pool of lamp and firelight the room stretched dark and bare to the hollow windows – "Are those the children – " Mrs. Burnell did not even open her eyes – her voice was tired and trembling – "Have either of them killed on the dray maimed for life." "No dear – perfectly safe and sound."

"Put down that lamp Kezia," said Aunt Beryl "or we shall have the house on fire before we're out of the packing cases. More tea – Stan?" "Well you might just give me ⅝ of a cup," said Burnell, leaning across the table – "Have another chop Beryl – Tip top meat isn't it. First rate First rate. Not too lean – not too fat – " He turned to his wife – "Sure you won't change your mind – Linda darling?" "Oh the very thought of it" . . . She raised one eyebrow in a way she had – The Grandmother brought the children 2 bowls of bread and milk and they sat up to the table, their faces flushed and sleepy behind the waving steam – "I had meat for my supper," said Isabel, still combing gently. "I had a whole chop for my supper – the bone an' all, an worcestershire sauce. Didn't I, Father – " "Oh, don't boast, Isabel," said Aunt Beryl. Isabel looked astounded – "I

49

Isabel looked astounded. "I wasn't boasting, was I, Mummy? I never thought of boasting. I thought they would like to know. I only meant to tell them."

"Very well. That's enough," said Burnell. He pushed back his plate, took a tooth-pick out of his pocket and began picking his strong white teeth.

"You might see that Fred has a bite of something in the kitchen before he goes, will you, mother?"

"Yes, Stanley." The old woman turned to go.

"Oh, hold on half a jiffy. I suppose nobody knows where my slippers were put? I suppose I shall not be able to get at them for a month or two – what?"

"Yes," came from Linda. "In the top of the canvas holdall marked 'urgent necessities.'"

"Well, you might get them for me, will you, mother?"

"Yes, Stanley."

Burnell got up, stretched himself, and going over to the fire he turned his back to it and lifted up his coat tails.

"By Jove, this is a pretty pickle. Eh, Beryl?"

Beryl, sipping tea, her elbows on the table, smiled over the cup at him. She wore an unfamiliar pink pinafore; the sleeves of her blouse were rolled up to her shoulders showing her lovely freckled arms, and she had let her hair fall down her back in a long pigtail.

"How long do you think it will take to get straight – couple of weeks – eh?" he chaffed.

"Good heavens, no," said Beryl airily. "The worst is over already. The servant girl and I have simply slaved all day, and ever since mother came she has worked like a horse, too. We have never sat down for a moment. We have had a day."

Stanley scented a rebuke.

"Well, I suppose you did not expect me to rush away from the office and nail carpets – did you?"

"Certainly not," laughed Beryl. She put down her cup and ran out of the dining-room.

50

wasn't boasting was I mummy? I never thought of boasting – I thought they'd like to know. I only meant to tell them – " "Very well. That's enough" said Burnell. He pushed back his plate, took a tooth pick out of his waistcoast pocket and began picking his strong white teeth. "You might see that Fred has a bite of something in the kitchen before he goes, will you Mother." "Yes, Stanley." The old woman turned to go – "Oh and hold on a jiffy. I suppose nobody knows where my slippers were put. I suppose I shan't be able to get at 'em for a ~~week~~ month or two eh?" "Yes," came from Linda. "In the top of the canvas hold all marked Urgent Necessities." "Well you might bring them to me will you Mother." "Yes Stanley." Burnell got up, stretched himself ~~and went over to the fire to warm his bottom~~ then his back to it and lifted up his coat tail – "By Jove this is a pretty pickle, eh Beryl." Beryl sipping tea, her elbow on the table, smiled over the cup at him – She wore an unfamiliar pink pinafore. The sleeves of her blouse were rolled up to her shoulders showing her lovely freckled arms she had let her hair fall down her back in a long ~~braid~~ pig tail. "How long do you think it will take you to get straight – couple of weeks? eh – " he chaffed. "Good Heavens no," said Beryl. "The worst is over already. All the beds are up – Everything's in the house – yours and Linda's room is finished already. The servant girl and I have simply slaved all day and ever since Mother came she's worked like a horse, too. We've never sat down for a moment. We *have* had a day." ~~At that~~ Stamping he scented a rebuke. "Well I suppose you didn't expect me to tear away from the office and ~~spread mattresses~~ nail carpets did you – " "Certainly not" said Beryl airily. She put down her cup and ran out of the dining

"What the hell does she expect us to do?" asked Stanley. "Sit down and fan herself with a palmleaf fan while I have a gang of professionals to do the job? By Jove, if she can't do a hand's turn occasionally without shouting about it in return for . . ."

And he gloomed as the chops began to fight the tea in his sensitive stomach. But Linda put up a hand and dragged him down to the side of her long chair.

"This is a wretched time for you, old boy," she said. Her cheeks were very white, but she smiled and curled her fingers into the big red hand she held. Burnell became quiet. Suddenly he began to whistle "Pure as a lily, joyous and free" – a good sign.

"Think you're going to like it?" he asked.

"I don't want to tell you, but I think I ought to, mother," said Isabel. "Kezia is drinking tea out of Aunt Beryl's cup."

IV They were taken off to bed by the grandmother. She went first with a candle; the stairs rang to their climbing feet. Isabel and Lottie lay in a room to themselves, Kezia curled in her grandmother's soft bed.

"Aren't there going to be any sheets, my granma?"

"No, not to-night."

"It's tickly," said Kezia, "but it's like Indians." She dragged her grandmother down to her and kissed her under the chin. "Come to bed soon and be my Indian brave."

"What a silly you are," said the old woman, tucking her in as she loved to be tucked.

"Aren't you going to leave me a candle?"

"No. Sh-h. Go to sleep."

"Well, can I have the door left open?"

She rolled herself up into a round but she did not go to sleep. From all over the house came the sound of steps. The house itself creaked and popped. Loud whispering voices came from downstairs. Once she heard Aunt Beryl's rush of high laughter, and once she heard a loud trumpeting

room – "What the hell did she expect to do," asked Stanley – "Sit down and fan herself with a palm leaf fan while I hired a gang of professionals to do the job? Eh? By Jove if she can't do a hand's turn occasionally without shouting about it in return for – – " and he glared as the chops began to fight the tea in his sensitive stomach. But Linda put up a hand and dragged him down – on to the side of her long cane chair. "This is a wretched time for you old boy," she said fondly – Her cheeks were very white but she smiled and curled her fingers round the big red hand she held – "And with a wife about as bright and gay as yesterday's button hole," she said – "You've been awfully patient, darling." "Rot," said Burnell, but he began to whistle the Holy City a good sign – "Think you're going to like it?" he asked – "I don't want to tell you but I think I ought to, Mother," said Isabel. "Kezia's drinking tea out of Aunt Beryl's cup – "

They were trooped off to bed by the Grandmother – She went first with a candle – the stairs rang to their climbing feet. Isabel and Lottie lay in a room to themselves – Kezia curled in the Grandmother's big bed. "Aren't there any sheets, my Grandma?" "No, not to-night." ~~Come to bed soon~~ "It's very tickly," said Kezia. "It's like Indians. Come to bed soon an be my indian brave." "What a silly you are," said the old woman tucking her in as she loved to be tucked. "Are you going to leave the candle." "No. Hush, go to sleep." "Well, kin I have the door left open?" She ~~folded herself up like a little cat~~ rolled herself into a round. But she did not go to sleep. From All over the house came the sound of steps – The house itself creaked and popped – Loud whispery voices rose and fell. Once she heard Aunt Beryl's – rush of high laughter. Once there

from Burnell blowing his nose. Outside the window hundreds of black cats with yellow eyes sat in the sky watching her – but she was not frightened. Lottie was saying to Isabel:

"I'm going to say my prayers in bed to-night."

"No, you can't, Lottie." Isabel was very firm. "God only excuses you saying your prayers in bed if you've got a temperature." So Lottie yielded:

> "Gentle Jesus meek anmile,
> Look pon a little chile.
> Pity me, simple Lizzie
> Suffer me to come to thee."

And then they lay down back to back, their little behinds just touching, and fell asleep.

Standing in a pool of moonlight Beryl Fairfield undressed herself. She was tired, but she pretended to be more tired than she really was – letting her clothes fall, pushing back with a languid gesture her warm, heavy hair.

"Oh, how tired I am – very tired."

She shut her eyes a moment, but her lips smiled. Her breath rose and fell in her breast like two fanning wings. The window was wide open; it was warm, and somewhere out there in the garden a young man, dark and slender, with mocking eyes, tip-toed among the bushes, and gathered the flowers into a big bouquet, and slipped under her window and held it up to her. She saw herself bending forward. He thrust his head among the bright waxy flowers, sly and laughing. "No, no," said Beryl. She turned from the window and dropped her nightgown over her head.

"How frightfully unreasonable Stanley is sometimes," she thought, buttoning. And then, as she lay down, there came the old thought, the cruel thought – ah, if only she had money of her own.

54

came a loud trumpeting from Burnell blowing his nose. Outside the
windows hundreds of black cats with yellow eyes sat in the sky watching
her but she was not frightened –

Lottie was saying to Isabel – "I'm going to say my prayers in bed
to-night – " "No you can't Lottie." Isabel was very firm. "God only
excuses you saying your prayers in bed if you've got a temperature." So
Lottie yielded –

> "Gentle Jesus meek an mile
> Look 'pon little chile
> Pity me simple Lizzie
> Suffer me come to thee.
> Fain would I to thee be brought
> Dearest Lor' forbd it not
> In the Kinkdom of thy grace
> Make a little chile a place – Amen."

And then they lay down back to back ~~their little behinds~~ just touching and
fell asleep.

Standing in a pool of moonlight Beryl Fairfield undressed herself – she
was tired but she pretended to be more tired than she really was – letting
her clothes fall – pushing back with a charming gesture her warm heavy
hair – "Oh how tired I am very tired" – she shut her eyes a moment but
her lips smiled – her breath rose and fell in her breast like fairy wings. The
window was open it was warm and still. Somewhere out there in the
garden a young man dark and slender with mocking eyes, tip toed among
the bushes and gathered the garden into a big bouquet and slipped under
her window and held it up to her – She saw herself bending forward – He
thrust his head among the white waxy flowers – "No no," said Beryl. She
turned from the window she dropped her night gown over her head –
"How frightfully unreasonable Stanley is sometimes," she thought
buttoning – and then as she lay down came the old thought the cruel
leaping thought "if I had money" only to be shaken off and beaten down
by calling to her rescue her endless pack of dreams – A young man

55

Prelude A young man, immensely rich, has just arrived from England. He meets her quite by chance. . . . The new governor is unmarried. . . . There is a ball at Government house. . . . Who is that exquisite creature in *eau-de-nil* satin? Beryl Fairfield. . . .

"The thing that pleases me," said Stanley, leaning against the side of the bed and giving himself a good scratch on his shoulders and back before turning in, "is that I've got the place dirt cheap, Linda. I was talking about it to little Wally Bell to-day and he said he simply could not understand why they had accepted my figure. You see land about here is bound to become more and more valuable . . . in about ten years' time . . . of course we shall have to go very slow and cut down expenses as fine as possible. Not asleep – are you?"

"No, dear, I've heard every word," said Linda.

He sprang into bed, leaned over her and blew out the candle. "Good night, Mr. Business Man," said she, and she took hold of his head by the ears and gave him a quick kiss. Her faint far-away voice seemed to come from a deep well.

"Good night, darling." He slipped his arm under her neck and drew her to him.

"Yes, clasp me," said the faint voice from the deep well.

Pat the handy man sprawled in his little room behind the kitchen. His sponge-bag, coat and trousers hung from the door-peg like a hanged man. From the edge of the blanket his twisted toes protruded, and on the floor beside him there was an empty cane bird-cage. He looked like a comic picture.

"Honk, honk," came from the servant girl. She had adenoids.

Last to go to bed was the grandmother.

"What. Not asleep yet?"

"No, I'm waiting for you," said Kezia. The old woman sighed and lay down beside her. Kezia thrust her head under her grandmother's arm and gave a little squeak. But the old woman only pressed her faintly, and sighed again, took out her teeth, and put them in a glass of water beside her on the

56

immensely rich just arrived from England meets her quite by chance. The new Governor is married. There is a ball at Government House to celebrate his wedding. Who is that exquisite creature in eau de nil satin? Beryl Fairfield.

"The thing that pleases me" said Stanley leaning against the side of the bed in his shirt and giving himself a good scratch before turning in – "is that, on the strict q.T. Linda I've got the place dirt cheap – I was talking about it to little Teddy Dean today and he said he simply couldn't understand why they'd accepted my figure you see land about here is bound to become more and more valuable – look in about 10 years time . . . Of course we shall have to go very slow from now on and keep down expenses – cut em as fine as possible. Not asleep, are you." "No dear I'm listening – " said Linda. He sprang into bed leaned over her and blew out the candle. "Good-night, Mr. Business man" she said and she took hold of his head by the ears and gave him a quick kiss. Her faint far away voice seemed to come from a deep well – "Goodnight, darling." He slipped his arm under her neck and drew her to him . . "Yes, clasp me," she said faintly, ~~almost as if she feared~~ in her far away sleeping voice

Pat the handy man sprawled in his little room behind the kitchen. His sponge bag coat and trousers hung from the door peg like a hanged man. From the blanket edge his twisted feet protruded – and on the floor of his room there was a empty cane bird cage. He looked like a comic picture.

"Honk – honk" came from the snoring servant girl next door she had adenoids.

Last to go to bed was the Grandmother.

"What – not asleep yet." "No – I'm waiting for you," said Kezia. The old woman sighed and lay down beside her. Kezia thrust her head under the Grandmother's arm. "Who am I – " she whispered – this was an old established ritual to be gone through between them. "You are my little brown bird," said the Grandmother. Kezia gave a guilty chuckle. The Grandmother ~~kissed her~~ took out her teeth and put them in a glass of water beside her on the floor.

floor.

In the garden some tiny owls, perched on the branches of a lace-bark tree, called: "More pork; more pork." And far away in the bush there sounded a harsh rapid chatter: "Ha-ha-ha . . . Ha-ha-ha."

V Dawn came sharp and chill with red clouds on a faint green sky and drops of water on every leaf and blade. A breeze blew over the garden, dropping dew and dropping petals, shivered over the drenched paddocks, and was lost in the sombre bush. In the sky some tiny stars floated for a moment and then they were gone – they were dissolved like bubbles. And plain to be heard in the early quiet was the sound of the creek in the paddock running over the brown stones, running in and out of the sandy hollows, hiding under clumps of dark berry bushes, spilling into a swamp of yellow water flowers and cresses.

And then at the first beam of sun the birds began. Big cheeky birds, starlings and mynahs, whistled on the lawns, the little birds, the goldfinches and linnets and fan-tails, flicked from bough to bough. A lovely kingfisher perched on the paddock fence preening his rich beauty, and a *tui* sang his three notes and laughed and sang them again.

"How loud the birds are," said Linda in her dream. She was walking with her father through a green paddock sprinkled with daisies. Suddenly he bent down and parted the grasses and showed her a tiny ball of fluff just at her feet. "Oh, papa, the darling." She made a cup of her hands and caught the tiny bird and stroked its head with her finger. It was quite tame. But a funny thing happened. As she stroked it began to swell, it ruffled and

Then the house was still.

In the garden some tiny owls called – perched on the branches of a lace bark tree, More pork more pork, and ~~long~~ far away from the bush came a harsh rapid chatter ~~of laughter~~ – Ha Ha Ha *Ha*. Ha-Ha-Ha-Ha!

Dawn came sharp and ~~cold~~ chill. The sleeping people turned over and hunched the blankets ~~together~~ higher – They sighed and stirred but the brooding house all hung about with shadows held the quiet in its lap a little longer – A breeze blew over the tangled garden dropping dew and dropping petals – shivered over the ~~dew~~ drenched paddock grass lifted the sombre bush and shook from it a wild and bitter scent. In the green sky ~~the little~~ tiny stars floated a moment and then they were gone, they were dissolved like bubbles. The cocks shrilled from the neighbouring farms – the cattle moved in their stalls – the horses grouped under the trees lifted their heads and swished their tails – and plainly to be heard in the early quiet was the ~~lapping~~ sound of the creek in the paddock running over the brown stones – running in and out of the sandy hollows – hiding under clumps of dark berry bushes – spilling into a swamp full of yellow water flowers and cresses – All the air smelled of water – ~~as the sun rose.~~ The lawn was hung with bright drops and spangles – And then quite suddenly – at the first glint of sun – ~~with the beautiful accord of a [?harsh] choir of english babies piping the anthem at sight of the lifting of Her~~ His ~~Majesty's hat~~ – the birds began to sing – Big cheeky birds, starlings and minors whistled on the lawns; the little birds, the goldfinches and fantails and linnets twittered flitting from bough to bough – and from tree to tree, hanging the garden with bright chains of song – a lovely king fisher perched on the paddock fence preening his rich ~~insect~~ beauty – "How loud the birds are" said Linda in her dream. She was walking with her father through a green field sprinkled with daisies – and suddenly he bent forward and parted the grasses and showed her a tiny ball of fluff just at her feet. "Oh Papa the darling." She made a cup of her hands and caught the bird and stroked its head with her finger. It was quite tame. But a strange thing happened. As she stroked it it began to swell – It ruffled and

pouched, it grew bigger and bigger and its round eyes seemed to smile knowingly at her. Now her arms were hardly wide enough to hold it and she dropped it into her apron. It had become a baby with a big naked head and a gaping bird-mouth, opening and shutting. Her father broke into a loud clattering laugh and she woke to see Burnell standing by the windows rattling the Venetian blind up to the very top.

"Hullo," he said. "Didn't wake you, did I? Nothing much wrong with the weather this morning."

He was enormously pleased. Weather like this set a final seal on his bargain. He felt, somehow, that he had bought the lovely day, too – got it chucked in dirt cheap with the house and ground. He dashed off to his bath and Linda turned over and raised herself on one elbow to see the room by daylight. All the furniture had found a place – all the old paraphernalia, as she expressed it. Even the photographs were on the mantelpiece and the medicine bottles on the shelf above the washstand. Her clothes lay across a chair – her outdoor things, a purple cape and a round hat with a plume in it. Looking at them she wished that she was going away from this house, too. And she saw herself driving away from them all in a little buggy, driving away from everybody and not even waving.

Back came Stanley girt with a towel, glowing and slapping his thighs. He pitched the wet towel on top of her hat and cape, and standing firm in the exact centre of a square of sunlight he began to do his exercises. Deep breathing, bending and squatting like a frog and shooting out his legs. He was so delighted with his firm, obedient body that he hit himself on the chest and gave a loud "Ah." But this amazing vigour seemed to set him worlds away from Linda. She lay on the white tumbled bed and watched him as if from the clouds.

"Oh, damn! Oh, blast!" said Stanley, who had butted into a crisp white shirt only to find that some idiot had fastened the neck-band and he was caught. He stalked over to Linda waving his arms.

"You look like a big fat turkey," said she.

pouched its feathers – it grew bigger and bigger and its round eyes *The Aloe*
seemed to smile at her – Now her arms were hardly wide enough to hold
it – she dropped it in her apron. It had become a baby with a big naked
head and a gaping bird mouth – opening and shutting – Her father broke
into a loud clattering laugh and Linda woke to see Stanley Burnell
standing by the windows rattling the venetian blinds up to the very top –
"Hullo" he said – "didn't wake you – did I? Nothing much the matter with
the weather this morning." He was enormously pleased – weather like
this set a final seal upon his bargain – he felt somehow – that he had
bought the sun too got it chucked in, dirt cheap, with the house and
grounds – He dashed off to his bath and Linda turned over, raised herself
on one elbow to see the room by daylight. It looked wonderfully lived in
already, all the old furniture had found a place – all the old "para-
phernalia" as she expressed it – even to photographs on the mantel-
piece and medicine bottles on a shelf over the washstand. But this room
was much bigger than their other room had been – that was a blessing.
Her clothes lay across a chair – her outdoor things – a purple cape and a
round sable with a plume on it – were tossed on the box ottoman –
Looking at them a silly thought brought a fleeting smile into her eyes –
"perhaps I am going away again to-day" and for a moment she saw herself
driving away from them all in a little buggy – driving away from every one
of them and waving – Back came Stanley girt with a towel, glowing and
slapping his thighs. He pitched the wet towel on top of her cape and hat
and standing firm in the exact centre of a square of sunlight he began to
do his exercises – deep breathing – bending – squatting like a frog and
shooting out his legs. He was so full of saturated with health that
everything he did delighted him, but this amazing health and vigour
seemed to set him miles and worlds away from Linda – she lay on the
white tumbled bed, and leaned towards him laughing as if from the sky –
 "Oh damn hang! Oh blast damn!" said Stanley who had butted into a
crisp shirt only to find that some idiot had fastened the neck band and he
was caught – He stalked over to her waving his arms. "Now you look the
image of a fat turkey," said she – "Fat I like that" said Stanley – "why I

61

"Fat. I like that," said Stanley. "I haven't a square inch of fat on me. Feel that."

"It's rock – it's iron," mocked she.

"You'd be surprised," said Stanley, as though this were intensely interesting, "at the number of chaps at the club who have got a corporation. Young chaps, you know – men of my age." He began parting his bushy ginger hair, his blue eyes fixed and round in the glass, his knees bent, because the dressing table was always – confound it – a bit too low for him. "Little Wally Bell, for instance," and he straightened, describing upon himself an enormous curve with the hairbrush. "I must say I've a perfect horror ..."

"My dear, don't worry. You'll never be fat. You are far too energetic."

"Yes, yes, I suppose that's true," said he, comforted for the hundredth time, and taking a pearl penknife out of his pocket he began to pare his nails.

"Breakfast, Stanley." Beryl was at the door. "Oh, Linda, mother says you are not to get up yet." She popped her head in at the door. She had a big piece of syringa stuck through her hair.

"Everything we left on the verandah last night is simply sopping this morning. You should see poor dear mother wringing out the tables and the chairs. However, there is no harm done – " this with the faintest glance at Stanley.

"Have you told Pat to have the buggy round in time? It's a good six and a half miles to the office."

"I can imagine what this early start for the office will be like," thought Linda. "It will be very high pressure indeed."

"Pat, Pat." She heard the servant girl calling. But Pat was evidently hard to

62

haven't got a square inch of fat on me. Feel that – " "My dear – hard as nails" mocked she – "You'd be surprised –" said Stanley as though this were intensely interesting, "at the number of chaps in the club who've got a corporation – young chaps, you know – about my own age –" He began parting and brushing his strong ~~sandy~~ ginger hair, his blue eyes fixed and round in the glass – ~~a bit~~ bent at the knees because the dressing table was always – confound it – a bit too low for him. "Little Teddy Dean for example" and he straightened, describing upon himself an enormous curve with the hair brush. "Of course they're sitting on their hind quarters all day at the office and when they're away from it – as far as I can make out they stodge and they snooze – I must say I've got a perfect horror." "Yes my dear don't worry you'll never be fat – You're far too energetic," repeating the familiar ~~assurance~~ formula that he never tired of hearing. "Yes. Yes I suppose that's true," and taking a ~~big pen~~ mother of pearl pen knife out of his pocket he began to pare his nails – "Breakfast, Stanley" Beryl was at the door – "Oh Linda Mother says don't get up – Stay where you are until after lunch won't you?" She popped her head in at the door. She had a big piece of syringa stuck through a braid of her hair. "Everything we left on the verandah last night is simply sopping this morning. You should see poor dear Mother wringing out the sofa and chairs – however, no harm done – not a *pennorth*'s of harm" this with the faintest glance at Stanley – "Have you told Pat what time to have the buggy round – ~~you see I'm~~ It's a good six-and-a-half miles – from here to the office – – " "I can imagine what his morning start off for the office will become" – thought Linda. Even when they lived in town – only half an hour away – the house had to slow down each morning – had to stop like a steamer – every soul on board summoned to the gangway to watch Burnell descending the ladder and into the little cockle shell – They must wave when he waved – give him good-bye for good-bye and ~~surround him~~ lavish upon him unlimited loving sympathy as though they saw on the horizon's brim the untamed land to which he curved his chest so proudly, the line of leaping savages ready to fall upon his valiant sword –

"Pat Pat," she heard the servant girl calling – But Pat was evidently not

find; the silly voice went baa-baaing through the garden.

Linda did not rest again until the final slam of the front door told her that Stanley was really gone.

Later she heard her children playing in the garden. Lottie's stolid, compact little voice cried: "Ke—zia. Isa—bel." She was always getting lost or losing people only to find them again, to her great surprise, round the next tree or the next corner. "Oh, there you are after all." They had been turned out after breakfast and told not to come back to the house until they were called. Isabel wheeled a neat pramload of prim dolls and Lottie was allowed for a great treat to walk beside her holding the doll's parasol over the face of the wax one.

"Where are you going to, Kezia?" asked Isabel, who longed to find some light and menial duty that Kezia might perform and so be roped in under her government.

"Oh, just away," said Kezia. . . .

to be found – the silly voice went baaing all over the garden. "It will be The Aloe
very high pressure indeed" – she decided – and did not rest again until the
final slam of the front door sounded – and Stanley was gone.

Later she heard her children playing in the garden. Lottie's ~~fat~~ stolid
compact little voice –cried "Kezia Isabel" – Lottie was always getting
lost or losing people and finding them again – astonished – round the next
tree or the next corner – "Oh *there* you are" – They had been turned out
to grass after breakfast with strict orders not to come near the house
until they were called – Isabel wheeled a neat pram load of prim dolls and
Lottie was allowed for a great treat to walk beside holding the doll
parasols over the face of the wax one – "Where are you going Kezia,"
asked Isabel, who longed to find some light and menial duty that Kezia
might ~~be fo~~ perform and so be roped in under her government. "Oh just
away," said Kezia.

"Come back, Kezia. Come back. You're not to go on the wet grass
until it's dry. Grandma says," ~~shrilled~~ called Isabel.

"Bossy! bossy!" Linda heard Kezia answer.

"Do the children's voices annoy you, Linda," asked old Mrs. Fairfield,
coming in at that moment with a breakfast tray. "Shall I ~~ask~~ tell them to
go further away from the house?"

"No, don't bother," said Linda. "Oh, Mother I do *not* want any
breakfast."

"I have not brought you any," said Mrs. Fairfield, putting down the tray
on the bed table. "A spot of porridge, a finger of toast – – – "

"The merest sensation of marmalade – " mocked Linda – But Mrs.
Fairfield remained serious. "Yes, dearie, and a little pot of fresh tea."

She brought from the cupboard a white woolen jacket trimmed with
red bows and buttoned it round her daughter.

"Must I?" pouted Linda, making a face at the porridge.

~~"Try," said her mother and smiled at Linda.~~

Mrs. ~~Burnell~~ Fairfield walked about the room. She lowered the blinds,
tidied away the evidences of Burnell's toilet and gently she lifted the
dampened plume of the little round hat. There was a charm and a grace in

65

Prelude

66

all her movements. It was not that she merely "set in order"; there seemed to be almost a positive quality in the obedience of things to her fine old hands. They found not only their proper but their perfect place. She wore a grey foulard dress patterned with white pansies, a white linen apron and one of those high caps shaped like a jelly mould of white tulle. At her throat a big silver brooch shaped like a crescent moon with five owls sitting on it and round her neck a black bead watch chain. If she had been a beauty in her youth and she had been a very great beauty – (Indeed, report had it that her miniature had been painted and sent to Queen Victoria as the belle of Australia) and one cannot help hoping it gave that stodgy little person "one in the eye") old age had touched her with exquisite gentleness. Her long curling hair was still black at her waist, grey between her shoulders and it framed her head in frosted silver. The late roses – the last roses – that frail pink kind, so reluctant to fall, such a wonder to find, still bloomed in her cheeks and behind big gold rimmed spectacles her blue eyes shone and smiled. And she still had dimples. On the backs of her hands, at her elbows – one in the left hand corner of her chin. Her body was the colour of old ivory. She bathed in cold water summer and winter and she could only bear linen next to her skin and suède gloves on her hands. Upon everything she used there lingered a trace of Cashmère bouquet perfume.

"How are you getting on downstairs," asked Linda, playing with her breakfast.

"Beautifully. Pat has turned out a treasure – He has laid all the linoleum and the carpets and Alice seems to be taking a *real interest* in the kitchen and pantries."

"Pantries! There's grandeur, after that bird cage of a larder in that other cubby hole!"

"Yes, I must say the house is wonderfully convenient and *ample* in every way. You should have a good look round when you get up."

Linda smiled, shaking her head.

"I don't want to. I don't *care*. The house can bulge cupboards and pantries, but other people will explore them. Not me."

Prelude

68

"But *why* not," asked Mrs. Fairfield, anxiously watching her.

"Because I don't feel the slightest crumb of interest, my Mother."

"But why don't you, dear? You ought to try – to begin – even for Stanley's sake. He'll be so bitterly disappointed if . . " Linda's laugh interrupted. "Oh, trust me – I'll satisfy Stanley. Besides I can *rave* all the better over what I haven't seen." "Nobody asks you to *rave*, Linda," said the old woman, sadly.

"Don't they?" Linda screwed up her eyes. "I'm not so sure. If I were to *jump* out of bed now, *fling* on my clothes, *rush* downstairs, *tear* up a ladder, hang pictures, eat an enormous lunch, romp with the children in the garden this [afternoon] and be swinging on the gate, waving, when Stanley hove in sight this evening I believe you'd be delighted – A normal, healthy day for a young wife and mother – A – – "

Mrs. Fairfield began to smile. "How absurd you are – How you exaggerate! What a baby you are," said she.

But Linda sat up suddenly and jerked off the "wooly".

"I'm boiling, I'm roasting." she declared. "I can't think what I'm doing in this big, stuffy old bed – I'm going to get up."

"Very well, dear," said Mrs. Fairfield –

Getting dressed ~~was never a lengthy business with Linda.~~ never took her long. Her hands flew. She had beautiful hands, white and tiny. The only *trouble* with them was that they would not keep her rings on them. Happily she only had two rings, her wedding ring and a peculiarly hideous affair, a square slab with four pin opals in it that Stanley had "stolen from a cracker" said Linda, the day they were engaged. But it was her wedding ring that disappeared so. It fell down every possible place and into every possible corner. Once she even found it in the crown of her hat. It was a familiar cry in the house "Linda's wedding ring has *gone again*" – Stanley Burnell could never hear that without horrible sense of discomfort. Good Lord! he wasn't superstitious – He left that kind of rot to people who had nothing better to think about – but all the same, it was *devilishly* annoying. Especially as Linda made so light of the affair and mocked him and said "are they as expensive as all that" and laughed at him and cried,

Prelude

70

holding up her bare hand – "Look, Stanley, it has all been a dream." He
was a fool to mind things like that, but they hurt him – they hurt like sin.

"Funny I should have dreamed about Papa last night" thought Linda, brushing her cropped hair that stood up all over her head in little bronzy rings. "What was it I dreamed?" No, she'd forgotten – "Something or other about a bird." But Papa was very plain – his lazy ambling walk. And she laid down the brush and went over to the marble mantelpiece and leaned her arms along it, her chin in her hands, and looked at his photograph. In his photograph he showed severe and imposing – a high brow, a piercing eye, clean shaven except for long "piccadilly weepers" draping his bosom. He was taken in the fashion of that time, standing, one arm on the back of a tapestry chair, the other clenched upon a parchment roll. "Papa!" said Linda. ~~Tenderly, wonderfully,~~ she smiled. "There you are my dear," she breathed, and then she shook her head quickly and frowned, and went on with her dressing.

Her Father had died the year that she married Burnell, the year of her sixteenth birthday. All her childhood had been passed in a long white house perched on a hill overlooking Wellington harbour – a house with a wild garden full of bushes and fruit-trees, long, thick grass and nasturtiums. Nasturtiums grew everywhere – there was no fighting them down. They even fell in a shower over the paling fence on to the road. Red, yellow, white, every possible colour; they lighted the garden like swarms of butterflies. The Fairfields were a large family of boys and girls with their beautiful mother and their gay, fascinating father (for it was only in his photograph that he looked stern) they were quite a "show" family and immensely admired. Mr. Fairfield managed a small insurance business that could not have been very profitable, yet they lived plentifully. He had a good voice; he liked to sing in public, he liked to dance and attend pic-nics – to put on his "bell topper" and walk out of Church if he disapproved of anything said in the sermon – and he had a passion for inventing highly unpracticable things, like collapsible umbrellas or folding lamps. He had one saying with which he met all difficulties. "Depend upon it, it will all come right after the Maori war."[2]

Prelude

72

Linda, his second to youngest child, was his darling, his pet, his playfellow. ~~Ah,~~ She was a wild thing, always trembling on the verge of laughter, ready for anything and eager. When he put his arm round her and held her he felt her thrilling with life. He understood her so beautifully and gave her so much love for love that he became a kind of daily miracle to her and all her faith centred in him – People barely touched her; ~~and they called her~~ she was regarded as a cold, heartless little creature, but she seemed to have an unlimited passion for that violent sweet thing called life – just being alive and able to run and climb and swim in the sea and lie in the grass ~~and "bask".~~ In the evenings she and her Father would sit on the verandah – she on his knees – and "plan".[3] "When I am grown up we shall travel everywhere – we shall see the whole world – won't we Papa?"

"We shall, my dear."

"One of your inventions will have been a great success – Bring you in a good round million yearly."

"We can manage on that."

"But one day we shall be rich and the next poor. One day we shall dine in a palace and the next we'll sit in a forest and toast mushrooms on a hatpin . . We shall have a little boat – we shall explore the interior of China on a raft – you will look sweet in one of those huge umbrella hats that Chinamen wear in pictures. We won't leave a corner of anywhere unexplored – shall we?"

"We shall look under the beds and in all the cupboards and behind every curtain."

"And we shan't go as father and daughter," she tugged at his "piccadilly weepers" and began kissing him. "We'll just go as a couple of boys together – Papa."

By the time Linda was fourteen the big family had vanished, only she and Beryl, who was ~~four~~ 2 years younger, were left. The girls had married; the boys had gone faraway – Linda left off attending the Select Academy for Young Ladies presided over by Miss Clara Finetta Birch (From England) a lady whose black hair lay so flat on her head that *every*body *said* it was only painted on, and she stayed at home to be a help

73

Prelude

74

to her mother. For three days she laid the table and took the mending basket on to the verandah in the afternoon but after that she "went mad-dog again" as her father expressed it and there was no holding her. "Oh, Mother, life is so *fearfully short*," said Linda. That summer Burnell appeared. Every evening a stout young man in a striped shirt, with fiery red hair and a pair of immature mutton chop whiskers passed their house, quite slowly, four times. Twice up the hill he went and twice down he came. He walked with his hands behind his back and each time he glanced once at the verandah where they sat – Who was he? None of them knew, but he became a great joke. "Here she blows," Mr. Fairfield would whisper. The young man came to be called the "Ginger Whale" – Then he appeared at Church, in a pew facing theirs, very devout and serious. But he had that unfortunate complexion that goes with his colouring and every time he so much as glanced in Linda's direction a crimson blush spread over his face to his ears. "Look out, my wench," said Mr. Fairfield. "Your clever Papa has solved the problem. That young fellow is after you."

"Henry! What rubbish. How can you say such things," said his wife.

"There are times," said Linda, "when I simply doubt your *sanity* Papa." But Beryl loved the idea. The ginger whale became "Linda's beau."

"You know as well I do that I am *never* going to marry," said Linda. "How can you be such a *traitor*, Papa – "

A social given by the Liberal Ladies Political League ripened matters a little. Linda and her Papa attended. She wore a green sprigged muslin with little capes on the shoulders that stood up like wings and he wore a frock coat and a wired buttonhole as big as a soup plate. The social began with a very "painful" concert. "She wore a wreath of roses" – "They played in the Beautiful Garden" "A Mother sat Watching" – "Flee Like a Bird to the Fountain" sang the political ladies with forlorn and awful vigour – The gentlemen sang with far greater vigour and a kind of defiant cheerfulness which was almost terrifying. They looked very furious, too. Their cuffs shot over their hands, or their trousers were far too long . . Comic recitations about flies on bald heads and engaged couples sitting

75

Prelude

on porch steps spread with glue were contributed by the chemist.
Followed an extraordinary meal called upon the hand printed
programme Tea and Coffee and consisting of ham-beef-or-tongue,
tinned salmon oyster patties, sanwiches, col' meat, jellies, huge cakes,
fruit salad in wash hand bowls, trifles bristling with almonds and large cups
of tea, dark brown in colour, tasting faintly of rust. Helping Linda to a
horrible-looking pink blanc-mange which Mr. Fairfield said was made of
strangled baby's head, he whispered – "the ginger whale is here. I've just
spotted him blushing at a sanwich. Look out, my lass. He'll sandbag you
with one of old Ma Warren's rock cakes." Away went the plates – away
went the table. Young Mr. Fantail, in evening clothes with brown button
boots sat down at the piano – and crashed into the "Lancers".

> Diddle dee dum tee tum te tum
> Diddle dee um te tum te tum
>
> – – –
>
> Diddle dee tum tee diddle tee tum!

And half way through the "evening" it actually came to pass – Smoothing
his white cotton gloves, a beetroot was *pale* compared to him a pillar box
was a tender pink. Burnell asked Linda for the pleasure and before she
realised what had happened his arm was round her waist and they were
turning round and round to the air of "Three Blind Mice" (arranged by
Mr. Fantail même). He did not talk while he danced, but Linda liked that.
She felt a "silly" – When the dance was over they sat on a bench against
the wall. Linda hummed the waltz tune and beat time with her glove –
She felt dreadfully shy and she was terrified of her father's merry eye – At
last Burnell turned to her. "Did you ever hear the story of the shy young
man who went to his first ball. He danced with a girl and then they sat on
the stairs – and they could not think of a thing to say – And after he'd
picked up everything she dropped from time to time – after the silence
was simply unbearable he turned round and stammered desperat 'd-do
you always w-wear fl f flannel next to the skin?' I feel rather like that
chap," said Burnell.

Then she did not hear them any more. What a glare there was in the room. She hated blinds pulled up to the top at any time, but in the morning it was intolerable. She turned over to the wall and idly, with one finger, she traced a poppy on the wall-paper with a leaf and a stem and a fat bursting bud. In the quiet, and under her tracing finger, the poppy seemed to come alive. She could feel the sticky, silky petals, the stem, hairy like a gooseberry skin, the rough leaf and the tight glazed bud. Things had a habit of coming alive like that. Not only large substantial things like furniture but curtains and the patterns of stuffs and the fringes of quilts and cushions. How often she had seen the tassel fringe of her quilt change into a funny procession of dancers with priests attending. . . . For there were some tassels that did not

into little men with brown top hats on – how often the washstand jug ~~had~~ sat in the basin like a fat bird in a round nest. "I dreamed about birds last night," thought Linda – What was it? No, she had forgotten – It's very very quiet here, thought Linda. She opened her eyes wide – ~~and in the silence~~ She heard the stillness spinning its soft endless web – How lightly she breathed – She scarcely had to breathe at all. Yes – everything in the room was alive – down to the minutest tiniest particle and she did not feel her bed, she floated held up in the air – She seemed to be listening with her wide open watchful eyes – or waiting for something ~~to happen~~ who just did not come – waiting for something to happen that just did not happen. A long time passed – she yielded, she yielded boundlessly to all the live things even to the point where she smiled their secret blind smile – when there came faint and from far away the hollow tock of a [*illegible*]

Tock tock tock tock, went

She turned over and went to sleep –the night was dreadfully long – In the middle of it the full moon opposite her window dabbling the bedclothes and the pillow and her hand and arms with strange restless light. It woke her. At first she could not realise what it is that made her so uneasy – She moaned and sighed and nearly sat up. Then she saw the moon in the upper pane of the window with dark torn clouds surrounding it.

Then she did not hear them any more. What a glare there was in the room. She hated blinds pulled up to the top at any time – but in the morning, in the morning especially! She turned over to the wall and idly, with one finger, she traced a poppy on the wall paper with a leaf and a stem and a fat bursting bud. In the quiet, under her tracing finger, the poppy seemed to come alive. She could feel the sticky, silky petals, the stem, hairy like a gooseberry skin, the rough leaf and the tight glazed bud. Things had a habit of coming alive in the quiet; she had often noticed it. Not only large, substantial things, like furniture, but curtains and the patterns of stuffs and fringes of quilts and cushions. How often she had seen the tassel fringe of her quilt change into a funny procession of dancers, with priests attending . . For there *were* some tassels that did not

79

dance at all but walked stately, bent forward as if praying or chanting. How often the medicine bottles had turned into a row of little men with brown top-hats on; and the washstand jug had a way of sitting in the basin like a fat bird in a round nest.

"I dreamed about birds last night," thought Linda. What was it? She had forgotten. But the strangest part of this coming alive of things was what they did. They listened, they seemed to swell out with some mysterious important content, and when they were full she felt that they smiled. But it was not for her, only, their sly secret smile; they were members of a secret society and they smiled among themselves. Sometimes, when she had fallen asleep in the daytime, she woke and could not lift a finger, could not even turn her eyes to left or right because THEY were there; sometimes when she went out of a room and left it empty, she knew as she clicked the door to that THEY were filling it. And there were times in the evenings when she was upstairs, perhaps, and everybody else was down, when she could hardly escape from them. Then she could not hurry, she could not hum a tune; if she tried to say ever so carelessly – "Bother that old thimble" – THEY were not deceived. THEY knew how frightened she was; THEY saw how she turned her head away as she passed the mirror. What Linda always felt was that THEY wanted something of her, and she knew that if she gave herself up and was quiet, more than quiet, silent, motionless, something would really happen.

"It's very quiet now," she thought. She opened her eyes wide, and she heard the silence spinning its soft endless web. How lightly she breathed; she scarcely had to breathe at all.

Yes, everything had come alive down to the minutest, tiniest particle, and she did not feel her bed, she floated, held up in the air. Only she seemed to be listening with her wide open watchful eyes, waiting for someone to come who just did not come, watching for something to happen that just did not happen.

dance at all but walked stately, bent forward as if praying or chanting . .
How often the medicine bottles had turned into a row of little men with brown top hats on; and often the wash stand jug sat in the basin like a fat bird in a round nest. "I dreamed about birds last night" thought Linda. What was it? No, she'd forgotten . . But the strangest part about this coming alive of things was what they did. They listened; they seemed to swell out with some mysterious important content and when they were full she felt that they smiled – Not for her (although she knew they "recognised" her) their sly meaning smile; They were members of a secret order and they smiled among themselves. Sometimes, when she had fallen asleep in the day time, she woke and could not lift a finger, could not even turn her eyes to left or right . . *they* were so strong; sometimes when she went out of a room and left it empty she knew as she clicked the door to that *they* were coming to life. And Ah, there were times, especially in the evenings when she was upstairs, perhaps, and everybody else was down when she could hardly tear herself away from "them" – when she could not hurry, when she tried to hum a tune to show them she did not care, when she tried to say ever so carelessly – "Bother that old thimble! Where ever have I put it!" but she never never deceived *them*. *They* knew how frightened she was; "they" saw how she turned her head away as she passed the mirror. For all their patience they wanted something of her. Half unconsciously she knew that if she gave herself up and was quiet – more than quiet, silent, motionless, something would happen . . . "It's very very quiet now," thought Linda. She opened her eyes wide; she heard the stillness spinning its soft endless web. How lightly she breathed – She scarcely had to breathe at all . . Yes, everything had come alive down to the minutest, tiniest particle and she did not feel her bed – She floated, held up in the air. Only she seemed to be listening with her wide open watchful eyes, waiting for some one to come who just did not come, watching for something to happen that just did not happen.

VI

In the kitchen at the long deal table under the two windows old Mrs. Fairfield was washing the breakfast dishes. The kitchen window looked out on to a big grass patch that led down to the vegetable garden and the rhubarb beds. On one side the grass patch was bordered by the scullery and washhouse and over this whitewashed lean-to there grew a knotted vine. She had noticed yesterday that a few tiny corkscrew tendrils had come right through some cracks in the scullery ceiling and all the windows of the lean-to had a thick frill of ruffled green.

"I am very fond of a grape vine," declared Mrs. Fairfield, "but I do not think that the grapes will ripen here. It takes Australian sun." And she remembered how Beryl when she was a baby had been picking some white grapes from the vine on the back verandah of their Tasmanian house and she had been stung on the leg by a huge red ant. She saw Beryl in a little plaid dress with red ribbon tie-ups on the shoulders screaming so dreadfully that half the street rushed in. And how the child's leg had swelled! "T-t-t-t!" Mrs. Fairfield caught her breath remembering. "Poor child, how terrifying it was." And she set her lips tight and went over to the stove for some more hot water. The water frothed up in the big soapy bowl with pink and blue bubbles on top of the foam. Old Mrs. Fairfield's arms were bare to the elbow and stained a bright pink. She wore a grey foulard dress patterned with large purple pansies, a white linen apron and a high cap shaped like a jelly mould of white muslin. At her throat there was a silver crescent moon with five little owls seated on it, and round her neck she wore a watch-guard made of black beads.

It was hard to believe that she had not been in that kitchen for years; she was so much a part of it. She put the crocks away with a sure, precise touch, moving leisurely and ample from the stove to the dresser, looking into the pantry and the larder as though there were not an unfamiliar corner. When she had finished, everything in the kitchen had become part of a series of patterns. She stood in the middle of the room wiping her hands on a check cloth; a smile beamed on her lips; she thought it looked very nice, very satisfactory.

In the kitchen at the long deal table under the two windows old Mrs.
Fairfield was washing the breakfast dishes. The kitchen windows looked
out on to a big grass patch that led down to the vegetable garden and the
rhubarb beds – On one side the grass patch was bordered by the scullery
and wash house and over this long white washed "lean to" there grew a
big knotted vine. She had noticed yesterday that some tiny corkscrew
tendrils had come right through some cracks in the scullery ceiling and all
the windows of the "lean to" had a thick frill of dancing green. "I am very
fond of a grape vine," decided Mrs. Fairfield, "but I do not think that the
grapes will ripen here. It takes Australian sun . ." and she suddenly
remembered how when Beryl was a baby she had been picking some
white grapes from the vine on the back verandah of their Tasmanian
house and she had been stung on the leg by a huge red ant. She saw Beryl
in a little plaid dress with red ribbon "tie ups" on the shoulders screaming
so dreadfully that half the street had rushed in . . and the child's leg had
swelled to an enormous size . . "T-t-t" Mrs. Fairfield caught her breath,
remembering. "Poor child – how terrifying it was!" and she set her lips
tight in a way she had and went over to the stove for some more hot
water – The water frothed up in the big soapy bowl with pink and blue
bubbles on top of the foam. Old Mrs. Fairfield's arms were bare to the
elbow and stained a bright pink. She wore a grey foulard dress patterned
with large purple pansies, a white linen apron and a high cap shaped like a
jelly mould of white tulle. At her throat there was a silver crescent moon
with five little owls seated on it and round her neck she wore a watch
guard made of black beads. It was very hard to believe that they had only
arrived yesterday and that she had not been in the kitchen for years – she
was so much a part of it, putting away the clean crocks with so sure and
precise a touch, moving, leisurely and ample from the stove to the
dresser, looking into the pantry and the larder as though there were not
an unfamiliar corner. When she had finished tidying everything in the
kitchen had become part of a series of pattern. She stood in the middle of
the room, wiping her hands on a check towel and looking about her, a tiny
smile beamed on her lips; she thought it looked very nice, very

"Mother! Mother! Are you there?" called Beryl.

"Yes, dear. Do you want me?"

"No. I'm coming," and Beryl rushed in, very flushed, dragging with her two big pictures.

"Mother, whatever can I do with these awful hideous Chinese paintings that Chung Wah gave Stanley when he went bankrupt? It's absurd to say that they are valuable, because they were hanging in Chung Wah's fruit shop for months before. I can't make out why Stanley wants them kept. I'm sure he thinks them just as hideous as we do, but it's because of the frames," she said spitefully. "I suppose he thinks the frames might fetch something some day or other."

"Why don't you hang them in the passage?" suggested Mrs. Fairfield; "they would not be much seen there."

"I can't. There is no room. I've hung all the photographs of his office there before and after building, and the signed photos of his business friends, and that awful enlargement of Isabel lying on the mat in her singlet." Her angry glance swept the placid kitchen. "I know what I'll do. I'll hang them here. I will tell Stanley they got a little damp in the moving so I have put them in here for the time being."

She dragged a chair forward, jumped on it, took a hammer and a big nail out of her pinafore pocket and banged away.

"There! That is enough! Hand me the picture, mother."

"One moment, child." Her mother was wiping over the carved ebony frame.

"Oh, mother, really you need not dust them. It would take years to dust all those little holes." And she frowned at the top of her mother's head and bit her lip with impatience. Mother's deliberate way of doing things was simply maddening. It was old age, she supposed, loftily.

At last the two pictures were hung side by side. She jumped off the chair, stowing away the little hammer.

"They don't look so bad there, do they?" said she. "And at any rate nobody need gaze at them except Pat and the servant girl – have I got a

84

satisfactory. If only servant girls could be taught to understand that it did The Aloe
not only matter how you put a thing away it mattered just as much *where*
you put it – or was it the other way about – – – . But at any rate they
never would understand; she had never been able to train them . .
"Mother, Mother are you in the kitchen?" called Beryl. "Yes, dear, Do
you want me?" "No, I'm coming," and Beryl ran in, very flushed, dragging
with her two big pictures. "Mother whatever can I do with these hideous
awful Chinese paintings that Chung Wah gave Stanley when he went
bankrupt. It's absurd to say they were valuable because they were
hanging in Chung Wah's fruit shop for months before. I can't understand
why Stanley doesn't want them to be thrown away – I'm sure he thinks
they're just as hideous as we do, but it's because of the frames – " she said,
spitefully. "I suppose he thinks the frames might fetch something one day.
Ugh! What a weight they are." "Why don't you hang them in the
passage" suggested Mrs. Fairfield. "They would not be much seen there."
"I can't. There isn't room. I've hung all the photographs of his office
before and after rebuilding there, and the signed photographs of his
business friends and that awful enlargement of Isabel lying on a mat in her
singlet. There isn't an inch of room left there." Her angry glance flew
over the placid kitchen. "I know what I'll do. I'll hang them here – I'll say
they got a little damp in the moving and so I put them up here in the warm
for the time being." She dragged forward a chair, jumped up on it, took a
hammer and a nail out of her deep apron pocket and banged away –
"There! That's high enough. Hand me up the picture, Mother." "One
moment, child – " she was wiping the carved ebony frame – "Oh,
Mother, *really* you need not dust them. It would take years to dust all
those winding little holes" and she frowned at the top of her Mother's
head and bit her lip with impatience. Mother's deliberate way of doing
things was simply maddening. It was old age, she supposed, loftily. At last
the two pictures were hung, side by side. She jumped off the chair,
stowing back the little hammer. "They don't look so bad there, do they,"
said she – "And at any rate nobody need ever see them except Pat and
the servant girl – Have I got a spider's web on my face, Mother? I've been

spider's web on my face, mother? I've been poking into that cupboard under the stairs and now something keeps tickling my nose."

But before Mrs. Fairfield had time to look Beryl had turned away. Someone tapped on the window: Linda was there, nodding and smiling. They heard the latch of the scullery door lift and she came in. She had no hat on; her hair stood upon her head in curling rings and she was wrapped up in an old cashmere shawl.

"I'm so hungry," said Linda: "where can I get something to eat, mother? This is the first time I've been in the kitchen. It says 'mother' all over; everything is in pairs."

"I will make you some tea," said Mrs. Fairfield, spreading a clean napkin over a corner of the table, "and Beryl can have a cup with you."

"Beryl, do you want half my gingerbread?" Linda waved the knife at her.

poking my head into that cupboard under the stairs and now something
keeps tickling me." But before Mrs. Fairfield had time to look Beryl had
turned away again – "Is that clock right. Is it really as early as that? Good
Heavens it seems years since breakfast?" "That reminds me," said Mrs.
Fairfield. "I must go upstairs and fetch down Linda's tray". . "There!"
cried Beryl. "Isn't that like the servant girl. Isn't that exactly like her. I
told her distinctly to tell you that I was too busy to take it up and would
you please instead. I never dreamed she hadn't told you!"

Some one tapped on the window. They turned away from the
pictures. Linda was there, nodding and smiling. They heard the latch of
the scullery door lift and she came in. She had no hat on; her hair stood up
on her head in curling rings and she was all wrapped up in an old Kashmir
shawl. "Please can I have something to eat," said she. "Linnet dear I am so
frightfully sorry. It's my fault," cried Beryl. "But I wasn't hungry. I would
have screamed if I had been," said Linda. "Mummy darling, make me a
little pot of tea in the brown china teapot." She went into the pantry and
began lifting the lids off a row of tins. "What grandeur my dears," she
cried, coming back with a brown scone and a slice of ginger bread—"a
pantry and a larder." "Oh but you haven't seen the outhouses yet" said
Beryl. "There is a stable and a huge barn of a place that Pat calls the feed
room and a woodshed and a tool house – all built round a square
courtyard that has big white gates to it. Awfully grand!" "This is the first
time I've even seen the kitchen" said Linda. "Mother has been here.
Everything is in pairs." "Sit down and drink your tea," said Mrs. Fairfield,
spreading a clean table napkin over a corner of the table. "And Beryl have
a cup with her. I'll watch you both while I'm peeling the potatos for
dinner. I don't know what has happened to the servant girl." "I saw her
on my way downstairs, Mummy. She's lying practically at full length on
the bathroom floor laying linoleum. And she is hammering it so frightfully
hard that I am sure the pattern will come through on to the dining-room
ceiling. I told her not to run any more tacks than she could help into
herself but I am afraid that she will be studded for life all the same. Have
half my piece of gingerbread, Beryl. Beryl, do you like the house now that

"Beryl, do you like the house now that we are here?"

"Oh yes, I like the house immensely and the garden is beautiful, but it feels very far away from everything to me. I can't imagine people coming out from town to see us in that dreadful jolting bus, and I am sure there is not anyone here to come and call. Of course it does not matter to you because – "

"But there's the buggy," said Linda. "Pat can drive you into town whenever you like."

That was a consolation, certainly, but there was something at the back of Beryl's mind, something she did not even put into words for herself.

"Oh, well, at any rate it won't kill us," she said dryly, putting down her empty cup and standing up and stretching. "I am going to hang curtains." And she ran away singing:

> How many thousand birds I see
> That sing aloud from every tree . . .

". . . birds I see That sing aloud from every tree. . . ." But when she reached the dining-room she stopped singing, her face changed; it became gloomy and sullen.

"One may as well rot here as anywhere else," she muttered savagely, digging the stiff brass safety-pins into the red serge curtains.

The two left in the kitchen were quiet for a little. Linda leaned her cheek on her fingers and watched her mother. She thought her mother looked wonderfully beautiful with her back to the leafy window. There was something comforting in the sight of her that Linda felt she could never do without. She needed the sweet smell of her flesh, and the soft feel of her cheeks and her arms and shoulders still softer. She loved the way her hair curled, silver at her forehead, lighter at her neck, and bright brown still in the big coil under the muslin cap. Exquisite were her mother's hands, and the two rings she wore seemed to melt into her creamy skin. And she was always so fresh, so delicious. The old woman could bear nothing but linen next to her body and she bathed in cold water winter and summer.

"Isn't there anything for me to do?" asked Linda.

we are *here*?" "Oh yes I like the house immensely and the garden is simply beautiful but it feels very far away from everything to me. I can't imagine people coming out from town to see us in that dreadful rattling 'bus and I am sure there isn't anybody here who will come and call . . Of course it doesn't matter to you particularly because you never liked living in town." "But we've got the buggy," said Linda. "Pat can drive you into town whenever you like. And after all it's only six miles away." That was a consolation certainly but there was something unspoken at the back of Beryl's mind, something she did not even put into words for herself. "Oh, well at any rate it won't kill us," she said dryly, putting down her cup and standing up and stretching. "I am going to hang curtains." And she ran away singing: "How many thousand birds I see, That sing aloft in every tree." But when she reached the dining room she stopped singing. Her face changed – hardened, became gloomy and sullen. "One may as well rot here as anywhere else," she said savagely digging the stiff brass safety pins into the red serge curtains. .

The two left in the kitchen were quiet for a little. Linda leaned her cheek in her fingers and watched her Mother. She thought her Mother looked wonderfully beautiful standing with her back to the leafy window – There was something comforting in the sight of her Mother that Linda felt she could never do without – She knew everything about her – just what she kept in her pocket and the sweet smell of her flesh and the soft feel of her cheeks and her arms and shoulders, still softer – the way the breath rose and fell in her bosom and the way her hair curled silver round her forehead, lighter at her neck and bright brown still in the big coil under the tulle cap. Exquisite were her Mother's hands and the colour of the two rings she wore seemed to melt into her warm white skin – her wedding ring and a large old fashioned ring with a dark red stone in it that had belonged to Linda's father . . And she was always so fresh so delicious. "Mother, you smell of cold water," she had said – The old woman could bear nothing next to her skin but fine linen and she bathed in cold water summer and winter – even when she had to pour a kettle of boiling water over the frozen tap. "Isn't there anything for me to do, Mother," she

"No, darling. I wish you would go into the garden and give an eye to your children; but that I know you will not do."

"Of course I will, but you know Isabel is much more grown up than any of us."

"Yes, but Kezia is not," said Mrs. Fairfield.

"Oh, Kezia has been tossed by a bull hours ago," said Linda, winding herself up in her shawl again.

But no, Kezia had seen a bull through a hole in a knot of wood in the paling that separated the tennis lawn from the paddock. But she had not liked the bull frightfully, so she had walked away back through the orchard, up the grassy slope, along the path by the lace bark tree and so into the spread tangled garden. She did not believe that she would ever not get lost in this garden. Twice she had found her way back to the big iron gates they had driven through the night before, and then had turned to walk up the drive that led to the house, but there were so many little paths on either side. On one side they all led into a tangle of tall dark trees and strange bushes with flat velvet leaves and feathery cream flowers that buzzed with flies when you shook them – this was the frightening side, and no garden at all. The little paths here were wet and clayey with tree roots spanned across them like the marks of big fowls' feet.

But on the other side of the drive there was a high box border and the paths had box edges and all of them led into a deeper and deeper tangle of flowers. The camellias were in bloom, white and crimson and pink and white striped with flashing leaves. You could not see a leaf on the syringa bushes for the white clusters. The roses were in flower – gentlemen's button-hole roses, little white ones, but far too full of insects to hold under anyone's nose, pink monthly roses with a ring of fallen petals round the bushes, cabbage roses on thick stalks, moss roses, always in bud, pink smooth beauties opening curl on curl, red ones so dark they seemed to turn back as they fell, and a certain exquisite cream kind with a slender red stem and bright scarlet leaves.

There were clumps of fairy bells, and all kinds of geraniums, and there were little trees of verbena and bluish lavender bushes and a bed of

asked. "No darling. Run and see what the garden is like. I wish you would give an eye to the children but that I know you will not do." "Of course I will, but you know Isabel is much more grown up than any of us." "Yes, but Kezia is not" said Mrs. Fairfield. "Oh Kezia's been tossed by a wild bull *hours* ago" said Linda, winding herself up in her shawl again.

But no, Kezia had seen a bull through a hole in a notch of wood in the high paling fence that separated the tennis lawn from the paddock, but she had not liked the bull frightfully and so she had walked away back ~~up~~ through the orchard up the grassy slope along the path by the lace bark tree and so into the spread tangled garden. She did not believe that she would ever not get lost in this garden. Twice she had found her way to the big iron gates ~~that~~ they had driven through last night and she had begun to walk up the drive that led to the house, but there were so many little paths on either side – – on one side they all led into a tangle of tall dark trees and strange bushes with flat velvety leaves and feathery cream flowers that buzzed with flies when you shook them – this was a frightening side and no garden at all. The little paths were wet and clayey with tree roots spanned across them, "like big fowls feet" thought Kezia. But on the other side of the drive there was a high box border and the paths had box edgings and all of them led into a deeper and deeper tangle of flowers. It was summer. The camellia trees were in flower, white and crimson and pink and white striped with flashing leaves – you could not see a leaf on the syringa bushes for the white clusters. All kinds of roses – gentlemen's button hole roses, little white ones but far too full of insects to put under any body's nose, pink monthly roses with a ring of fallen petals round the bushes, cabbage roses on thick fat stalks, moss roses, always in bud, pink smooth beauties opening curl on curl, red ones so dark that they seemed to turn black as they fell and a certain exquisite cream kind with a slender red stem and bright red leaves. Kezia knew the name of that kind: it was her grandmother's favourite. There were clumps of fairy bells and cherry pie and all kinds of geraniums and there were little trees of verbena and bluish lavender bushes and a bed of pelagoniums with velvet eyes and leaves like moth's wings. There was a

pelagoniums with velvet eyes and leaves like moths' wings. There was a bed of nothing but mignonette another of nothing but pansies — borders of double and single daisies and all kinds of little tufty plants she had never seen before.

The red-hot pokers were taller than she; the Japanese sunflowers grew in a tiny jungle. She sat down on one of the box borders. By pressing hard at first it made a nice seat. But how dusty it was inside! Kezia bent down to look and sneezed and rubbed her nose.

And then she found herself at the top of the rolling grassy slope that led down to the orchard. . . . She looked down at the slope a moment; then she lay down on her back, gave a squeak and rolled over and over into the thick flowery orchard grass. As she lay waiting for things to stop spinning, she decided to go up to the house and ask the servant girl for an empty match-box. She wanted to make a surprise for the grandmother. . . . First she would put a leaf inside with a big violet lying on it, then she would put a very small white picotee, perhaps, on each side of the violet, and then she would sprinkle some lavender on the top, but not to cover their heads.

She often made these surprises for the grandmother, and they were always most successful.

"Do you want a match, my granny?"

"Why, yes, child, I believe a match is just what I'm looking for."

The grandmother slowly opened the box and came upon the picture inside.

"Good gracious, child! How you astonished me!"

"I can make her one every day here," she thought, scrambling up the grass on her slippery shoes.

But on her way back to the house she came to that island that lay in the middle of the drive, dividing the drive into two arms that met in front of the house. The island was made of grass banked up high. Nothing grew on the top except one huge plant with thick, grey-green, thorny leaves, and out of the middle there sprang up a tall stout stem. Some of the leaves of the plant were so old that they curled up in the air no longer; they turned back, they

bed of nothing but mignonette and another of nothing but pansies –
borders of double and single daisies, all kinds of little tufty plants she
never

 The red hot pokers were taller than she; the Japanese sunflowers grew
in a tiny jungle. She sat down on one of the box borders. ~~If you~~ By pressing
hard at first it made a very pleasant springy seat but how dusty it was
inside – She bent down to look and sneezed and rubbed her nose. And
then she found herself again at the top of the rolling grassy slope that led
down to the orchard and beyond the orchard to an avenue of pine trees
with wooden seats between bordering one side of the tennis court . . She
looked at the slope a moment; then she lay down on her back gave a tiny
squeak and rolled over and over into the thick flowery orchard grass. As
she lay still waiting for things to stop spinning round she decided to go up
to the house and ask the servant girl for an empty match-box. She wanted
to make a surprise for the grandmother. First she would put a leaf inside
with a big violet lying on it – then she would put a very small little white
picotee perhaps, on each side of the violet and then she would sprinkle
some lavender on the top, but not to cover their heads. She often made
these surprises for the grandmother and they were always most
successful: "Do you want a match, my Granny?" "Why, yes, child. I
believe a match is the very thing I am looking for –" ~~Then came the
thrilling moment when~~ The Grandmother slowly opened the box and
came upon the picture inside. "Good gracious child! how you astonished
me!" "Did I – did I really astonish you?" Kezia threw up her arms with joy.
"I can make her one every day here" she thought, scrambling up the grass
slope on her slippery shoes. But on her way to the house she came to the
island that lay in the middle of the drive, dividing the drive into two arms
that met in front of the house. The island was made of grass banked up
high. Nothing grew on the green top at all except one ~~big kind of~~ huge
round plant ~~or tree,~~ with thick grey-green thorny leaves ~~notched like
teeth of a saw~~ and out of the middle there ~~reared~~ sprang up a tall stout
stem. Some of the leaves of this plant were so old that they curved up in
the air no longer, they turned back – they were split and broken – some

Prelude were split and broken; some of them lay flat and withered on the ground.

Whatever could it be? She had never seen anything like it before. She stood and stared. And then she saw her mother coming down the path. "Mother, what is it?" asked Kezia.

Linda looked up at the fat swelling plant with its cruel leaves and fleshy stem. High above them, as though becalmed in the air, and yet holding so fast to the earth it grew from, it might have had claws instead of roots. The curving leaves seemed to be hiding something; the blind stem cut into the air as if no wind could ever shake it.

"That is an aloe, Kezia," said her mother.

"Does it ever have any flowers?"

"Yes, Kezia," and Linda smiled down at her, and half shut her eyes. "Once every hundred years."

VII On his way home from the office Stanley Burnell stopped the buggy at the Bodega, got out and bought a large bottle of oysters. At the Chinaman's shop next door he bought a pineapple in the pink of condition, and noticing a basket of fresh black cherries he told John to put him in a pound of those as well. The oysters and the pine he stowed away in the box under the front seat, but the cherries he kept in his hand.

Pat, the handy-man, leapt off the box and tucked him up again in the brown rug.

"Lift yer feet, Mr. Burnell, while I give yer a fold under," said he.

"Right! Right! First-rate!" said Stanley. "You can make straight for home now."

Pat gave the grey mare a touch and the buggy sprang forward.

"I believe this man is a first-rate chap," thought Stanley. He liked the look of him sitting up there in his neat brown coat and brown bowler. He liked the way Pat had tucked him in, and he liked his eyes. There was nothing servile about him – and if there was one thing he hated more than another it was servility. And he looked as if he was pleased with his job – happy and contented already.

The grey mare went very well; Burnell was impatient to be out of the

94

of them lay flat and withered on the ground – but the fresh leaves curved The Aloe
up in to the air with their spiked edges; some of them looked as though
they had been painted with broad bands of yellow. Whatever could it be?
She had never seen anything like it before – She stood and stared. And
then she saw her Mother coming down the path with a red carnation in
her hand – "Mother what is it?" asked Kezia. Linda looked up at the fat
swelling plant with its cruel leaves its towering fleshy stem. High above
them, as though becalmed in the air, and yet holding so fast to the earth it
grew from it might have had claws and not roots. The curving leaves
seemed to be hiding something; the big blind stem cut into the air as if no
wind could ever shake it. "That is an aloe, Kezia," said Linda. "Does it
ever have any flowers." "Yes my child" said her Mother and she smiled
down at Kezia, half shutting her eyes, "once every hundred years."

Chapter III.

On his way home from the office Stanley Burnell stopped the buggy at
the "Bodega", got out and bought a large bottle of oysters. At
the chinaman's shop next door he bought a pine apple in the pink of
condition and noticing a basket of fresh black cherries he told John to put
him up a pound of those as well. The oysters and pine apple he stowed
away in the box under the front seat – but the cherries he kept in his
hand. Pat, the handy man, leapt off the box and tucked him up again in a
brown rug. "Lift yer feet, Mr. Burnell while I give her a fold under," said
he. "Right, right – first rate!" said Stanley – "you can make straight for
home now." "I believe this chap man is a first rate chap" thought he as Pat
gave the grey mare a touch and the buggy sprang forward. He liked the
look of him sitting up there in his neat dark brown coat and brown
bowler – he liked the way Pat had tucked him in and he liked his eyes –
There was nothing servile about him, – and if there was one thing he
hated more than another in a servant it was servility – and he looked as
though he liked his were pleased with his job – he looked happy and
contented. The grey mare went very well. Burnell was impatient to be

95

town. He wanted to be home. Ah, it was splendid to live in the country – to get right out of that hole of a town once the office was closed; and this drive in the fresh warm air, knowing all the while that his own house was at the other end, with its garden and paddocks, its three tip-top cows and enough fowls and ducks to keep them in poultry, was splendid too.

As they left the town finally and bowled away up the deserted road his heart beat hard for joy. He rooted in the bag and began to eat the cherries, three or four at a time, chucking the stones over the side of the buggy. They were delicious, so plump and cold, without a spot or a bruise on them.

Look at those two, now – black one side and white the other – perfect! A perfect little pair of Siamese twins. And he stuck them in his button-hole. . . . By Jove, he wouldn't mind giving that chap up there a handful – but no, better not. Better wait until he had been with him a bit longer.

He began to plan what he would do with his Saturday afternoons and his Sundays. He wouldn't go to the club for lunch on Saturday. No, cut away from the office as soon as possible and get them to give him a couple of slices of cold meat and half a lettuce when he got home. And then he'd get a few chaps out from town to play tennis in the afternoon. Not too many – three at most. Beryl was a good player, too. . . . He stretched out his right arm and slowly bent it, feeling the muscle. . . . A bath, a good rub-down, a cigar on the verandah after dinner. . . .

On Sunday morning they would go to church—children and all. Which reminded him that he must hire a pew, in the sun if possible and well forward so as to be out of the draught from the door. In fancy he heard himself intoning extremely well: "When thou did overcome the *Sharp*ness of Death Thou didst open the *King*dom of Heaven to *all* Believers." And he saw the neat brass-edged card on the corner of the pew – Mr. Stanley Burnell and family. . . . The rest of the day he'd loaf about with Linda. . . . Now they were walking about the garden; she was on his arm, and he was explaining to her at length what he intended doing at the office the week following. He heard her saying: "My dear, I think that is most wise. . . ." Talking things over with Linda was a wonderful help even though they

out of the town. He wanted to be home. Ah, it was splendid to live in the country – to get right out of this hole of a town once the office was closed and this long drive in the fresh warm air knowing all the time that his own house was at the other end with its garden and paddocks, its three tip top cows and enough fowls and ducks to keep them in eggs and poultry was splendid, too. As they left the town finally and bowled away up the quiet road his heart beat hard for joy – He rooted in the bag and began to eat the cherries, three or four at a time chucking the stones over the side of the buggy. They were delicious, so plump and cold without a spot or a bruise on them. Look at ~~that~~ these two now – black one side and white the other – perfect – a perfect little pair of siamese twins – and he stuck them in his button hole – By Jove, he wouldn't mind giving that chap up there a handful, but no, better not! Better wait until he had been with him a bit longer. He began to plan what he would do with his Saturday afternoons and Sundays. He wouldn't go to the Club for lunch on Saturday. No, cut away from the office as soon as possible and get them to give him a couple of slices of cold meat and half a lettuce when he got home. And then he'd get a few chaps out from town to play tennis in the afternoons. Not too many – three at most. Beryl was a good player too. He stretched out his right arm and slowly bent it, feeling the muscles. ~~And on Sunday morning~~ A bath, a good rub down, a cigar on the verandah after dinner. On Sunday morning they would go to church – children and all – which reminded him that he must hire a pew *in* the sun if possible – and well forward so as to be out of the draught from the door – In fancy he heard himself intoning, extremely well:

"When-thou-didst-over*come* the sharpness of death Thou didst open the *King*dom of Heaven to *All* Believers" and he saw the neat brass edged card on the corner of the pew "Mr Stanley Burnell and Family." The rest of the day he'd loaf about with Linda. Now she was on his arm; ~~and~~ they were walking about the garden together and he was explaining to her at length what he intended doing at the office the week following. He heard her saying: "My dear, I think that is *most wise*." Talking things out with Linda was a wonderful help even though they were apt to drift away from

97

were apt to drift away from the point.

Hang it all! They weren't getting along very fast. Pat had put the brake on again. Ugh! What a brute of a thing it was. He could feel it in the pit of his stomach.

A sort of panic overtook Burnell whenever he approached near home. Before he was well inside the gate he would shout to anyone within sight: "Is everything all right?" And then he did not believe it was until he heard Linda say: "Hullo! Are you home again?" That was the worst of living in the country – it took the deuce of a long time to get back. . . . But now they weren't far off. They were on the top of the last hill; it was a gentle slope all the way now and not more than half a mile.

Pat trailed the whip over the mare's back and he coaxed her: "Goop now. Goop now."

It wanted a few minutes to sunset. Everything stood motionless bathed in bright, metallic light and from the paddocks on either side there streamed the milky scent of ripe grass. The iron gates were open. They dashed through and up the drive and round the island, stopping at the exact middle of the veranda.

"Did she satisfy yer, sir?" said Pat, getting off the box and grinning at his master.

"Very well indeed, Pat," said Stanley.

Linda came out of the glass door; her voice rang in the shadowy quiet. "Hullo! Are you home again?"

At the sound of her his heart beat so hard that he could hardly stop himself dashing up the steps and catching her in his arms.

"Yes, I'm home again. Is everything all right?"

Pat began to lead the buggy round to the side gate that opened into the courtyard.

"Here, half a moment," said Burnell. "Hand me those two parcels." And he said to Linda, "I've brought you back a bottle of oysters and a pineapple," as though he had brought her back all the harvest of the earth.

They went into the hall; Linda carried the oysters in one hand and the pineapple in the other. Burnell shut the glass door, threw his hat down, put

the point . . Hang it all! They weren't getting along very fast. Pat had put
the brake on again. "He's a bit too ready with that brake! Ugh! What a
brute of a thing it is – I can feel it in the pit of my stomach." A sort of panic
overtook Burnell whenever he approached near home. Before he was
well inside the gate he would shout to any one in sight, "is everything all
right?" and then he did not believe it was until he had heard Linda cry
"Hullo, you old boy!" That was the worst, of living in the country. It took
the deuce of a long time to get back. But now they weren't far off. They
were on top of the last hill – it was a gentle slope all the way now and not
more than ½ a mile. Great Scott! what was that – Some fool of a woman
had come from the roadside and waving shouting enough to frighten the
mare into fits! Pat kept up a constant trailing of the whip across the
mare's back and he coaxed her – "goop now goop now!" It wanted a few
moments to sunset, everything stood motionless in a bathed in bright
metallic light and from the paddocks on either side there streamed the
warm milky smell of ripe hay – He saw the trees of the garden, The iron
gates were open. They dashed through and up the drive and round the
island stopping at the exact middle of the verandah. "Did she satisfy yer,
sir," said Pat, getting off the box and grinning at his master. "Very well
indeed Pat," said Stanley. Linda came out of the glass door – out of the
shadowy hall – her voice rang in the quiet. "Hullo, you're home again."
"Yes, home again," said At the sound of it his happiness beat up so hard
and strong that he could hardly stop himself dashing up the steps and
catching her in his arms – "Yes home again. Is everything all right."
"Perfect" said she. Pat began to lead the buggy mare round to the side
gate that gave onto the courtyard. "Here half a moment" said Burnell and
he took out of the seat "Hand me those two parcels – will you." And he
said to Linda "I've brought you back a bottle of oysters and a pine apple"
as though he had brought her back all the riches harvest of the earth.
They went into the hall; Linda carried the oysters under one arm and the
pineapple under the other – Burnell shut the glass door threw his hat on
the hall stand and put his arms round her, straining her to him kissing the
top of her head, her ears her lips – her eyes – "Oh dear Oh dear" she said

99

his arms round her and strained her to him, kissing the top of her head, her ears, her lips, her eyes.

"Oh, dear! Oh, dear!" said she. "Wait a moment. Let me put down these silly things," and she put the bottle of oysters and the pine on a little carved chair. "What have you got in your buttonhole – cherries?" She took them out and hung them over his ear.

"Don't do that, darling. They are for you."

So she took them off his ear again. "You don't mind if I save them. They'd spoil my appetite for dinner. Come and see your children. They are having tea."

The lamp was lighted on the nursery table. Mrs. Fairfield was cutting and spreading bread and butter. The three little girls sat up to table wearing large bibs embroidered with their names. They wiped their mouths as their father came in ready to be kissed. The windows were open; a jar of wild flowers stood on the mantelpiece, and the lamp made a big soft bubble of light on the ceiling.

"You seem pretty snug, mother," said Burnell, blinking at the light. Isabel and Lottie sat one on either side of the table, Kezia at the bottom – the place at the top was empty.

"That's where my boy ought to sit," thought Stanley. He tightened his arm round Linda's shoulder. By God, he was a perfect fool to feel as happy as this!

"We are, Stanley. We are very snug," said Mrs. Fairfield, cutting Kezia's bread into fingers.

"Like it better than town – eh, children?" asked Burnell.

"Oh, yes," said the three little girls, and Isabel added as an after-thought: "Thank you very much indeed, father dear."

"Come upstairs," said Linda. "I'll bring your slippers."

But the stairs were too narrow for them to go up arm in arm. It was quite dark in the room. He heard her ring tapping on the marble mantelpiece as she felt for the matches.

"I've got some, darling. I'll light the candles."

But instead he came up behind her and again he put his arms round her

"Wait a minute let me put down these *silly* things" and she put down the
bottle of oysters and the pine on a little carved chair – "What have you
got in your buttonhole, cherries?" – and she took them out and hung
them over his ear. "No don't do that darling. They're for you." So she ~~put~~
took them off his ear and ran them through her brooch pin – "You don't
mind if I don't eat them now. Do you? They'll spoil my appetite for dinner
– Come and see your children. They're having tea." The lamp was lighted
on the nursery table: Mrs. Fairfield was cutting and spreading bread and
butter and the three little girls sat up to table wearing large bibs
embroidered with their names. They wiped their mouths as their Father
came in ready to be kissed. There was jam on the table too a plate of
home made knobbly buns and cocoa steaming in a Dewar's Whisky
Advertisement jug – a big toby jug, half brown half cream with a picture
of a man on it smoking a long clay pipe. The windows were wide open.
There was a jar of wild flowers on the mantelpiece and the lamp made a
big soft bubble of light on the ceiling – "You seem pretty snug Mother"
said Burnell, looking round and blinking at the light ~~and smiling at the~~ little
girls. They sat ~~one on each side of the table~~ Isabel and Lottie on either
side of the table, Kezia at the bottom – the place at the top was empty –
"That's where my boy ought to sit" thought Stanley – He tightened his
arm round Linda's shoulder. By God! he was a perfect fool to feel as happy
as this – – "We are Stanley. We are very snug," said Mrs. Fairfield, cutting
Kezia's bread and jam into fingers. "Like it better than town eh children"
said Burnell. "Oh yes, Daddy" said the three little girls and Isabel added as
an afterthought, "Thank you very much *indeed* Father dear."

"Come upstairs and have a wash" said Linda – "I'll bring your slippers."
But the stairs were too narrow for them to go up arm in arm. It was quite
dark in their room – He heard her ring tapping the marble as she felt
along the mantelpiece for matches. "I've got some darling. I'll light the
candles." But instead, he came up behind her and caught her put his arms

and pressed her head into his shoulder.

"I'm so confoundedly happy," he said.

"Are you?" She turned and put her hands on his breast and looked up at him.

"I don't know what has come over me," he protested.

It was quite dark outside now and heavy dew was falling. When Linda shut the window the cold dew touched her finger tips. Far away a dog barked. "I believe there is going to be a moon," she said.

At the words, and with the cold wet dew on her fingers, she felt as though the moon had risen – that she was being strangely discovered in a flood of cold light. She shivered; she came away from the window and sat down upon the box ottoman beside Stanley.

In the dining-room, by the flicker of a wood fire, Beryl sat on a hassock playing the guitar. She had bathed and changed all her clothes. Now she wore a white muslin dress with black spots on it and in her hair she had pinned a black silk rose.

> Nature has gone to her rest, love,
>> See, we are alone.
> Give me your hand to press, love,
>> Lightly within my own.

She played and sang half to herself, for she was watching herself playing and singing. The firelight gleamed on her shoes, on the ruddy belly of the guitar, and on her white fingers. . . .

"If I were outside the window and looked in and saw myself I really would be rather struck," thought she. Still more softly she played the accompaniment – not singing now but listening.

". . . The first time that I ever saw you, little girl – oh, you had no idea that you were not alone – you were sitting with your little feet upon a hassock, playing the guitar. God, I can never forget. . . ." Beryl flung up her head and began to sing again:

> Even the moon is aweary . . .

round her and pressed her head into his shoulder. "I'm so confoundedly happy" he said. "Are you?" She turned and put her two hands flat on his breast and looked up at him – "I don't know what's come over me" he protested. It was quite dark outside now and heavy dew was falling. When she shut the window the tips of her fingers the dew wet her finger tips. Far away, a dog barked. "I believe there's going to be a moon" said she – At the words and with the wet cold dew touching her lips and cheeks she felt as though the moon had risen – that she was being bathed in cold light – she shivered she came away from the window and sat down on the box ottoman beside Stanley –

In the dining room by the flickering glow of a wood fire Beryl sat on a hassock playing the guitar. She had bathed and changed all her clothes. Now she wore a white muslin dress with big black spots on it and in her hair she had pinned a black rose –

> Nature has gone to her rest love
> See we are all alone
> Give me your hand to press love
> Lightly within my own –

She played and sang in a half to herself – for she was watching herself playing and singing she saw the fire light on her shoes and skirt on the ruddy belly of the guitar on her white fingers. "If I were outside the window and looked in and saw myself I really would be rather struck" she thought – Still more softly she played the accompaniment not singing – "The first time I ever saw you little girl you had no idea that you weren't alone! You were sitting with your little feet up on a hassock playing the guitar – I can never forget –" and she flung back her head at the imaginary speaker and began to sing again

> Even the moon is aweary –

But there came a loud bang at the door. The servant girl's crimson face popped through.

"Please, Miss Beryl, I've got to come and lay."

"Certainly, Alice," said Beryl, in a voice of ice. She put the guitar in a corner. Alice lunged in with a heavy black iron tray.

"Well, I have had a job with that oving," said she. "I can't get nothing to brown."

"Really!" said Beryl.

But no, she could not stand that fool of a girl. She ran into the dark drawing-room and began walking up and down. . . . Oh, she was restless, restless. There was a mirror over the mantel. She leaned her arms along and looked at her pale shadow in it. How beautiful she looked, but there was nobody to see, nobody.

"Why must you suffer so?" said the face in the mirror. "You were not made for suffering. . . . Smile!"

Beryl smiled, and really her smile *was* so adorable that she smiled again – but this time because she could not help it.

VIII

"Good morning, Mrs. Jones."

"Oh, good morning, Mrs. Smith. I'm so glad to see you. Have you brought your children?"

"Yes, I've brought both my twins. I have had another baby since I saw you last, but she came so suddenly that I haven't had time to make her any clothes yet. So I left her. . . . How is your husband?"

"Oh, he is very well, thank you. At least he had a nawful cold but Queen Victoria – she's my godmother, you know – sent him a case of pineapples and that cured it im–mediately. Is that your new servant?"

"Yes, her name's Gwen. I've only had her two days. Oh, Gwen, this is my friend, Mrs. Smith."

"Good morning, Mrs. Smith. Dinner won't be ready for about ten minutes."

"I don't think you ought to introduce me to the servant. I think I ought to

But there came a loud knock at the door. The servant girl popped in her flushed face. "If you please Miss – kin I come and lay the dinner" – "Certainly Alice" said Beryl – in a voice of ice. She put the guitar in a corner – Alice lunged in with a heavy ~~tin tray~~ black iron tray, "Well I *ave* had a job with that ~~stove~~ oving" said she. "I can't get nothing to brown."

"*Really*" said Beryl – But no, she could not bear that fool of a girl – She went into the dark drawing room and began walking up and down – She was restless, restless restless. There was a mirror over the mantelpiece she leaned her arms along and looked at ~~herself in it~~ her pale shadow in it – "I look as though I have been drowned" – said she –

Chapter IV children and Ducks

"**G**ood Morning Mrs. Jones."
"Oh, good morning Mrs. Smith. I'm so glad to see you. Have you brought your children?" "Yes, I've brought both my twins. I have had another baby since I saw you last but she came so suddenly that I haven't had time to make her any clothes yet and so I left her at home. How's your husband." "Oh he's very [well] thank you. At least he had an awful sore throat, but Queen Victoria (she's my grandmother you know) sent him a case of pineapples and they cured it immediately – Is that your new servant." "Yes, her name's Gwen. I've only had her two days – Oh Gwen, this is my friend Mrs. Smith." "Good morning Mrs. Smith. Dinner won't not be ready for about ten minutes." "I don't think you ought to introduce me to the servant, I think I ought to just begin talking to her."

just begin talking to her."

"Well, she's more of a lady-help than a servant and you do introduce lady-helps, I know, because Mrs. Samuel Josephs had one."

"Oh, well, it doesn't matter," said the servant carelessly, beating up a chocolate custard with half a broken clothes peg. The dinner was baking beautifully on a concrete step. She began to lay the cloth on a pink garden seat. In front of each person she put two geranium leaf plates, a pine needle fork and a twig knife. There were three daisy heads on a laurel leaf for poached eggs, some slices of fuchsia petal cold beef, some lovely little rissoles made of earth and water and dandelion seeds, and the chocolate custard which she had decided to serve in the pawa shell she had cooked it in.

"You needn't trouble about my children," said Mrs. Smith graciously. "If you'll just take this bottle and fill it at the tap – I mean at the dairy."

"Oh, all right," said Gwen, and she whispered to Mrs. Jones: "Shall I go and ask Alice for a little bit of real milk?"

But someone called from the front of the house and the luncheon party melted away, leaving the charming table, leaving the rissoles and the poached eggs to the ants and to an old snail who pushed his quivering horns over the edge of the garden seat and began to nibble a geranium plate.

"Come round to the front, children. Pip and Rags have come."

The Trout boys were the cousins Kezia had mentioned to the storeman. They lived about a mile away in a house called Monkey Tree Cottage. Pip was tall for his age, with lank black hair and a white face, but Rags was very small and so thin that when he was undressed his shoulder blades stuck out like two little wings. They had a mongrel dog with pale blue eyes and a long tail turned up at the end who followed them everywhere; he was called Snooker. They spent half their time combing and brushing Snooker and dosing him with various awful mixtures concocted by Pip, and kept secretly by him in a broken jug covered with an old kettle lid. Even faithful little Rags was not allowed to know the full secret of these mixtures. . . .

"Well she isn't really quite a servant. She's more of a lady help than a servant and you do introduce Lady Helps I know because Mrs. Samuel Josephs had one." "Oh well, it doesn't *matter*" said the new servant airily, beating up a chocolate custard with half a broken clothes peg. The dinner was baking beautifully on a concrete step – She began to lay the cloth on a broad pink garden seat. In front of each person she put 2 geranium leaf plates, a pine needle fork and a twig knife. There were three daisy heads on a laurel leaf for poached eggs, some slices of fuchsia petals for cold meat, some beautiful little rissoles made of earth and water and dandelion seeds, and the chocolate custard. Which she decided to serve in the pawa shell she had cooked it in – "You needn't trouble about my children" said Mrs. Smith graciously – "If you'll just take this bottil and fill it at the tap – I mean in the dairy." "Oh all right" said Gwen and she whispered to Mrs. Jones "Shall I go an ask Alice for a little bit of real milk?" But some one called from the front of the house "children children" and the luncheon party ~~scrambled to its feet~~ melted away leaving the charming table leaving the rissoles and the eggs on the stove – to the little ants and to an old snail who pushed his quivering horns over the edge of the pink garden seat and began slowly to nibble a geranium plate. "Come round to the front door children. Rags and Pip have come." The Trout Boys were cousins to the Burnells. They lived about a mile away in a house called Monkey Tree Cottage. Pip was tall for his age ~~and thin~~ with lank black hair and a white face but Rags was very small, and so thin that when he was undressed his shoulder blades stuck out like two little wings. They had a mongrel dog too ~~that followed them everywhere~~ with pale blue eyes and ~~a thin~~ long tail that turned up at the end who followed them everywhere; he was called Snooker ~~and though.~~ They were always combing and brushing Snooker and treating him in various extraordinary ~~home made concoctions that Pip~~ mixtures concocted by Pip and kept secretly by him in a broken jug to be diluted ~~as the occasion demanded~~ in a kerosene tin of hot water and applied to the shivering ~~creature –~~ but Snooker ~~always~~ was always full of fleas and he stank abominably. "~~Look out now Rags. Don't you touch that when I'm not here – If you put the tip of your finger~~

107

Take some carbolic tooth powder and a pinch of sulphur powdered up fine, and perhaps a bit of starch to stiffen up Snooker's coat. . . . But that was not all; Rags privately thought that the rest was gun-powder. . . . And he never was allowed to help with the mixing because of the danger. . . . "Why, if a spot of this flew in your eye, you would be blinded for life," Pip would say, stirring the mixture with an iron spoon. "And there's always the chance – just the chance, mind you – of it exploding if you whack it hard enough. . . . Two spoons of this in a kerosene tin will be enough to kill thousands of fleas." But Snooker spent all his spare time biting and snuffling, and he stank abominably.

"It's because he is such a grand fighting dog," Pip would say. "All fighting dogs smell."

The Trout boys had often spent the day with the Burnells in town, but now that they lived in this fine house and boncer garden they were inclined to be very friendly. Besides, both of them liked playing with girls – Pip, because he could fox them so, and because Lottie was so easily frightened, and Rags for a shameful reason. He adored dolls. How he would look at a doll as it lay asleep, speaking in a whisper and smiling timidly, and what a treat it was to him to be allowed to hold one. . . .

"Curve your arms round her. Don't keep them stiff like that. You'll drop her," Isabel would say sternly.

Now they were standing on the verandah and holding back Snooker,

~~in it then it'ld wither your hand off –~~"

He would see Pip mix some carbolic tooth powder and a bit of sulphur powdered fine and perhaps a pinch of starch to stiffen up Snooker's coat but he knew that was not all. There was something else added that Pip wouldn't tell him of covered with an old kettle lid. Rags privately thought it was gunpowder. Even Rags was not ~~real~~ allowed ~~freely told the secret~~ to share the secret of these mixtures. And he was never never on any account ~~allowed~~ permitted to help or to look on because of the danger – "Why if a spot of this flew up" Pip would say, stirring the mixture with an iron spoon "you'd be blinded to death and there's always the chance – just the chance of it exploding – if you whack it hard enough. Two spoon fulls of this will be enough ~~to kill~~ in a kerosene tin of water to kill thousands of fleas." Nevertheless Snooker spent all his leisure biting and nudging himself and he stank abominably – "It's because he's such a grand fighting dog" Pip would say. "All fighting dogs smell –" The Trout boys had often gone into town and spent the day with the Burnells but now that they had ~~come~~ become neighbours and lived in this big house and bonzer[5] ~~gates~~ garden they were inclined to be very friendly. Besides both of them liked playing with girls Pip because he could fox them so and because Lottie Burnell was so easily frightened and Rags for a shameful reason because he adored dolls. The way he would look at a doll as it lay asleep, speaking in a whisper and smiling timidly and the great treat it was to him to stretch out his arms and be given ~~Isabel's~~ a doll to hold! "Curl your arms round her. Don't keep them stiff out like that. You'll drop her" Isabel would command sternly. ~~And Rags would blush for fear and excitement. Now they were standing on the verandah watching Mrs. Fairfield where she cut some slices of ginger bread off a big square slab. "That's our ginger bread," shouted Pip. "We brought it over with us – our Mum made it, It's got more nuts than yours ever has – Look! it's all over nuts! I've had a tiny bit. I shelled the almonds. I stuck my hand in the saucepan of boiling water and grabbed them out and gave them a pinch and some of them popped right up and flew bang against the ceiling" – now that Now they were standing on the verandah and holding back~~

Prelude who wanted to go into the house but wasn't allowed to because Aunt Linda hated decent dogs.

"We came over in the bus with mum," they said, "and we're going to spend the afternoon with you. We brought over a batch of our gingerbread for Aunt Linda. Our Minnie made it. It's all over nuts."

"I skinned the almonds," said Pip. "I just stuck my hand into a saucepan of boiling water and grabbed them out and gave them a kind of pinch and the nuts flew out of the skins, some of them as high as the ceiling. Didn't they Rags?"

Rags nodded. "When they make cakes at our place," said Pip, "we always stay in the kitchen, Rags and me, and I get the bowl and he gets the spoon and the eggbeater. Sponge cake's best. It's all frothy stuff, then."

He ran down the verandah steps to the lawn, planted his hands on the grass, bent forward, and just did not stand on his head.

"That lawn's all bumpy," he said. "You have to have a flat place for standing on your head. I can walk round the monkey tree on my head at our place. Can't I, Rags?"

"Nearly," said Rags faintly.

"Stand on your head on the verandah. That's quite flat," said Kezia.

"No, smarty," said Pip. "You have to do it on something soft. Because if

Snooker who wanted to go into the house but wasn't allowed to because Aunt Linda hated decent dogs. "We came over with Mum on the bus" they said and we're going to stay to dinner and spend the afternoon — "What time's dinner at your new place." "The same time as we always used to have it," said Lottie. "When the bell rings." "Pooh! that isn't what time" said Pip. "We always have our dinner hal' pas' twelve. Let's go round to the kitchen and ask your servant what time yours is." "We're not allowed to go into the kitchen in the morning" said Isabel. "We have to keep away from the back of the house." "Well, Rags and I are because we're 'visitors'," said Pip. "Come on Rags."

But when they had passed through the side gate opening with a big iron ring that led into the courtyard they forgot all about asking the servant.

"The same as we always used to have" said Lottie "except we have cold milk instead of water to drink."

Now they were standing on the verandah and holding back Snooker who wanted to go into the house but wasn't allowed to because Aunt Linda hated decent dogs. "We came over on the bus with Mum," they said "and we're going to spend the afternoon and stay to tea. We brought over a batch of our gingerbread for Aunt Linda. Our Minnie made it. It's all over nuts – much more than yours ever has." "I shelled the almonds" said Pip. "I just stuck my hand in a saucepan of boiling water and grabbed them out and gave them a kind of pinch and the nuts flew out of the shells some of them as high as the ceiling. Didn't they Rags?" "When they make cakes at our place," said Pip "we always stay in the kitchen Rags and me and I get the bowl and he gets the spoon and the egg beater – Sponge cake's best – it's all frothy stuff then." He ran down the verandah steps on to the lawn, planted his hands on the grass bent forward and just did not stand on his head – "Pooh!" he said "that lawn's all bumpy, you have to have a flat place for standing on your head – I can walk all round the monkey tree on my head at our place – nearly, can't I Rags?" "Nearly!" said Rags faintly. "Stand on your head on the verandah. That's quite flat," said Lottie. "No, smartie," said Pip, "you have to do it

Prelude

you give a jerk and fall over, something in your neck goes click, and it breaks off. Dad told me."

"Oh, do let's play something," said Kezia.

"Very well," said Isabel quickly, "we'll play hospitals. I will be the nurse and Pip can be the doctor and you and Lottie and Rags can be the sick people."

Lottie didn't want to play that, because last time Pip had squeezed something down her throat and it hurt awfully.

"Pooh," scoffed Pip. "It was only the juice out of a bit of mandarin peel."

"Well, let's play ladies," said Isabel. "Pip can be the father and you can be all our dear little children."

"I hate playing ladies," said Kezia. "You always make us go to church hand in hand and come home and go to bed."

Suddenly Pip took a filthy handkerchief out of his pocket. "Snooker! Here, sir" he called. But Snooker, as usual, tried to sneak away, his tail between his legs. Pip leapt on top of him, and pressed him between his knees.

"Keep his head firm, Rags," he said, and he tied the handkerchief round Snooker's head with a funny knot sticking up at the top.

"Whatever is that for?" asked Lottie.

"It's to train his ears to grow more close to his head – see?" said Pip. "All fighting dogs have ears that lie back. But Snooker's ears are a bit too soft."

"I know," said Kezia. "They are always turning inside out. I hate that."

Snooker lay down, made one feeble effort with his paw to get the handkerchief off, but finding he could not, trailed after the children, shivering with misery.

IX Pat came swinging along; in his hand he held a little tomahawk that winked in the sun.

"Come with me," he said to the children, "and I'll show you how the kings of Ireland chop the head off a duck."

They drew back – they didn't believe him, and besides, the Trout boys

112

on something soft see? Because if you give a jerk – just a very little jerk
and fall over like that bump yourself something in your neck goes click
and it breaks right off. Dad told me . . " "Oh do let's have a game," said
Kezia – "Do let's play something or other – " "Very well" said Isabel
quickly "we'll play hospitals. I'll be the nurse and Pip can be the doctor
and you and Rags and Lottie can be the sick people" – But No, Lottie
didn't not want to play that because last time Pip squirted something
down her throat and it hurt awfully. "Pooh!" said Pip "it was only the
juice out of a bit of orange peel – " "Well let's play ladies" said Isabel "and
Pip can be my husband and you can be my three dear little children – Rags
can be the baby – " "I *hate* playing ladies" said Kezia "because you always
make us go to church hand in hand and come home again an ~~have a sleep~~
go to bed" – Suddenly Pip took a filthy handkerchief out of his pocket –
"Snooker, here sir" he called, but Snooker as usual, began to slink away
with his long bent tail between his legs. Pip leapt on top of him – and held
him by his knees – "Keep his head firm Rags" he said as he tied the
handkerchief round Snooker's head with a funny sticking up knot at the
top. "What ever is that for" – asked Lottie. "It's to train his ears to grow
~~right~~ more close to his head, see" said Pip. "All fighting dogs have ears
that lie kind of back and they prick up – but Snooker's got rotten ears
they're too soft." "I know" said Kezia, "they're always turning inside out
I *hate* that." "Oh it isn't that" said Pip "but I'm training his ears to look a
bit more fierce see" – Snooker lay down and made one feeble effort with
his paw to get the handkerchief off but finding he could not he trailed
after the children with his head bound up in the dirty rag – shivering with
misery. Pat came swinging by. In his hand he held a little tomahawk ~~with a~~
~~shining~~ that winked in the sun. "Come with me now" he said to the
children "and I'll show you how the Kings of Ireland chop off the head of a
duck." They held back – they didn't believe him it was one of his jokes,

had never seen Pat before.

"Come on now," he coaxed, smiling and holding out his hand to Kezia.

"Is it a real duck's head? One from the paddock?"

"It is," said Pat. She put her hand in his hard dry one, and he stuck the tomahawk in his belt and held out the other to Rags. He loved little children.

"I'd better keep hold of Snooker's head if there's going to be any blood about," said Pip, "because the sight of blood makes him awfully wild." He ran ahead dragging Snooker by the handkerchief.

"Do you think we ought to go?" whispered Isabel. "We haven't asked or anything. Have we?"

At the bottom of the orchard a gate was set in the paling fence. On the other side a steep bank led down to a bridge that spanned the creek, and once up the bank on the other side you were on the fringe of the paddocks. A little old stable in the first paddock had been turned into a fowl-house. The fowls had strayed far away across the paddock down to a dumping ground in a hollow, but the ducks kept close to that part of the creek that flowed under the bridge.

Tall bushes overhung the stream with red leaves and yellow flowers and clusters of blackberries. At some places the stream was wide and shallow, but at others it tumbled into deep little pools with foam at the edges and quivering bubbles. It was in these pools that the big white ducks had made themselves at home, swimming and guzzling along the weedy banks.

114

and besides the Trout boys had never seen Pat before – "Come on now"
he coaxed, smiling and holding out his hand to Kezia. "A real duck's head"
she said. "One from ours in the paddock where the fowls and ducks are"
– "It is" said Pat. She put her hand in his hard dry one, and he stuck the
tomahawk in his belt and held out the other to Rags – He loved little
children. "I'd better keep hold of Snooker's head, if there's going to be
any blood about" said Pip – trying not to show his excitement "because
the sight of blood makes him awfully wild sometimes" – He ran ahead
dragging Snooker by the knot in the handkerchief. "Do you think we
ought to" whispered Isabel to Lottie. "Because we haven't asked
Grandma or anybody have we?" "But Pat's looking after us," said Lottie.

At the bottom of the orchard a gate was set in the paling fence. On the
other side there was a steep bank leading down to a bridge that spanned
the creek and once up the bank on the other side you were ~~at~~ on the
fringe of the paddocks. A little disused stable in the first paddock had
been turned into a fowl house. All about it there spread wire netting
chicken runs new made by Pat. The fowls strayed far away across the
paddock down to a little dumping ground in a hollow on the other side
but the ducks kept close to that part of the creek that flowed under the
bridge and ran hard by the fowl house – Tall bushes overhung the stream
with red leaves and Dazzling yellow flowers and clusters of red and white
berries, and a little further on there were cresses and a water plant with a
flower like a yellow foxglove. At some places the stream was wide and
shallow, ~~you could find stepping stones and cross over,~~ enough to cross
by stepping stones but at other places it tumbled suddenly into a deep
rocky pool like a little lake with foam at the edges ~~and big bubbles and did~~
~~not escape except through a narrow waterfall – And it was in this pool~~
~~that the ducks had been swimming together and dive and move down —~~
~~They were [illegible] creatures and very greedy~~ with foam at the edge
and big quivering bubbles. ~~(The children called these pools "basins")~~
~~where they flowed out there was quite a tiny waterfall – and~~ It was in
these pools that the big white ducks loved to swim and guzzle ~~and~~ along
the ~~reedy~~ weedy banks. Up and down they swam, preening their dazzling

115

Up and down they swam, preening their dazzling breasts, and other ducks with the same dazzling breasts and yellow bills swam upside down with them.

"There is the little Irish navy," said Pat, "and look at the old admiral there with the green neck and the grand little flagstaff on his tail."

He pulled a handful of grain from his pocket and began to walk towards the fowl-house, lazy, his straw hat with the broken crown pulled over his eyes.

"Lid. Lid-lid-lid-lid-" he called.

"Qua. Qua-qua-qua-qua-" answered the ducks, making for land, and flapping and scrambling up the bank they streamed after him in a long waddling line. He coaxed them, pretending to throw the grain, shaking it in his hands and calling to them until they swept round him in a white ring.

From far away the fowls heard the clamour and they too came running across the paddock, their heads thrust forward, their wings spread, turning in their feet in the silly way fowls run and scolding as they came.

Then Pat scattered the grain and the greedy ducks began to gobble. Quickly he stooped, seized two, one under each arm, and strode across to the children. Their darting heads and round eyes frightened the children – all except Pip.

"Come on, sillies," he cried, "they can't bite. They haven't any teeth. They've only got those two little holes in their beaks for breathing through."

"Will you hold one while I finish with the other?" asked Pat. Pip let go of Snooker. "Won't I? Won't I? Give us one. I don't mind how much he kicks."

He nearly sobbed with delight when Pat gave the white lump into his arms.

There was an old stump beside the door of the fowl-house. Pat grabbed the duck by the legs, laid it flat across the stump, and almost at the same moment down came the little tomahawk and the duck's head flew off the stump. Up the blood spurted over the white feathers and over his hand.

When the children saw the blood they were frightened no longer. They crowded round him and began to scream. Even Isabel leaped about crying:

116

breasts and other ducks with yellow bills and yellow feet swam upside
down below them in the clear still water. "There they are" said Pat.
"There's the little Irish Navy, and look at the old Admiral there with the
green neck and the grand little flag staff on his tail." He pulled a handful of
grain out of his pocket and began to walk towards the fowl house lazily,
his old broad straw hat with the broken crown pulled off his eyes. "Lid-lid
lid lid-lid lid" he shouted – "Qua! Qua Qua!" shouted answered the
ducks, making for land and flopping and scrambling up the bank – They
streamed after him in a long waddling line – He coaxed them pretending
to throw the grain shaking it in his hands and calling to them until they
swept round him close round him quacking and pushing against each
other in a white ring – From far away the fowls heard the clamour and
they too came running across the paddock, their heads crooked forward,
their wings spread, turning in their feet in the silly way fowls run and
scolding as they ran came. Then Pat scattered the grain and the greedy
ducks began to gobble – Quickly he bent forward, seized two, tucked
them quacking and struggling one under each arm and strode across to
the children. Their darting heads, their flat beaks and round eyes
frightened the children – and they drew back all except Pip. "Come on
sillies" he cried, "They can't hurt, they haven't got any teeth have they
Pat – they've only got those 2 little holes in their beaks to breathe
through." "Will you hold one while I finish with the other" asked Pat. Pip
let go of Snooker – He danced up and down "Won't I! Won't I! Give us
one – I'll hold him. I'll not let him go. I don't care how much he kicks – give
us give us!" He nearly sobbed with delight when Pat put the white lump
in his arms – There was an old stump beside the door of the fowlshed –
Pat carried over the other duck, he gave it grabbed it up in one hand,
whipped out his little tomahawk – lay the duck flat on the stump and
suddenly down came the tomahawk and the duck's head flew off the
stump – up and up the blood spurted over the white feathers, over his
hand – And an extraordinary thing happened – When the children saw it
they were frightened no more – they crowded round him [and] began to
scream – even Isabel leaped about and called out "The blood the blood" –

"The blood! The blood!" Pip forgot all about his duck. He simply threw it away from him and shouted, "I saw it. I saw it," and jumped round the wood block.

Rags, with cheeks as white as paper, ran up to the little head, put out a finger as if he wanted to touch it, shrank back again and then again put out a finger. He was shivering all over.

Even Lottie, frightened little Lottie, began to laugh and pointed at the duck and shrieked: "Look, Kezia, look."

"Watch it!" shouted Pat. He put down the body and it began to waddle—with only a long spurt of blood where the head had been; it began to pad away without a sound towards the steep bank that led to the stream. . . . That was the crowning wonder.

"Do you see that? Do you see that?" yelled Pip. He ran among the little girls tugging at their pinafores.

"It's like a little engine. It's like a funny little railway engine," squealed Isabel.

But Kezia suddenly rushed at Pat and flung her arms round his legs and butted her head as hard as she could against his knees.

"Put head back! Put head back!" she screamed.

When he stooped to move her she would not let go or take her head away. She held on as hard as she could and sobbed: "Head back! Head back!" until it sounded like a loud strange hiccup.

"It's stopped. It's tumbled over. It's dead," said Pip.

Pat dragged Kezia up into his arms. Her sun-bonnet had fallen back, but she would not let him look at her face. No, she pressed her face into a bone in his shoulder and clasped her arms round his neck.

The children stopped screaming as suddenly as they had begun. They stood round the dead duck. Rags was not frightened of the head any more. He knelt down and stroked it now.

"I don't think the head is quite dead yet," he said. "Do you think it would keep alive if I gave it something to drink?"

But Pip got very cross: "Bah! You baby." He whistled to Snooker and went off.

118

Pip forgot all about his duck – He simply threw it away from him – and *The Aloe*
shouted "I saw it, I saw it" and jumped round the wood block –

Rags with cheeks as white as paper ran up to the little head and put out
a finger as if he meant to touch it then drew back again and again put out a
finger. He was shivering all over. Even Lottie frightened Lottie began to
laugh and point at the duck and shout "Look Kezia look look look" –
"Watch it" shouted Pat and he put down the white body and it began to
waddle – with only a long spurt of blood where the head had been – it
began to ~~waddle~~ pad along dreadfully ~~silently~~ quiet towards the steep
ledge that led to the stream – It was the crowning wonder. "Do you see
that – do you see it?" yelled Pip and he ran among the little girls pulling at
their pinafores – "It's like an engine – it's like a funny little darling
engine – " squealed Isabel – But Kezia suddenly rushed at Pat and flung
her arms round his legs and butted her head as hard as she could against
his knees; "Put head back put head back" she screamed – When he
stooped to move her she would not let go or take her head away – She
held as hard as ever she could and sobbed "head back head back" – until it
sounded like a loud, strange hiccough. "It's stopped it's tumbled over it's
dead" – said Pip. Pat dragged Kezia up into his arms. Her sunbonnet had
fallen back but she would not let him look at her face. No she pressed her
face into a bone in his shoulder and put her arms round his neck –

The children stopped squealing as suddenly as they had begun – they
stood round the dead duck. Rags was not frightened of the head any
more. He knelt down and stroked it with his finger and said "I don't think
perhaps the head is quite dead yet. It's warm Pip. Would it keep alive if I
gave it something to drink – " But Pip got very cross and said – "Bah! you
baby – " He whistled to Snooker and went off – and when Isabel went up

119

Prelude When Isabel went up to Lottie, Lottie snatched away.

"What are you always touching me for, Isabel?"

"There now," said Pat to Kezia. "There's the grand little girl."

She put up her hands and touched his ears. She felt something. Slowly she raised her quivering face and looked. Pat wore little round gold ear-rings. She never knew that men wore ear-rings. She was very much surprised.

"Do they come on and off?" she asked huskily.

X Up in the house, in the warm tidy kitchen, Alice, the servant girl, was getting the afternoon tea. She was "dressed." She had on a black stuff dress that smelt under the arms, a white apron like a large sheet of paper, and a lace bow pinned on to her hair with two jetty pins. Also her comfortable carpet slippers were changed for a pair of black leather ones that pinched her corn on her little toe something dreadful. . . .

It was warm in the kitchen. A blow-fly buzzed, a fan of whity steam came out of the kettle, and the lid kept up a rattling jig as the water bubbled. The clock ticked in the warm air, slow and deliberate, like the click of an old woman's knitting needle, and sometimes — for no reason at all, for there wasn't any breeze — the blind swung out and back, tapping the window.

Alice was making water-cress sandwiches. She had a lump of butter on the table, a barracouta loaf, and the cresses tumbled in a white cloth.

But propped against the butter dish there was a dirty, greasy little book, half unstitched, with curled edges, and while she mashed the butter she read:

"To dream of black-beetles drawing a hearse is bad. Signifies death of one you hold near or dear, either father, husband, brother, son, or intended. If beetles crawl backwards as you watch them it means death from fire or from great height such as flight of stairs, scaffolding, etc.

120

to Lottie, Lottie snatched away. ~~and she~~ "What are you always touching
me for Is a *bel*."

"There now" said Pat to Kezia "There's the grand little girl" – She put
up her hands and touched his ear. She felt something – Slowly she raised
her quivering face and looked – Pat wore little round gold earrings. How
very funny – She never knew men wore ear rings. She was very much
surprised! She quite forgot about the duck. "Do they come off and on,"
she asked huskily?

Alice in the Kitchen

Up at the house in the warm, tidy kitchen Alice the servant girl had
begun to get the afternoon tea ready – She was dressed. She had on a
black cloth dress that smelt under the arms, a white apron so stiff that it
rustled like paper to her every breath and movement – and a white
muslin bow pinned on top of her head by 2 large pins – and her
comfortable black felt slippers were changed for a pair of black leather
ones that pinched ~~her every~~ the corn on her little toe "Somethink
dreadful." It was warm in the kitchen – A big blow fly ~~flew~~ buzzed round
and round in a circle bumping against the ceiling – a curl of white steam
came out of the spout of the black kettle and the lid ~~flipped up and down~~
kept up a rattling jig as the water bubbled – The kitchen clock ticked in
the warm air slow and deliberate like the click of an old woman's knitting
needles and sometimes, for no reason at all, for there wasn't any breeze
outside the heavy venetians swung out and back tapping against the
windows. Alice was making water cress sanwitches. She had a ~~big butter~~
plate of butter ~~in a white cloth~~ on the table before her and a big loaf called
a "barracouta"[6] and the cresses tumbled together in the white cloth she
had dried them in – But propped against the butter dish there was a dirty
greasy little book – half unstitched with curled edges – And while she
mashed some butter soft for spreading she read – "To dream of four
black beetles dragging a hearse is bad. ~~It~~ Signifies ~~the~~ death of one you
hold near or dear either father husband brother son or intended. If the
beetles crawl backwards as you watch them it means death by fire or

"Spiders. To dream of spiders creeping over you is good. Signifies large sum of money in near future. Should party be in family way an easy confinement may be expected. But care should be taken in sixth month to avoid eating of probable present of shellfish. ..."

How many thousand birds I see.

Oh, life. There was Miss Beryl. Alice dropped the knife and slipped the *Dream Book* under the butter dish. But she hadn't time to hide it quite, for Beryl ran into the kitchen and up to the table, and the first thing her eye lighted on were those greasy edges. Alice saw Miss Beryl's meaning little smile and the way she raised her eyebrows and screwed up her eyes as though she were not quite sure what that could be. She decided to answer if Miss Beryl should ask her: "Nothing as belongs to you, Miss." But she knew Miss Beryl would not ask her.

Alice was a mild creature in reality, but she had the most marvellous retorts ready for questions that she knew would never be put to her. The composing of them and the turning of them over and over in her mind comforted her just as much as if they'd been expressed. Really, they kept her alive in places where she'd been that chivvied she'd been afraid to go to bed at night with a box of matches on the chair in case she bit the tops off in her sleep, as you might say.

"Oh, Alice," said Miss Beryl. "There's one extra to tea, so heat a plate of yesterday's scones, please. And put on the Victoria sandwich as well as the coffee cake. And don't forget to put little doyleys under the plates – will you? You did yesterday, you know, and the tea looked so ugly and common. And, Alice, don't put that dreadful old pink and green cosy on the afternoon teapot again. That is only for the mornings. Really, I think it ought to be kept for the kitchen – it's so shabby, and quite smelly. Put on the Japanese one. You quite understand, don't you?"

Miss Beryl had finished.

"That sing aloud from every tree ..."

from great height, such as flight of stairs, scaffolding etc. *Spiders*. To
dream of spiders creeping over you is good. ~~It~~ signifies large sum of
money in the near future. Should party be in family way an easy
confinement may be expected but care should be taken in sixth month to
avoid eating of probable present of shell fish." "How Many Thousand
Birds I see". Oh Life, there was Miss Beryl – Alice dropped the knife and
stuffed her Dream Book under the butter dish but she hadn't time to hide
it quite for Beryl ran into the kitchen and up to the table and the first
thing her eye lighted on – although she didn't say anything were the grey
edges sticking out from the plate ~~edge.~~ Alice saw Miss Beryl's ~~mean scorn~~
scornful meaning little smile and the way she raised her eyebrows and
screwed up her eyes as though she couldn't quite make out *what* that was
under the plate ~~edge~~ – She decided to answer if Miss Beryl should ask her
what it was – "Nothing as belongs to you Miss" "no business of yours
Miss" but she knew Miss Beryl would not ask her – . Alice was ~~the~~ a
~~mildest~~ creature in reality but she always had the most marvellous
retorts ready for the questions that she knew would never be put to her
– The composing of them and the turning of them over and over in her
brain comforted her just as much as if she'd really expressed them and
kept her self respect alive in places where she ~~was~~ had been that chivvied
she'd been afraid to go to bed at night with a box of matches on the chair
by her in case she bit the tops off in her sleep – as you might say. "Oh
Alice," said Miss Beryl "there's one extra to tea, so heat a plate of
yesterday's scones please and put on the new Victoria ~~sponge cake~~
sanwich as well as the coffee cake. And don't forget to put little doyleys
under the plates will you – You did yesterday again you know and the tea
looked *so* ugly and common. And Alice please don't put that dreadful old
pink and green cosy on the afternoon tea pot again. That is only for the
mornings and really I think it had better be kept for kitchen use – it's so
shabby and quite smelly – Put on the Chinese one out of the drawer in the
dining room side board – You quite understand, don't you. We'll have tea
as soon as it is ready – " Miss Beryl turned away – "That sing aloft on
every tree" she sang as she left the kitchen very pleased with her *firm*

123

she sang as she left the kitchen, very pleased with her firm handling of Alice.

Oh, Alice was wild. She wasn't one to mind being told, but there was something in the way Miss Beryl had of speaking to her that she couldn't stand. Oh, that she couldn't. It made her curl up inside, as you might say, and she fair trembled. But what Alice really hated Miss Beryl for was that she made her feel low. She talked to Alice in a special voice as though she wasn't quite all there; and she never lost her temper with her – never. Even when Alice dropped anything or forgot anything important Miss Beryl seemed to have expected it to happen.

"If you please, Mrs. Burnell," said an imaginary Alice, as she buttered the scones, "I'd rather not take my orders from Miss Beryl. I may be only a common servant girl as doesn't know how to play the guitar, but . . ."

This last thrust pleased her so much that she quite recovered her temper.

"The only thing to do," she heard, as she opened the dining-room door, "is to cut the sleeves out entirely and just have a broad band of black velvet over the shoulders instead. . . ."

handling of Alice.

Oh, Alice was wild! ~~She fair trembled~~ She wasn't one to mind being told, but there was something in the way Miss Beryl had of speaking to her that she couldn't stand. It made her curl up inside as you might say and she fair trembled. But what Alice really hated Miss Beryl for was – she made her feel low: she talked to Alice in a special voice as though she wasn't quite all there and she never lost her temper – never, even when Alice dropped anything or forgot anything she seemed to have expected it to happen . . . "If you please Mrs. Burnell," said an imaginary Alice, as she went on buttered the scones, "I'd rather not take my orders from Miss Beryl. I may be only a common servant girl ~~but I know my place~~ as doesn't know how to play the guitar." This last thrust pleased her so much that she quite recovered her temper. She carried her tray along the passage to the dining room ~~and banged the door panel with her foot for someone to open to her.~~[7] "The only thing to do," she heard as she opened the door "is to cut the sleeves out entirely and just have a broad band of black velvet over the shoulders and round the arms instead." Mrs. Burnell with her elder and younger sisters leaned over the table in the act of performing a very severe operation upon a white satin dress spread out before them. Old Mrs. Fairfield sat by the window in the sun with a roll of pink knitting in her lap. "My dears" said Beryl, "here comes the tea *at last*" and she swept a place clear for the tray. "But Doady ~~dear~~" she said to Mrs. Trout, "I don't think I should dare to appear without any sleeves at all should I?" "My dear" said Mrs. Trout "all I can say is that there isn't ~~a sign of a sleeve in one~~ one single evening dress in Mess' Readings last catalogue that has even ~~the~~ a sign of a sleeve. Some of them have a rose on the shoulder and a piece of black velvet but some of them haven't even that – and they look perfectly charming! ~~Have you got everything you want inquired Alice, speaking directly to Mrs. Burnell, but Beryl just looking in the hot water jug to see that Alice hadn't forgotten to fill it answered quietly "Yes everything thank you Alice."~~ What would look very pretty on the black velvet straps of your dress would be red poppies. I wonder if I can spare a couple out of this hat – " She was

Prelude

126

wearing a big cream leghorn hat trimmed with a wreath of ~~silk~~ poppies and daisies – and as she spoke she unpinned it and ~~put~~ laid it on her knee ~~and turned it around~~ and ran her hands over her dark silky hair. "Oh I think two poppies would look perfectly heavenly – " said Beryl, "and just be the right finish but of course I won't hear of you taking them out of that new hat, Doady – Not for worlds."

"It would be sheer murder," said Linda dipping a water cress sanwich into the salt cellar – and smiling at her sister – "But I haven't the faintest feeling about this hat, or any other for the matter of that," said Doady – and she looked mournfully at the bright thing on her knees and heaved a profound sigh. The three sisters were very unlike as they sat round the table – Mrs. Trout, tall and pale with heavy eyelids that dropped over her grey eyes, and rare, slender hands and feet was quite a beauty. ~~She was a widow. Her husband had died five years before and immediately upon his death, before he was cold she had married again, far more thoroughly and more faithfully than she ever had married him~~ But Life bored her. She was sure that something very tragic was going to happen to her soon – She had felt it coming on for years – What it was she could not exactly say but she was "fated" somehow. How often, when she had sat with Mother Linda and Beryl as she was sitting now ~~she had thought~~ her heart had said "How little they know" – or as it had then – "What a mockery this hat will be one day," and she had heaved just such a profound sigh. . . . And each time before her children were born she had thought that the tragedy would be fulfilled then – her child would be born dead or she saw the nurse going into Richard her husband and saying "Your child lives *but*" – and here the nurse pointed one finger upwards like the ~~figure of~~ illustration of Agnes in David Copperfield[8] – your wife is no more" – – But no, nothing particular had happened except that they had been boys and she had wanted girls, tender little caressing girls, not too strong with hair to curl and sweet little bodies to dress in white muslin threaded with pale blue – ~~For years now she had been a martyr to headaches.~~ Ever since her marriage she had lived at Monkey Tree Cottage – Her husband left for town at 8 o'clock every morning and did not return until half-past six

Prelude

128

at night. Minnie was a wonderful servant. She did everything there was to be done in the house and looked after the little boys and even worked in the garden – – So Mrs. Trout became a perfect martyr to headaches. Whole days she ~~used to lie~~ spent ~~reading~~ on the drawing room sofa with the blinds pulled down and a linen handkerchief steeped in eau de cologne on her forehead. And as she lay there she used to wonder why it was that she was so certain that life held something terrible for her ~~she used to~~ and to try to imagine what that terrible thing could be – – – until by and by she made up perfect novels with herself for the heroine, all of them ending with some shocking catastrophe. "Dora" (for in these novels she always thought of herself in the third person: ~~it gave her greater freedom for touching [? the reader]~~ it was more "touching" somehow) "Dora felt strangely happy that morning. She lay on the verandah ~~listening to a~~ looking out on the peaceful garden and she felt how sheltered and how blest her life had been after all. Suddenly the gate opened: A ~~rough~~ working man, a perfect stranger to her pushed up the path and standing in front of her, he pulled off his cap, his rough face full of pity. 'I've bad news for you Mam' 'Dead?' cried Dora clasping her hands. 'Both dead?' " Or since the Burnells had come to live at Tarana . . She woke at the middle of the night. The room was full of a strange glare. "Richard! Richard wake! Tarana is on fire" – – . At last all were taken out – they stood on the blackened grass watching the flames rage. Suddenly – the cry went up, Where was Mrs. Fairfield. God! Where was she. "Mother!" cried Dora, dropping onto her knees on the wet grass. "Mother." And then she saw her Mother appear at an upper window – Just for a moment she seemed to faintly waver – – There came a sickening crash. . . .

These dreams were so powerful that she would turn over buried her face in the ribbon work cushion and sobbed. But they were a profound secret – and Doady's melancholy was always put down to her dreadful headaches. . "Hand over the scissors Beryl and I'll snip them off now." "Doady! You are to do nothing of the kind," said Beryl handing her 2 pairs of scissors to choose from – The poppies were snipped off. "I hope you will really like Tarana" she said, sitting back in her chair and sipping her

Prelude

130

tea. "Of course it is at its best now but I can't help feeling a little afraid
that it will be very damp in the winter. Don't you feel that, Mother? The
very fact that the garden is so lovely is a bad sign in a way – and then of
course it is quite in the valley – isn't it – I mean it is lower than any of the
other houses." "I expect it will be flooded from the autumn to the
spring" said Linda: "we shall have to set little frog traps Doady, little
mouse traps in bowls of water baited with a spring of watercress instead
of a piece of cheese – And Stanley will have to row to the office in an open
boat. He'd love that. I can imagine the glow he would arrive in and the
way he'd measure his chest twice a day to see how fast it was expanding."
"Linda you are very silly – very" said Mrs. Fairfield. "What can you expect
from Linda," said ~~Beryl~~ Dora "she laughs at everything. Everything. I
often wonder if there will ever be anything that Linda will not laugh at."
"Oh, I'm a heartless ~~little~~ creature!" said Linda. She got up and went over
to her Mother. "Your cap is just a tiny wink crooked, Mamma" said she,
and she patted it straight with her quick little hands and kissed her
Mother. "A perfect little icicle" she said and kissed her again. "You mean
you love to think you are" said Beryl, and she blew into her thimble,
popped it on and drew the white satin dress towards her – and in the
silence that followed she had a strange feeling – she felt her anger like a
little serpent dart out of her bosom and strike at Linda. "Why do you
always pretend to be so indifferent to everything," she said. "You
pretend you don't care where you live, or if you see anybody or not, or
what happens to the children or even what happens to you. You can't be
sincere and yet you keep it up – you've kept it up for years – ~~ever since –~~
~~and Beryl paused, shoved down a little pleat very carefully – ever since~~
~~Father died. Oh she had such a sense of relief when she said that: she~~
~~breathed freely again – Linda's cheeks went white –~~ In fact" – and she
gave a little laugh of joy and relief to be so rid of the serpent – she felt
positively delighted – "I can't even remember when it started now –
Whether it started *with* Stanley or before Stanley's time or after you'd
had rheumatic fever or when Isabel was born – " "Beryl" said Mrs.
Fairfield sharply. "That's quite enough, quite enough!" But Linda jumped

131

XI The white duck did not look as if it had ever had a head when Alice placed it in front of Stanley Burnell that night. It lay, in beautifully basted resignation, on a blue dish – its legs tied together with a piece of string and a wreath of little balls of stuffing round it.

It was hard to say which of the two, Alice or the duck, looked the better basted; they were both such a rich colour and they both had the same air of gloss and strain. But Alice was fiery red and the duck a Spanish mahogany.

up. Her cheeks were very white. "Don't stop her Mother" she cried, "she's got a perfect right to say whatever she likes. Why on earth shouldn't she." "She has *not*" said Mrs. Fairfield. "She has no right *what*ever." Linda opened her eyes at her Mother. "What a way to contradict anybody," she said. "I'm ashamed of you – And how Doady must be enjoying herself. The very first time she comes to see us at our new house we sit hitting one another over the head – " The door handle rattled and turned. Kezia looked tragically in. "Isn't it *ever* going to be tea time" – she asked – "No, never!" said Linda. "Your Mother doesn't care Kezia ~~if~~ whether you ever ~~saw her again~~ set eyes upon her again. She doesn't care if you starve. You are all going to be sent to a Home for Waifs and Strays to-morrow." "Don't tease" said Mrs. Fairfield. "She believes every word." And she said to Kezia, "I'm coming darling. Run upstairs to the bathroom and wash your face your hands *and* your knees."

On the way home with her children Mrs. Trout began an entirely new "novel". It was night. Richard was out somewhere (He always was on these occasions.) She was sitting in the drawing room by candlelight playing over "Solveig's Song" when Stanley Burnell appeared – hatless – pale – at first he could not speak. "Stanley tell me what is it" . . and she put her hands on his shoulders. "Linda has gone!" he said hoarsely. Even Mrs. Trout's imagination could not question this flight. She had to ~~pass on~~ accept it very quickly and pass on. "She never cared," said Stanley – "God knows I did all I could – but she wasn't happy I knew she wasn't happy."

"Mum" said Rags ~~"which does a calf belong to the cow or the bull, Mother~~ which would you rather be if you had to a duck or a fowl – I'd rather be a fowl, much rather."

The white duck did not look as if it had ever had a head when Alice placed it in front of Stanley Burnell that evening.[9] It lay, in beautifully basted resignation, on the blue dish; its legs tied together with a piece of string and a wreath of little balls of stuffing round it. It was hard to say which of the two, Alice or the duck looked the better basted. ~~for she was plump and dark fiery up to her ears~~ They were both such a rich colour and they

133

Burnell ran his eye along the edge of the carving knife. He prided himself very much upon his carving, upon making a first-class job of it. He hated seeing a woman carve; they were always too slow and they never seemed to care what the meat looked like afterwards. Now he did; he took a real pride in cutting delicate shaves of cold beef, little wads of mutton, just the right thickness, and in dividing a chicken or a duck with nice precision. . . .

"Is this the first of the home products?" he asked, knowing perfectly well that it was.

"Yes, the butcher did not come. We have found out that he only calls twice a week."

But there was no need to apologise. It was a superb bird. It wasn't meat at all, but a kind of very superior jelly. "My father would say," said Burnell, "this must have been one of those birds whose mother played to it in infancy upon the German flute. And the sweet strains of the dulcet instrument acted with such effect upon the infant mind . . . Have some more, Beryl? You and I are the only ones in this house with a real feeling for food. I'm perfectly willing to state, in a court of law, if necessary, that I love good food."

Tea was served in the drawing-room, and Beryl, who for some reason had been very charming to Stanley ever since he came home, suggested a game of crib. They sat at a little table near one of the open windows. Mrs. Fairfield disappeared, and Linda lay in a rocking-chair, her arms above her head, rocking to and fro.

"You don't want the light – do you, Linda?" said Beryl. She moved the tall lamp so that she sat under its soft light.

How remote they looked, those two, from where Linda sat and rocked. The green table, the polished cards, Stanley's big hands and Beryl's tiny ones, all seemed to be part of one mysterious movement. Stanley himself, big and solid, in his dark suit, took his ease, and Beryl tossed her bright head

both had the same air of gloss and stain – Alice a peony red and the duck a spanish magohanay. Burnell ran his eye along the edge of the carving knife; he prided himself very much upon his carving; upon making a first-class job of it – He hated seeing a woman carve; they were always too slow and they never seemed to care what the meat looked like after they'd done with it. Now he did, he really took it seriously – he really took a pride in cutting delicate shaves of beef, little slices of mutton just the right thickness in his dividing a chicken or a duck with ~~such~~ nice precision – so that it could appear a second time and still ~~be recognized~~ look a decent member of society. "Is this one of the home products" he asked, knowing perfectly well that it was. "Yes dear, the butcher didn't come; we have discovered that he only comes three times a week." But there wasn't any need to apologise for it; it was a superb bird – it wasn't meat at all, it was a kind of very superior jelly. "Father would say" said Burnell "that this was one of those birds whose mother must have played to it in infancy upon the german flute and the sweet strains of the dulcet instrument acted with such effect upon the infant mind – Have some more Beryl. Beryl you and I are the only people in this house with a real feeling for food – I am perfectly willing to state in a court of law, if the necessity arises that I love good food" – Tea was served in the drawing room after dinner and Beryl who for some reason had been very charming to Stanley ever since he came home suggested he and she should play a game of crib. They sat down at a little table near one of the open windows. ~~A tall lamp above Beryl's head shone on the thick braids of bright hair.~~ Mrs. Fairfield had gone upstairs and Linda lay in a rocking chair her arms above her head – rocking to and fro. "You don't want the light do you Linda" said Beryl and she moved the tall lamp to her side, so that she sat under its soft light. How remote they looked those two – from where ~~Beryl~~ Linda watched and rocked – The green table, the bright polished cards, Stanley's big hands and Beryl's tiny white ones, moving the tapping red and white pegs along the little board seemed all to be part of one united in some mysterious movement. Stanley himself ~~rested~~ resting at ease big and solid in his loose fitting dark suit, ~~there was~~

and pouted. Round her throat she wore an unfamiliar velvet ribbon. It changed her, somehow – altered the shape of her face – but it was charming, Linda decided. The room smelled of lilies; there were two big jars of arums in the fire-place.

"Fifteen two – fifteen four – and a pair is six and a run of three is nine," said Stanley, so deliberately, he might have been counting sheep.

"I've nothing but two pairs," said Beryl, exaggerating her woe because she knew how he loved winning.

The cribbage pegs were like two little people going up the road together, turning round the sharp corner, and coming down the road again. They were pursuing each other. They did not so much want to get ahead as to keep near enough to talk – to keep near, perhaps that was all.

But no, there was always one who was impatient and hopped away as the other came up, and would not listen. Perhaps the white peg was frightened of the red one, or perhaps he was cruel and would not give the red one a chance to speak. . . .

In the front of her dress Beryl wore a bunch of pansies, and once when the little pegs were side by side, she bent over and the pansies dropped out and covered them.

"What a shame," said she, picking up the pansies. "Just as they had a chance to fly into each other's arms."

"Farewell, my girl," laughed Stanley, and away the red peg hopped.

The drawing-room was long and narrow with glass doors that gave on to the verandah. It had a cream paper with a pattern of gilt roses, and the furniture, which had belonged to old Mrs. Fairfield, was dark and plain. A little piano stood against the wall with yellow pleated silk let into the carved front. Above it hung an oil painting by Beryl of a large cluster of surprised looking clematis. Each flower was the size of a small saucer, with a centre like an astonished eye fringed in black. But the room was not finished yet.

such had a look of health and wellbeing about him – and there was Beryl in the white and black muslin dress with her ~~hair like~~ bright head bent under the lamp light. ~~She had a~~ Round her throat she wore a black velvet ribbon – It changed her – altered the shape of her face and throat somehow – but it was very charming – Linda decided. The room smelled of lilies – there were 2 big jars of white arums in the fireplace – "Fifteen two – fifteen four and a pair is ~~three~~ six and a run of three is nine," said Stanley so deliberately he might have been counting sheep. "I've nothing but 2 pairs" said Beryl, exaggerating her woefulness, because she knew how he loved winning. The cribbage pegs were like 2 little people going up the road together, turning round the sharp corner coming down the road again. They were pursuing each other. They did not so much want to get ahead as to keep near enough to talk – to keep near – perhaps that was all. But no, there was one always who was impatient and hopped away as the other came up and wouldn't listen perhaps one was frightened of the other or perhaps the white one was cruel and ~~would not listen~~ did not want to hear and would not even give him a chance to speak. In the bosom of her dress Beryl wore a bunch of black pansies, and once just as the little pegs were close side by side – as she bent over – the pansies dropped out and covered them – "What a shame to stop them," said she – ~~just picking up~~ as she picked up the pansies, "just when they had a moment to fly into each other's arms!" "Goodbye my girl," laughed Stanley and away the red peg hopped – – The drawing room was long and narrow with 2 windows and a ~~large~~ glass door that gave on to the verandah. It had a cream paper with a pattern of gilt roses, and above the white marble mantelpiece was the big mirror in a gilt frame wherein Beryl had seen her drowned reflection. A white polar bear skin lay in front of the fireplace and the furniture which had belonged to old Mrs. Fairfield was dark and plain – A little piano stood against the wall with yellow pleated silk let into the carved back. Above it there hung a ~~large~~ oil painting by Beryl of a large cluster of surprised looking clematis – for each flower was the size of a small saucer ~~and its "middle"~~ with a centre like an astonished eye fringed in black. But the room was not "finished'

137

Stanley had set his heart on a Chesterfield and two decent chairs. Linda liked it best as it was. . . .

Two big moths flew in through the window and round and round the circle of lamplight.

"Fly away before it is too late. Fly out again."

Round and round they flew; they seemed to bring the silence and the moonlight in with them on their silent wings. . . .

"I've two kings," said Stanley. "Any good?"

"Quite good," said Beryl.

Linda stopped rocking and got up. Stanley looked across. "Anything the matter, darling?"

"No, nothing. I'm going to find mother."

She went out of the room and standing at the foot of the stairs she called, but her mother's voice answered her from the verandah.

The moon that Lottie and Kezia had seen from the storeman's wagon was full, and the house, the garden, the old woman and Linda — all were bathed in dazzling light.

"I have been looking at the aloe," said Mrs. Fairfield. "I believe it is going to flower this year. Look at the top there. Are those buds, or is it only an effect of light?"

As they stood on the steps, the high grassy bank on which the aloe rested rose up like a wave, and the aloe seemed to ride upon it like a ship with the oars lifted. Bright moonlight hung upon the lifted oars like water, and on the green wave glittered the dew.

"Do you feel it, too," said Linda, and she spoke to her mother with the special voice that women use at night to each other as though they spoke in their sleep or from some hollow cave — "Don't you feel that it is coming towards us?"

She dreamed that she was caught up out of the cold water into the ship with the lifted oars and the budding mast. Now the oars fell striking quickly, quickly. They rowed far away over the top of the garden trees, the paddocks and the dark bush beyond. Ah, she heard herself cry: "Faster!

138

yet – Stanley meant to buy a Chesterfield and two decent chairs and – goodness only knows – Linda liked it best as it was. ~~Some~~ Two big moths flew in through the window and round and round the circle of lamplight. "Fly away sillies before it is too late. Fly out again" ~~into the garden, you~~ but no – round and round they flew. And they seemed to bring the silence of the moonlight in with them on their tiny wings . . .

"I've two Kings" said Stanley "any good?" "Quite good" said Beryl. Linda stopped rocking and got up. Stanley looked across. "Anything the matter, darling?" He felt her restlessness. "No nothing I'm going to find Mother." She went out of the room ~~and along the passage to~~ and standing at the foot of the stairs she called "Mother – " But Mrs. Fairfield's voice came ~~from the front door steps~~ across the hall from the verandah.

~~"I'm out here, dear. I am just having a look at the night. Do you want me? Yes,"~~ said Linda. ~~She crossed the hall and went out on to the verandah –~~ The moon that Lottie and Kezia had seen from the storeman's wagon was nearly full – and ~~so bright, a dazzling~~ the house, the garden, old Mrs. Fairfield and Linda – all were ~~held caught~~ bathed in a dazzling light – ~~On the white verandah pillars glittered the dew.~~ – "I have been looking at the aloe" said Mrs. Fairfield. "I believe it is going to flower – this year. Wouldn't that be wonderfully lucky! Look at the top there! All those buds – or is it only an effect of light." As they stood on the steps the high grassy bank on which the aloe rested – ~~seemed to lifted~~ rose up like a wave ~~in the air~~ and the aloe seemed to ride upon it like a ship with the oars lifted – ~~the~~ bright moonlight hung upon those lifted oars like water and on the green wave glittered the dew ~~like dancing foam~~ – "Do you feel too," said Linda and she spoke, like her mother with the "special" voice that women use at night to each other, as though they spoke in their sleep or from the bottom of a deep well – "don't you feel that it is coming towards us?" And she dreamed that she and her mother were caught up on the cold water and into the ship with the lifted oars and the budding mast. And now the oars ~~were~~ fell, striking quickly quickly and they rowed far away over the tops of the garden trees over the paddocks and the dark bush beyond. She saw her mother, sitting quietly in the boat,

139

The Aloe

The Aloe VI commencé March 12

Faster!" to those who were rowing.

How much more real this dream was than that they should go back to the house where the sleeping children lay and where Stanley and Beryl played cribbage.

"I believe those are buds," said she. "Let us go down into the garden, mother. I like that aloe. I like it more than anything here. And I am sure I shall remember it long after I've forgotten all the other things."

She put her hand on her mother's arm and they walked down the steps, round the island and on to the main drive that led to the front gates.

Looking at it from below she could see the long sharp thorns that edged the aloe leaves, and at the sight of them her heart grew hard. ... She particularly liked the long sharp thorns. ... Nobody would dare to come near the ship or to follow after.

"Not even my Newfoundland dog," thought she, "that I'm so fond of in the daytime."

For she really was fond of him; she loved and admired and respected him tremendously. Oh, better than anyone else in the world. She knew him through and through. He was the soul of truth and decency, and for all his practical experience he was awfully simple, easily pleased and easily hurt. ...

If only he wouldn't jump at her so, and bark so loudly, and watch her with such eager, loving eyes. He was too strong for her; she had always hated things that rush at her, from a child. There were times when he was frightening – really frightening. When she just had not screamed at the top of her voice: "You are killing me." And at those times she had longed to say the most coarse, hateful things. ...

"You know I'm very delicate. You know as well as I do that my heart is affected, and the doctor has told you I may die any moment. I have had three great lumps of children already. ..."

Yes, yes, it was true. Linda snatched her hand from mother's arm. For all

"sunning" herself in the moonlight as she expressed it. No, after all, it
would be better if her Mother did not come, for she heard herself cry
faster faster to those who were rowing. How much more natural this
dream was than that she should go back to the house where the children
lay sleeping and where Stanley and Beryl sat playing cribbage – "I believe
there are buds," said she. "Let us go down into the garden Mother – – I
like that Aloe. I like it more than anything else here, and I'm sure I shall
remember it long after I've forgotten all the other things." ~~Yes, there it~~
~~lay, hovering on the bank, waiting for her whenever the moment should~~
~~come –~~ Whenever she should make up her mind to stay no longer – ~~– She~~
~~took her Mother's arm and they went down together into the garden.~~
She put her hand on her Mother's arm: and they walked down the steps,
round the island and on to the main "drive" that led to the front gates –
Looking at it from below she could see the long sharp thorns that edged
the Aloe leaves, and at the sight of them ~~she felt~~ her heart grew hard. She
particularly liked the long sharp thorns. Nobody would dare to come
near her ship or to follow after. "Not even my New Foundland dog"
thought she "whom I'm so fond of in the day time." For she really was
fond of him. She loved and admired and respected him tremendously –
and she understood him. *Oh,* better than anybody else in the world, she
knew him through and through – He was the soul of truth and sincerity
and ~~there was something awfully charming about his~~ for all his ~~business~~
practical experience he was awfully simple, easily pleased and easily hurt
– If only he didn't jump up at her so and bark so loudly and thump with his
tail and watch her with such eager loving eyes! He was too strong for her.
She always *had* hated things that rushed at her even when she was a child
– ~~He was frightening~~ There were times when he was frightening – really
frightening, when she just hadn't screamed at the top of her voice – "you
are killing me" – and when she had longed to say the most coarse hateful
things. "You know I'm very delicate. You know as well as I do that my
heart is seriously affected and Doctor Dean has told you that I may die
any moment – I've had three great lumps of children already." Yes, yes it
was true – and thinking of it, she snatched her hand away from her

141

her love and respect and admiration she hated him. And how tender he always was after times like those, how submissive, how thoughtful. He would do anything for her; he longed to serve her. . . . Linda heard herself saying in a weak voice:

"Stanley, would you light a candle?"

And she heard his joyful voice answer: "Of course I will, my darling." And he leapt out of bed as though he were going to leap at the moon for her.

It had never been so plain to her as it was at this moment. There were all her feelings for him, sharp and defined, one as true as the other. And there was this other, this hatred, just as real as the rest. She could have done her feelings up in little packets and given them to Stanley. She longed to hand him that last one, for a surprise. She could see his eyes as he opened that. . . .

She hugged her folded arms and began to laugh silently. How absurd life was – it was laughable, simply laughable. And why this mania of hers to keep alive at all? For it really was a mania, she thought, mocking and laughing.

"What am I guarding myself for so preciously? I shall go on having children and Stanley will go on making money and the children and the gardens will grow bigger and bigger, with whole fleets of aloes in them for me to choose from."

She had been walking with her head bent, looking at nothing. Now she looked up and about her. They were standing by the red and white camellia trees. Beautiful were the rich dark leaves spangled with light and the round flowers that perch among them like red and white birds. Linda

mother's arm for all her love and respect and admiration she hated him. It had never been so plain to her as it was at this moment – There were all her "feelings" about Stanley one just as true as the other – sharp defined – She could have done them up in little packets – and there was this other – just as separate as the rest, this hatred and yet just as real. She wished she had done them up in little packets and given them to Stanley – especially the last one – she would like to watch him while he opened that .. And how tender he always was after times like that, how submissive – how thoughtful. He would do anything for her he longed to serve her. Linda heard herself saying in a weak voice, "Stanley would you ~~turn out the light~~ light a candle" and she heard his joyful eager answer "My darling of course I shall" and through he went giving a leap out of bed and drawing the moon out of the sky for her – ~~Linda threw back her head and laughed~~ – She hugged her folded arms and began to laugh silently. Oh dear Oh dear how absurd it all was! It really was funny – simply funny, and the idea of her hating Stanley (she could see his astonishment if she had cried out or given him the packet) was funniest of all. Yes it was perfectly true what Beryl had said that afternoon. She didn't care for anything – but it wasn't a pose – Beryl was wrong there – She laughed because she couldn't *help* laughing. –

And why this mania to keep alive? For it really was mania! What am I guarding myself so preciously for she thought mocking and silently laughing? I shall go on having children and Stanley will go on making money and the children and the houses will grow bigger and bigger, with larger and larger gardens – and whole fleets of aloe trees in them – for me to choose from – –

Why this mania to keep alive indeed? In the bottom of her heart she knew that now she was not being perfectly sincere. She had a reason but she couldn't express it, no not even to herself. She had been walking with her head bent looking at nothing – now she looked up and about her. Her mother and she were standing by the red and white camellia trees. Beautiful were the rich dark leaves spangled with light and the round flowers that perched among the leaves like red and white birds. Linda

pulled a piece of verbena and crumpled it, and held her hands to her mother.

"Delicious," said the old woman. "Are you cold, child? Are you trembling? Yes, your hands are cold. We had better go back to the house."

"What have you been thinking about?" said Linda. "Tell me."

"I haven't really been thinking of anything. I wondered as we passed the orchard what the fruit trees were like and whether we should be able to make much jam this autumn. There are splendid healthy currant bushes in the vegetable garden. I noticed them to-day. I should like to see those pantry shelves thoroughly well stocked with our own jam. . . ."

pulled a piece of verbena and crumbled it and held up the cup of her hand to her Mother – "Delicious" said Mrs. Fairfield bending over to smell – "Are you cold, child are you trembling? Yes, your hands are cold. We had better go back to the house" – "What have you been thinking of" said Linda – "Tell me" – But Mrs. Fairfield said "I haven't really been thinking of anything at all. I wondered as we passed the orchard what the fruit trees were like, whether we should be able to make much Jam this autumn – There are splendid black currant and gooseberry bushes in the vegetable garden. I noticed them to-day. I should like to see those pantry shelves thoroughly well stocked with our own jam – "[10]

~~Patrick Sheehan had a little room off the kitchen store – The wall by one side of his bed~~

Dearest Nancy I am sure you are calling me names but I'm not a little pig, dear. This is really and truly the first moment I've had to myself for over a fortnight. As it is I'm so exhausted I can hardly hold a pen and my head still jars because of the strain and of packing cases, for we've been moving dear – In the spring my brother in law decided he could not bear the *giddy whirl* of Hiltonville any longer (!!) As he has decided this at least twice a year ever since I have lived with them I didn't really pay much attention.

Saturday morning. Tarana

My dearest Ray

I know you are calling me names, but this is really the first moment I've had to myself for over a fortnight. The dreadful deed is done, my dear. We have actually ~~left the giddy whirl of town (!!) and that horrid little piggy house which really was rather dreadful and here we are high and dry~~ moved! In a way its an awful relief for my brother in law has been threatening to tear us away from the giddy whirl of town (!) for years. In fact I had got so used to hearing his sighs for the country that when he began this spring I never dreamed of taking it seriously – But while he was sighing this house came onto the market and practically without saying a word to us he went and had a look at it, bought it the house and

XII "My Darling Nan,

Don't think me a piggy wig because I haven't written before. I haven't had a moment, dear, and even now I feel so exhausted that I can hardly hold a pen.

Well, the dreadful deed is done. We have actually left the giddy whirl of town, and I can't see how we shall ever go back again, for my brother-in-law has bought this house 'lock, stock and barrel,' to use his own words.

In a way, of course, it is an awful relief, for he has been threatening to take a place in the country ever since I've lived with them – and I must say the house and garden are awfully nice – a million times better than that awful cubby-hole in town.

But buried, my dear. Buried isn't the word.

We have got neighbours, but they are only farmers – big louts of boys who seem to be milking all day, and two dreadful females with rabbit teeth who brought us some scones when we were moving and said they would be pleased to help. But my sister who lives a mile away doesn't know a soul here, so I am sure we never shall. It's pretty certain nobody will ever come out from town to see us, because though there is a bus it's an awful old rattling thing with black leather sides that any decent person would rather die than ride in for six miles.

Such is life. It's a sad ending for poor little B. I'll get to be a most awful frump in a year or two and come and see you in a mackintosh and a sailor hat tied on with a white china silk motor veil. So pretty.

told us to pack. Men are thoughtful creatures. Linda, as usual, sat and
smiled, and Mother said she was very glad for the children's sakes, so
there was nothing left for poor little B. to do but grin and bear it – We
had a simply awful ~~week~~ fortnight. I picnicked here for the first week with
a new servant girl and a new handyman and got things more or less ready
for the house is much bigger than those wretched letter box in town was
– and we had to have cartloads of new furniture and interesting things like
linoleum and lamps. And after an awful time, at the end of the week the
others came with the remains of the old furniture trailing before and
after them –

A letter from Beryl Fairfield to her friend Nan Fry.

My darling Nan,

Don't think me a piggy-wig because I haven't written before: I haven't
had a moment dear and even now I feel so exhausted that I can hardly
hold a pen – Well, the dreadful deed is done. We have actually left the
giddy whirl of town (!) and I can't see how we shall ever go back again, for
my brother-in-law has bought this house "lock stock and barrel" to use
his own words. In a way it's an awful relief for he's been threatening to
take a place in the country ever since I've lived with them – and I must say
the house and garden are awfully nice – a million times better than that
dreadful cubby hole in town – But buried – my dear – buried isn't the
word! We have got neighbours but they're only farmers – big louts of
boys who always seem to be milking and two dreadful females with
protruding teeth who came over when we were moving and brought us
some scones and said they were sure they'd be very willing to help. My
sister, who lives a mile away says she doesn't really know a soul here, so
I'm sure we never never shall and I'm certain no body will ever come out
from town to see us because though there is a bus it's an awful old rattling
thing with black leather sides that any decent person would rather die
than ride in for six miles! Such is life! It's a sad ending for poor little B. I'll
get to be a most frightful frump in a year or two and come and see you in a
mackintosh with a sailor hat tied on with a white china silk motor veil!

Stanley says that now we are settled – for after the most awful week of my life we really are settled – he is going to bring out a couple of men from the club on Saturday afternoons for tennis. In fact, two are promised as a great treat to-day. But, my dear, if you could see Stanley's men from the club … rather fattish, the type who look frightfully indecent without waistcoats – always with toes that turn in rather – so conspicuous when you are walking about a court in white shoes. And they are pulling up their trousers every minute – don't you know – and whacking at imaginary things with their rackets.

I used to play with them at the club last summer, and I am sure you will know the type when I tell you that after I'd been there about three times they all called me Miss Beryl. It's a weary world. Of course mother simply loves the place, but then I suppose when I am mother's age I shall be content to sit in the sun and shell peas into a basin. But I'm not – not – not.

What Linda thinks about the whole affair, per usual, I haven't the slightest idea. Mysterious as ever. . . .

My dear, you know that white satin dress of mine. I have taken the sleeves out entirely, put bands of black velvet across the shoulders and two big red poppies off my dear sister's *chapeau*. It is a great success, though when I shall wear it I do not know."

Beryl sat writing this letter at a little table in her room. In a way, of course, it was all perfectly true, but in another way it was all the greatest rubbish and she didn't believe a word of it. No, that wasn't true. She felt all those things, but she didn't really feel them like that.

It was her other self who had written that letter. It not only bored, it rather disgusted her real self.

148

Stanley says that now we're settled, for after the most ghastly fortnight of my life we really are settled, he is going to bring out a couple of men from the club each week for tennis – on Saturday afternoons – In fact two are promised us as a *great treat* today – But my dear if you could see Stanley's men from the club, rather fattish – the type who look frightfully indecent without waistcoats – always with toes that turn in rather – so conspicuous too, when you're walking about a tennis court in white shoes and pulling up their trousers, every minute – don't you know and whacking at imaginary things with their racquets. I used to play with them at the Club Court last summer – and I'm sure you'll know the type when I tell you that after I'd been there about 3 times they *all* called me Miss Beryl! It's a weary world. Of course Mother simply loves this place, but then when I am Mother's age I suppose I shall be quite content to sit in the sun and shell peas into a basin but I'm not not not. What Linda really thinks about the whole affair, per usual I haven't the slightest idea. She is as mysterious as ever.

My dear you know that white satin dress of mine. I've taken the sleeves out entirely put straps of black velvet across the shoulders and two big red poppies off my dear sister's chapeau. It's a great success though *when* I shall wear it I do not know . . .

Beryl sat writing this letter at a little table in front of the window in her room. In a way of course it was all perfectly true but in another way it was all the greatest rubbish and she didn't mean a word of it. No, that wasn't right – ~~The letter didn't really belong to her~~ – She felt all those things but she didn't really feel them like that – The Beryl that wrote that letter might have been leaning over her shoulder and guiding her hand – so separate was she: and yet in a way, perhaps she was more real than the other, the real Beryl. ~~It was this second Beryl~~ She had been getting stronger and stronger for a long ~~time~~ while. There had been a time when the real Beryl had just really made use of the false one to get her out of awkward positions – to glide her over hateful ~~things~~ moments – to help her to bear the stupid ugly sometimes beastly things that happened – She had as it were called to the unreal Beryl, and seen her coming, and seen

149

"Flippant and silly," said her real self. Yet she knew that she'd send it and she'd always write that kind of twaddle to Nan Pym. In fact, it was a very mild example of the kind of letter she generally wrote.

Beryl leaned her elbows on the table and read it through again. The voice of the letter seemed to come up to her from the page. It was faint already, like a voice heard over the telephone, high, gushing, with something bitter in the sound. Oh, she detested it to-day.

"You've always got so much animation," said Nan Pym. "That's why men are so keen on you." And she had added, rather mournfully, for men were not at all keen on Nan, who was a solid kind of girl, with fat hips and a high colour – "I can't understand how you can keep it up. But it is your nature, I suppose."

What rot. What nonsense. It wasn't her nature at all. Good heavens, if she had ever been her real self with Nan Pym, Nannie would have jumped out of the window with surprise. . . . My dear, you know that white satin of mine. . . . Beryl slammed the letter-case to.

her going away again, quite definitely and simply – But that was long ago.
The unreal Beryl was greedy and jealous of the real one – Gradually she
took more and stayed longer – Gradually she came more quickly and now
the real Beryl was hardly certain sometimes if she were there or not –
Days, weeks at a time passed without her ever for a moment ceasing to
act a part, for that is what it really came to and then, quite suddenly, when
the unreal self had ~~done something~~ forced her to do something she did
not want to do at all she had come into her own again and for the first
time realised what had been happening. Perhaps it was because she was
not leading the life that she wanted to – She had not a chance to really
express herself – she was always living below her power – and therefore
she had no need of her real self – her real self only made her ~~suffer~~
wretched.

In a way of course it was all perfectly true but in another was it was all
the greatest rubbish and she didn't believe a word of it.[11] No, that wasn't
right: she *felt* all those things but she didn't really feel them *like that*. It was
her other self, whose slave or whose mistress she was which? who had
written that letter. It not only bored – it rather disgusted her real self.
"Flippant and silly" said her real self, yet she knew she'd sent it and that
she'd always write that kind of twaddle to Nan Fry – In fact it was a very
mild example of the kind of letter she generally wrote. Beryl leaned her
elbows on the table and read it through again – the voice of the letter
seemed to come up to her from the page – faint already like ~~the~~ a voice
heard over a telephone wire, high, gushing – ~~and~~ with something bitter in
the sound – Oh, she *detested* it today. "You've always got so much
animation B" said Nan Fry – "That's why men are so keen on you" – and
she had added, rather mournfully – (for men weren't keen on Nan – she
was a solid kind of girl with fat hips and a high colour) "I can't understand
how you keep it up, but it's your nature I suppose." What rot! What
nonsense! But it wasn't her nature at all! Good Heavens! if she'd ever
been her real self with ~~Nan Fry~~ Nannie would have jumped out of the
window with surprise. My dear you know that white satin dress of mine –
Ugh! Beryl slammed her letter case to. She jumped up and half

Prelude　　She jumped up and half unconsciously, half consciously she drifted over to the looking-glass.

There stood a slim girl in white – a white serge skirt, a white silk blouse, and a leather belt drawn in very tightly at her tiny waist.

Her face was heart-shaped, wide at the brows and with a pointed chin – but not too pointed. Her eyes, her eyes were perhaps her best feature; they were such a strange uncommon colour – greeny blue with little gold points in them.

She had fine black eyebrows and long lashes – so long, that when they lay on her cheeks you positively caught the light in them, someone or other had told her.

Her mouth was rather large. Too large? No, not really. Her underlip protruded a little; she had a way of sucking it in that somebody else had told her was awfully fascinating.

Her nose was her least satisfactory feature. Not that it was really ugly. But it was not half as fine as Linda's. Linda really had a perfect little nose. Hers spread rather – not badly. And in all probability she exaggerated the spreadiness of it just because it was her nose, and she was so awfully critical of herself. She pinched it with a thumb and first finger and made a little face. . . .

Lovely, lovely hair. And such a mass of it. It had the colour of fresh fallen leaves, brown and red with a glint of yellow. When she did it in a long plait she felt it on her backbone like a long snake. She loved to feel the weight of it dragging her head back, and she loved to feel it loose, covering her bare arms. "Yes, my dear, there is no doubt about it, you really are a lovely little thing."

152

consciously – half unconsciously she drifted over to the looking glass –
There stood a slim girl dressed in white – a short white serge skirt – a
white silk blouse and a white leather belt drawn in tight round her tiny
waist – She had a heart shaped face – wide at the brows and with a
pointed chin – but not too pointed – – Her eyes – her eyes were perhaps
her best feature – such a strange uncommon colour too, greeny blue with
little gold spots in them. She had fine black eyebrows and long black
lashes – so long that when they lay on her cheek they positively caught
the light some [one] or other had told her – Her mouth was rather large
– too large? No, not really. Her underlip protruded a little. She had a way
of sucking it in that somebody else had told her was awfully fascinating.
Her nose was her least satisfactory feature – Not that it was really ugly –
but it wasn't half as fine as Linda's. Linda really had a perfect little nose.
Hers spread rather – not badly – and in all probability she exaggerated the
spreadness of it just because it was her nose and she was so awfully critical
of herself. She pinched it with her thumb and second finger and made a
little face – Lovely long hair. And such a mass of it. It was the colour of
fresh fallen leaves – brown and red, with a glint of yellow. Almost it
seemed to have a life of its own – it was so warm and there was such a
deep ripple in it. When she plaited it in one thick plait it hung on her back
just like a long snake – she loved to feel the weight of it drag her head
back – she loved to feel it loose covering her bare arms. It had been a
~~passion~~ fashion among the girls at Miss Beard's to brush Beryl's hair. "Do
do let me brush your hair darling Beryl," but nobody ~~had~~ brushed it as
beautifully as Nan Fry. Beryl would sit in front of the dressing table in her
cubicle – ~~dressed in~~ wearing a white linen wrapper – ~~On the dressing~~
~~table two candles~~ and behind her stood Nannie in a dark red woolen
gown buttoned up to her chin – Two candles gave a pointing, flickering
light – Her hair streamed over the chair back – she shook it out – she ~~gave~~
yielded it up to Nannie's adoring hands. In the glass Nannie's face above
the dark gown was like a round ~~blind~~ sleeping mask. Slowly she brushed,
with long caressing strokes – her hand and the brush were like one thing
upon the warm hair. She would say with a kind of moaning passion, laying

153

At the words her bosom lifted; she took a long breath of delight, half closing her eyes.

But even as she looked the smile faded from her lips and eyes. Oh, God, there she was, back again, playing the same old game. False — false as ever. False as when she'd written to Nan Pym. False even when she was alone with herself, now.

What had that creature in the glass to do with her, and why was she staring? She dropped down to one side of her bed and buried her face in her arms.

"Oh," she cried, "I am so miserable — so frightfully miserable. I know that I'm silly and spiteful and vain; I'm always acting a part. I'm never my real self

down the brush and looping the hair in her hands – "it's more beautiful than ever B. It really is lovelier than last time" – and now she would brush again – she seemed to send herself to sleep with the movement and the gentle sound – she had something of the look of a blind cat – – as though it were she who was being stroked and not Beryl – But nearly always these brushings came to an unpleasant ending. Nannie did something silly. Quite suddenly she would snatch up Beryl's hair and bury her face in it and kiss it, or clasp her hands round Beryl's head and press ~~her the~~ Beryl's head back against her ~~hard~~ firm breast sobbing – "you are so beautiful. You don't know how beautiful you are beautiful beautiful." And at these moments Beryl had such a feeling of horror such a violent thrill of physical dislike for Nan Fry – "That's enough – that's quite enough. Thank you. You've brushed it beautifully. Good night Nan."[12] She didn't even try to suppress a contempt and her disgust – – And the curious thing was that Nan Fry seemed rather to understand this – even to expect it, never protesting but stumbling away out of the cubicle – and perhaps whispering *"forgive me"* at the door – And the *more* curious thing was that Beryl let her brush her hair again – and let this happen again, – – and again there was this "silly scene" between them always ending in the same way more or less, and never never referred to in the daytime. But she *did* brush hair so beautifully. Was her hair less bright now? No, not a bit – "Yes, my dear, there's no denying it, you really are a lovely little thing" – At the words her breast lifted, she took a long breath, smiling with delight, half closing her eyes as if she held a sweet sweet bouquet up to her face – a fragrance that ~~took the breath~~ made her faint. But even as she looked the smile faded from her lips and eyes – and oh God! There she was, back again, playing the same old game – False, false as ever! False as when she'd written to Nan Fry – False even when she was alone with herself now. What had that creature in the glass to do with her really and why on earth was she staring at her? She dropped down by the side of her bed and buried her head in her arms. "Oh," she said "I'm so miserable, so frightfully miserable. I know I'm silly and spiteful and vain. I'm always acting a part, I'm never my real self for a minute" – And plainly, plainly she

155

for a moment." And plainly, plainly, she saw her false self running up and down the stairs, laughing a special trilling laugh if they had visitors, standing under the lamp if a man came to dinner, so that he should see the light on her hair, pouting and pretending to be a little girl when she was asked to play the guitar. Why? She even kept it up for Stanley's benefit. Only last night when he was reading the paper her false self had stood beside him and leaned against his shoulder on purpose. Hadn't she put her hand over his, pointing out something so that he should see how white her hand was beside his brown one.

How despicable! Despicable! Her heart was cold with rage. "It's marvellous how you keep it up," said she to the false self. But then it was only because she was so miserable — so miserable. If she had been happy and leading her own life, her false life would cease to be. She saw the real Beryl — a shadow . . . a shadow. Faint and unsubstantial she shone. What was there of her except the radiance? And for what tiny moments she was really she. Beryl could almost remember every one of them. At those times she had felt: "Life is rich and mysterious and good, and I am rich and mysterious and good, too." Shall I ever be that Beryl for ever? Shall I? How

saw her false self running up and down the stairs, laughing a special trilling laugh if they had visitors, standing under the lamp if a man came to dinner so that he should see how the light shone on her hair, pouting and pretending to be a little girl when she was asked to play the guitar – Why she even kept it up for Stanley's benefit! Only last night when he was reading the paper – she had ~~leaned against his shoulder~~ stood beside him and leaned against him *on purpose* and she had put her hand over his pointing out something and said at the same time – "Heavens! Stanley how brown your hands are" – only that he should notice how white hers were! How despicable! Her heart grew cold with rage! "It's marvellous how you keep it up!" said she to her false self! but then it was only because she was so miserable – so miserable! If she'd been happy – if she'd been living *her own life* all this ~~never~~ false life would simply cease to be – and now she saw the real Beryl a radiant shadow – – – a shadow – – – Faint and unsubstantial shone the real ~~Beryl~~ self – what was there of her except that radiance? And for what tiny moments she was really she. Beryl could almost remember every one of them – – ~~By radiance~~ she did not mean that she was exactly happy then it was a "feeling" that overwhelmed her at certain times – – certain nights when the wind blew with a forlorn cry and she lay cold in her bed wakeful and listening certain lovely evenings when she passed down a road where there were houses and big gardens and the sound of a piano came from one of the houses – and then certain Sunday nights in Church, when the glass flickered and the pews were shadowy and the lines of the hymns were almost too sweet and sad to bear. And rare rare times, rarest of all, when it was not the voice of outside things that had moved her so – she remembered one of them, when she had sat up one night with Linda. Linda was very ill – she had watched the pale dawn come in through the blinds and she had seen Linda – lying, propped up high with pillows, her arms ~~along the sheets~~ outside the quilt and the shadow of her hair dusky against the white – and at all these times she had felt ~~the~~ "radiance": Life is wonderful – life is rich and mysterious. But it is good too and I am rich and mysterious and good. Perhaps that is what she might have said – – but she did not say those

157

Prelude can I? And was there ever a time when I did not have a false self? . . . But just as she had got that far she heard the sound of little steps running along the passage; the door handle rattled. Kezia came in.

"Aunt Beryl, mother says will you please come down? Father is home with a man and lunch is ready."

Botheration! How she had crumpled her skirt, kneeling in that idiotic way.

"Very well, Kezia." She went over to the dressing table and powdered her nose.

Kezia crossed too, and unscrewed a little pot of cream and sniffed it. Under her arm she carried a very dirty calico cat.

When Aunt Beryl ran out of the room she sat the cat up on the dressing table and stuck the top of the cream jar over its ear.

"Now look at yourself," said she sternly.

The calico cat was so overcome by the sight that it toppled over backwards and bumped and bumped on to the floor. And the top of the cream jar flew through the air and rolled like a penny in a round on the linoleum – and did not break.

But for Kezia it had broken the moment it flew through the air, and she picked it up, hot all over, and put it back on the dressing table.

Then she tip-toed away, far too quickly and airily. . . .

158

things – then she knew her false self was quite quite gone and she longed to be always as she was just at that moment – to become *that* Beryl forever – – "Shall I? How can I? and did I ever not have a false self?" But just ~~as she~~ when she had got that far she heard the sound of wheels coming up the drive and little steps running along the passage to her door and Kezia's voice calling "Aunt Beryl. Aunt Beryl!" She got up – Botheration! How she had crumpled her skirt. Kezia burst in. "Aunt Beryl – Mother says will you please come down because Father's home and lunch is ready – " "Very well Kezia." She went over to the dressing table and powdered her nose. Kezia crossed over too and unscrewed a little pot of cream and sniffed it. Under her arm Kezia carried a very dirty calico cat. When Aunt Beryl had run out of the room she sat the cat up on the dressing table and stuck the top of the cream jar over one of its ears. *Now* look at yourself said she sternly. The calico cat was so appalled at the effect that it toppled backwards and bumped and bounced on the floor and the top of the cream jar flew through the air and rolled like a penny in a round on the linoleum and did not break. But for Kezia it had broken the moment it flew through the air and she picked it up, hot all over, put it on the dressing table and walked away, ~~looking very guilty~~ *far* too quickly – and airily.

~~Stanley had only been able to hook one man after all. He'd left it a bit too late and all the men he phoned were fixd up except this young chap, just out from England who was staying at the Club. He had brought a letter of introduction to Stanley from The Head Office in London – and Stanley had lunched with him twice. He seemed a decent sort of chap – quiet – a bit stand offish like most of these English "Tommies"[13] – but Stanley supposed he'd thaw. At any rate – he'd jumped at the chance of an afternoon's tennis and turned up on Saturday at the office at midday togged up to the nines – White flanells covered with an immense thick coat – one pocket of which bulged with a silk muffler – white boots – raquet in a press – a slightly unfamiliar straw hat with a – ribbon round it. Wonder if I ought to warn him that there aint going to be no royalty~~

Prelude

160

-thought Stanley thrusting his bowler and taking his gloves from where *The Aloe*
-he always kept them at the office — under the cover of a typewriting
-machine —

Notes

1. Kathleen Mansfield Beauchamp wrote under the name Katherine Mansfield from 1910. This story is based on the Beauchamp family's move from 11 Tinakori Road in Thorndon to "Chesney Wold" in Karori, Easter 1893.

As in so many of her stories, the characters share much with Mansfield's own family and friends, from whom their names are frequently derived. Harold Beauchamp, like Kezia's father, courted his wife, the delicate Annie Burnell Dyer, at an early age, and on their marriage provided a home for her mother and two sisters. His mother's maiden name and that of his wife's grandmother are combined in the name Stanley Burnell. Grandmother Dyer (*née* Margaret Isabella Mansfield) moved with the family to Karori — and the name she is given here is an obvious anglicising of Beauchamp. Beryl is drawn from Aunt Belle Dyer, who continued to live with the Beauchamps until she left for England — also at Harold's expense — in 1903.

The eldest of the Beauchamp daughters, Vera Margaret, shared her middle name with Grandmother Dyer, and so becomes Isabel. Charlotte, a year older than Kathleen, loses in age but keeps her own name. Kezia seems to have derived from Job 42:14, where she is listed as the second of Job's three daughters in a verse Mansfield as a girl underlined in her Old Testament. Pip and Rags Trout are based on two cousins, Barrie and Eric Waters, the sons of Mrs. Beauchamp's eldest sister, Agnes. (A Baptist missionary called Trout had married into the Dyers in 1814). They did in fact live close by in Karori, and had moved from the city in the same week as the Beauchamps.

Pat the handyman keeps the name of his original, Pat Sheehan. Alice also retains the name of an actual maid. The Samuel Josephs were based on a Jewish family who lived next door in Thorndon. Harold Beauchamp chose the father, Walter Nathan, as his partner when he took over an importing firm in 1894. One of the daughters later became engaged to a man named Joseph.

"Tarana", the name given to "Chesney Wold", was, according to Mrs. Jeanne Renshaw, Mansfield's surviving sister, the name of the house in Hill Street where Grandmother Dyer was living at the time of her death in 1906.

2. Joseph Dyer, the grandfather on whom this character is based, was born in London in 1816. He emigrated to Australia when he was twenty-one, and married in Sydney. The family settled in Wellington in the late 1850s, a few years before the first fighting broke out in Taranaki. Wars between British forces and the Maoris continued until 1872; long enough, presumably, for an expression like this to become current.

3. Two sections of *The Aloe*, discarded from *Prelude*, found their way in a revised form into *At the Bay* in 1922. One became this paragraph in Section VI:

... Now she sat on the veranda of their Tasmanian home, leaning against her father's knee. And he promised, "As soon as you and I are old enough, Linny, we'll cut off somewhere, we'll escape. Two boys together. I have a fancy I'd like to sail up a river in China." Linda saw that river, very wide, covered with little rafts and boats. She saw the yellow hats of the boatmen and she heard their high, thin voices as they called ...

"Yes, papa."

But just then a very broad young man with bright ginger hair walked slowly past their house, and slowly, solemnly even, uncovered. Linda's father pulled her ear teasingly, in the way he had.

"Linny's beau," he whispered.

"Oh, papa, fancy being married to Stanley Burnell!"

The paragraph immediately following in *At the Bay* also picks up sentences from *The Aloe* (see p. 141):

Well, she was married to him. And what was more she loved him. Not the Stanley whom everyone saw, not the everyday one; but a timid, sensitive, innocent Stanley who knelt down every night to say his prayers, and who longed to be good. Stanley was simple. If he believed in people – as he believed in her, for instance – it was with his whole heart. He could not be disloyal; he could not tell a lie. And how terribly he suffered if he thought anyone – she – was not being dead straight, dead sincere with him!

4. All that survives of this notebook, which Mansfield obviously wrote in a revised form in "The Aloe III" book, are two pages of rough draft, and the second paragraph, which was not reworked, on the inside of the back cover.

5. "bonzer": Australian slang for "enjoyable or excellent" (*Heinemann New Zealand Dictionary*, 1979).

6. "barracouta": a longish narrow loaf with a rounded raised crust, fancifully resembling the barracouta fish (*Thyrsites atun*).

7. There is a note on the margin of the manuscript at this point: "Mrs. Trout in the dining room".

8. A gesture made by Agnes Wickfield, which became a verbal motif in Dickens' *David Copperfield*.

9. On a blank page opposite the text Mansfield drew up a list of what was so far written, and what was proposed:

> The Journey Home
> The Aloe ..
> Stanley Burnell: Beryl plays the guitar
> The Samuel Josephs: the Journey and Supper: Bed for all.
> Dan: Burnell courting Linda: Mrs Burnell Beryl: Kezia: The Aloe
> Stanley Burnell drives home: The nursery: Beryl with a guitar Children: Alice: The Trout sisters: Mrs Trout's latest novel:
> Cribbage: Linda and her Mother:
> really 13 chapters.
> They cut down the stem when Linda is ill. She has been counting on the flowering of the aloe:

10. When she had written this section of the story, Mansfield broke off to note on the facing page:

> It is a strange fact about Madame Allegre. She walks very well, quite beautifully – I saw her just now go down to the bottom of the garden with a pail in one hand and a basket in the other.
> Prepare charcoal fire every morning night before getting turning in. Then one has only to go down, put a match to it and stick on the funnel, and it's ready by the time you're dressed! How clever.
> I must break through again. I feel so anxious and so worried about the Sardinia that I can't write. What I have done seems to me awfully, impossibly good compared to the STUFF I wrote yesterday. I believe if I had another shock (!) – if for instance Mdlle Marthe turned up
> I might manage but at present, je veux mourir. I ought to write a letter from Beryl to Nan Fry.
> This is all too laborious!

Mansfield's sister Chaddie Perkins was then aboard the P. & O. liner *Sardinia*, sailing from India to England at a time when the Germans had intensified their submarine activities against British shipping. On 21 March Mansfield travelled to Marseilles, where the sisters briefly met.

Aunt Martha, or Mlle Marthe, was a euphemism Mansfield used for menstruation.

11. Facing the page where this was written, Mansfield made the following note:

> Beryl Fairfield.
> What is it that I'm getting at? It is really Beryl's "Sosie". The fact that for a long time now, she really hasn't been even able to control her second self: its her second self who now

controls her .. There was [a] kind of radiant being who wasn't either spiteful or malicious of whom she'd had a glimpse whose very voice was different to hers who was grave who never would have dreamed of doing the things that she did. Had she banished this being or had it really got simply tired and left her. I want to get at all this through her just as I got at Linda through Linda. To suddenly merge her into herself

12. At this point in the manuscript, on a separate page, Mansfield wrote these verses:

> Robin sends to Beryl —
>
> Lives like logs of driftwood
> Tossed on a watery main
> Other logs encounter
> Drift, touch, part again
>
> And so it is with our lives
> On life's tempestuous sea
> We meet, we greet, we sever
> Drifting eternally.

13. "English Tommies": like the phrase "English johnny" which Mansfield used in her story *Millie* in 1912, this is presumably a contemporary New Zealand expression for a recent immigrant.